Seeing Baya

The Abakanowicz Arts and Culture Collection

Seeing Baya

Portrait of an Algerian Artist in Paris

Alice Kaplan

The University of Chicago Press *Chicago and London*

The University of Chicago Press, Chicago 60637
The University of Chicago Press, Ltd., London
© 2024 by Alice Kaplan
All rights reserved. No part of this book may be used or reproduced in any manner whatsoever without written permission, except in the case of brief quotations in critical articles and reviews. For more information, contact the University of Chicago Press, 1427 East 60th Street, Chicago, IL 60637.
Published 2024
Printed in Canada

33 32 31 30 29 28 27 26 25 24 1 2 3 4 5

ISBN-13: 978-0-226-83508-2 (cloth)
ISBN-13: 978-0-226-83509-9 (e-book)
DOI: https://doi.org/10.7208/chicago/9780226835099.001.0001

Publication of this edition has been generously supported by the Abakanowicz Arts and Culture Charitable Foundation.

Library of Congress Cataloging-in-Publication Data

Names: Kaplan, Alice Yaeger, author.
Title: Seeing Baya : portrait of an Algerian artist in Paris / Alice Kaplan.
Other titles: Abakanowicz arts and culture collection.
Description: Chicago ; London : The University of Chicago Press, 2024. | Series: The Abakanowicz arts and culture collection | Includes bibliographical references and index
Identifiers: LCCN 2024009342 | ISBN 9780226835082 (cloth) | ISBN 9780226835099 (ebook)
Subjects: LCSH: Baya, 1931–1998. | Baya, 1931–1998—Exhibitions. | Baya, 1931–1998—Appreciation—France. | Galerie Maeght (Paris, France) | Artists—Algeria—Biography. | Women artists—Algeria—Biography. | Art and society—France—History—20th century. | Art—France—Paris—Exhibitions.
Classification: LCC N7388.3.B39 K36 2024 | DDC 759.965—dc23/eng/2024040
LC record available at https://lccn.loc.gov/2024009342

♾ This paper meets the requirements of ANSI/NISO Z39.48-1992 (Permanence of Paper).

For the women of Lioum Adab:

Djamila, Ilhem, Manel, Nelia, Nihal, Ryane, Thissas, Yousra

Contents

1. Bordj el Kiffan ... 1
2. The Maeght Gallery, November 21, 1947 ... 8
3. Marguerite Caminat ... 17
4. Baya Begins to Make Art ... 30
5. Behind the Curtains of the European Museum ... 35
6. Frank McEwen ... 40
7. Love ... 50
8. Dream of the Mother ... 53
9. Who Is Speaking? (Part I) ... 56
10. Baya Goes to Paris ... 63
11. Baya's Hosts ... 66
12. Nelly Vigilante ... 71
13. The Shadow of Violence ... 77
14. Marcelle Sibon ... 87
15. "Magnificent, but in rags" ... 92
16. Who Is Speaking? (Part II) ... 100
17. Photographs and Fabric ... 115
18. Les Messieurs ... 120
19. Baya Is Launched ... 125
20. Homecoming ... 129
21. Separation ... 136

Acknowledgments 155
Notes 161
Index 185

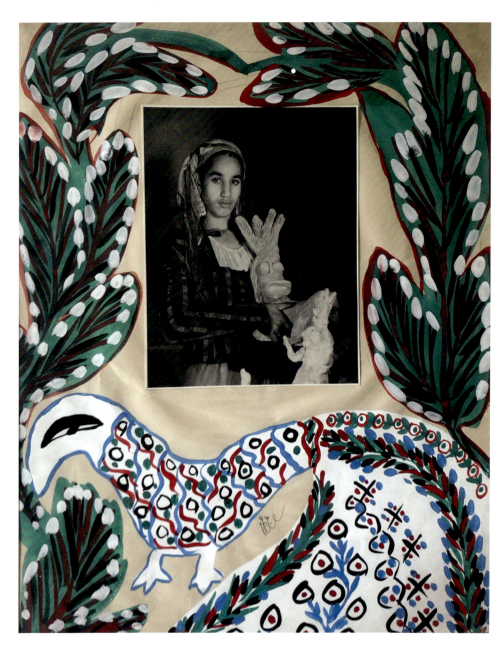

FIGURE 0: André Ostier's portrait of Baya, decorated by Baya (1947). Black-and-white photograph with gouache. By permission of the Children of Baya Mahieddine. Photograph: © 2024 by André Ostier / Association des amis d'André Ostier. (See also fig. 29, p. 116.)

1

Bordj el Kiffan

IT'S A HOT DAY in July in the summer of 2022, two and a half years into the pandemic. I'm living with friends in a fourth-floor apartment in the heart of Algiers, a neighborhood of people who make do. We don't have much: four armchairs woven in sea rush, a wooden table that expands to fill a room, a cabinet with red glass doors. I find these sparsely furnished spaces calming, conducive to writing. My own room, decorated only with a bed, a desk, and a cupboard, has high ceilings and cool black-and-white tile on the floors. Still, the heat is overwhelming. We've finally abandoned our scruples and put in air conditioning units in two of the rooms, adding to the buzz from the condensers all around the neighborhood. On my balcony, water from the unit is dripping out of a plastic tube, driving away the pigeons. Across the hall, behind the bathroom window, one of them has nested, and when I walk past to make some coffee in the kitchen, I hear the flutter of wings, the cooing of a mother and squab. We're not going to disturb them until the baby has grown enough to fly.

I return to my desk, to the Algerian artist named Baya whose paintings are always with me now. Against the black-and-white floor, her colors jump off the page. I'm spending more and more of my days lost in her fantasy gardens of mauves and greens and blues, her bright-eyed birds and women and girls looking at each other, looking at me. I keep seeing the fifteen-year-old artist, the one in the

1947 newsreel. In the final seconds, the camera zooms in on her face and she flashes an electric smile. Her look is challenging, sarcastic, amused, annoyed—triumphant even. But can I really read the look on her face? She emerged that year as a star of the postwar Parisian art world. She's back in style now, the subject of exhibitions from New York to Venice to Abu Dhabi, but it's 1947 that draws me in.

When I was a child my favorite painting at the local museum was Franz Marc's *The Large Blue Horses*, rendered in a blue so intense that the animals moved under my gaze. Baya takes me back to a time when I could see more, unburdened by the weight of information, the erosion of a life of thinking. When I close the catalog, her shapes and colors stay with me and my vision of the real world changes. The nesting pigeons behind the bathroom window are Baya's emissaries.

She was working on a flower farm when a French woman and her English husband noticed her talent and took her to Algiers to work as their maid. A gallery owner saw her paintings and gave her a solo exhibition in Paris. I've scanned into my computer the notes and correspondence that the French woman's family gave to the colonial archives in Aix-en-Provence. Marguerite Caminat's handwriting is hard to decipher, and a flood in her house means that some of the pages she gave to the Archives nationales d'outre-mer are smudged. She's underlined passages in red—messages to herself, and now to me. *Here is where she wanted me to pay attention.* I realize that the red passages are part of her preparation for the book she planned to write about Baya, after her protégée became a world-famous artist. I'm constantly perplexed by Marguerite's scribbles. I don't know when she wrote or when she copied what she'd originally written. Baya's stories of childhood look as if Marguerite jotted them down in the moment. But her chronology of Baya's life seems to have been created with several decades' retrospection.

Marguerite Caminat's papers keep me guessing, so I've decided to work around them. In Marseille, I've visited with Marguerite's great-niece, Sibylle. In Blida, twenty-five miles south of Algiers, Youcef Ouragui, known in town as "Memory Man," has shown me

a few of his fifty scrapbooks and shared his memories of Baya's house and her garden courtyard overflowing with greenery and blooms, butterflies and birds, living illustrations of her paintings. With my editor, Selma Hellal, I've walked down the street where Baya raised six children and wandered through the hallways of the town seat of Blida, where a small Baya painting has been placed discreetly outside the mayor's chambers.

At 2 p.m., Baya's daughter-in-law texts me that she's found a place to park in front of the metro stop. She's taking time off from her work to show me a part of Baya's world I could never have found on my own. Salima Mahieddine is accustomed to sharing her knowledge of Baya with researchers and curators, who reach out to her husband's family for stories.

I push up the sleeves of my cotton shirt, lock the door behind me. I walk past truck farmers selling their melons and men in *djellaba* en route to the mosque. A world of commerce and prayer. I spot Salima, waiting patiently in her SUV. Her car is high off the ground, and I need to hang onto the arm rest to hoist myself onto the passenger's seat. Salima greets me energetically. She's a take-charge person, so I sit back and let her drive. We head first to El Hyl Coffee in Hydra for refreshments, and I launch in French into a litany of questions: What did Marguerite mean in her chronology of Baya's life when she wrote about Baya's family living in the *tribu Sidi M'hammed*? I've seen the word "tribu" and the map of the tribes of Algeria produced by Napoleon, but was it possible that a tribe of Arabs and Berbers from Kabylia, Baya's people, would have made their way to an outer district of the city of Algiers? Over drinks of cold hibiscus tea, Salima explains the ethnic divisions of colonial Algeria and a society of kinship groups that existed long before the French invasion. The people of Kabylia were often on the move, pushed out of their homes by poverty and necessity. Baya's people migrated from their original home in Kabylia to the outskirts of Algiers, where they worked as temporary farm laborers.

Our conversation wanders back and forth, to different phases

of Baya's life, and Salima's. She talks about her friendship with her mother-in-law, how she accompanied Maman to a series of French cities, how they shared a hotel room and talked into the night. The two of them weren't big sleepers. Baya rarely talked about her beginnings as a painter, but one night in Toulon she told Salima she had started to make art by copying the dresses from the fashion magazines strewn about the farmhouse where she and her grandmother worked—the farmhouse in the place now called Bordj el Kiffan, where we're headed.

We climb back into the SUV and follow signs that take us past the airport. I notice that the palm trees lining the highway, the ones I first saw in 2012, planted for the fiftieth anniversary of the Liberation, have become huge. We're caught in rush-hour traffic. Time slows down. We pass Tribu Sidi M'Hamed, where Baya lived with her grandmother and uncle and brother in makeshift housing with earthen floors. The place is known today as the site of a branch of the University of Algiers. All I can see out the window are tall buildings. The cars are bumper-to-bumper; we're barely moving. There's plenty of time to talk about our respective travels, our work, about Salima's husband, Bachir, the third of Baya's six children, and about his career as a pilot with Air Algérie. He's inherited his mother's acute vision and, as I'll soon discover, her diamond gaze. I learn about their oldest daughter's brilliant studies in Canada. About Baya's home in Blida, recently torn down and replaced with a new house. It should have been turned into a museum, a celebration of Baya's legacy. As Salima and I talk, her memories blend into my own visit to Blida, and I picture Baya's home as Salima knew it, with its garden, its birds, the kitchen table where Baya worked with her favorite brushes on large pieces of paper.

We're driving toward Baya's beginnings, toward her life as a twelve-year-old day laborer in colonial Algeria. Bordj el Kiffan, formerly Fort-de-l'Eau, is no longer the sleepy resort town of the 1940s; it's a busy eastern suburb of Algiers, just past the airport. The inland farms are gone, replaced by high-rises. When we finally reach

Bordj el Kiffan, we drive through the commercial center alongside a modern tramway line. Salima gestures toward the land bordering the road: "All this was the Farges flower farm." Behind the tram line is an array of apartment buildings. We turn off the main road, and Salima rounds the corner. The SUV is valiant on and off the freeway. She drives into an empty space between two of the buildings, nothing to meet the eye but an insignificant patch of dirt and weeds, not even the size of a vacant lot. Look! Salima points at a curved piece of black metal. I can see what she's pointing to, but she has to explain. It's the girding for one of the greenhouses on the farm, where the rhizomes and the bulbs were cultivated. So discreet you could trip over it. Totally out of time and place, this rusty piece of steel, this protuberance waiting to be extracted. The farmhouse is gone and there's no one living who can tell me what happened to Baya here. Nothing is left but this accidental memorial.

So here I am, an American biographer in Algiers, grappling with an indecipherable archive and a bygone world. "Well at least you're not French," my Algerian friends joke. As far as I know, I'm not descended from the colonizers, the torturers, the land grabbers. I'm an American woman who goes to Algiers (a midwestern Jewish-American woman) to learn about an Algerian woman who went to Paris (a Kabyle-Arab Algerian woman). Am I credible as a biographer? Am I appropriating her story? That's an American question, the question so many people outside the United States balk at. Still, in my own national context, I have no birthright, no national, ethnic, linguistic or religious connection to Baya. Could I possibly know enough to honor her?

The disappearance of women like Baya from the artistic and literary record is a global historical phenomenon. There are certainly a thousand stories like this one, yet Baya's reached out to me from the first time I saw her art. In Algeria, where Baya is an icon, everyone "knows" her, the way you know a myth. In France, where she got her start, she's been largely forgotten. Drawn to the remarkable documents available to me through my lifelong romance with archi-

val digging, I set out to breathe some life into the actors in this binational drama.

My book begins with Baya's first trip to Paris. The European gaze brought the poignancy of her situation home to me: she was simultaneously celebrated and erased. I had hoped that the colonial archive that Marguerite's family deposited in Aix—letters, photographs, and press clippings—would give me everything I needed to untangle the situation, but it has turned out to be the most difficult archive I've ever worked with. In the beginning of her career as an artist, Baya didn't yet express herself in writing. She painted, and her faces and colors and designs revealed aspects of her emotional life and her aesthetics that were missing from the publicity surrounding her.

It's not lost on me that I'm telling her story in large part through the life of Marguerite Caminat, the white European woman who saw Baya's genius and recognized her talent, and who fit the young Algerian girl's talent to her own modernist standards. Caminat, charmed by the excitement of Algeria in the 1940s, was a liberal intellectual who couldn't see her blind spots and who outlined her distant love story with Baya in the loneliness of old age. Throughout the writing of this book, I'll be threading the tension between her generosity and her prejudices. I understand that as much as I point out the ways in which Marguerite Caminat's relationship to Baya was fraught, someone will point out my own flaws as a fallible American woman, the product of this flawed nation and of my own generation. If I make Baya legible to a new generation, and if my work encourages a new set of critiques—including critiques of my frame, of my intentions, of my writing—I'll consider myself a contributor to the wheel of understanding. For now, thanks to her story, I'll never see postwar France in the same light again.

Modernism is poison, a friend writes, poisonous in its voracious appropriation of native cultures. And another friend writes, Seriously? Would Baya have been better off staying on her flower farm? What kind of a world is this, in which those are the choices? Biogra-

phy is treacherous, for there's no life that is completely open to us, no identity that is untrammeled. There is no biographer who doesn't project their own story onto another life, who doesn't appropriate what they don't know. No archive can account for the impenetrable combination of accident and choice and circumstance woven into a single life. For too long, Baya's life has been in danger of flitting past us, a streak of color on an unfinished canvas.

2

The Maeght Gallery, November 21, 1947

A DOORMAN WELCOMES the visitors, who are eager to escape the November chill. The men unbutton their overcoats, the women caress their fur stoles before abandoning them to the *vestiaire*. High heels are clicking against marble floors, silk skirts are swishing, and perfume is wafting, the brands that enchant—Rochas, Chanel, Dior.

Aimé Maeght is forty-four years old, in the prime of life, and his art gallery is thriving. He's surrounded by Braques, Matisses, and of course Bonnards. Bonnard, the mentor who had encouraged him to open his gallery, just died in January, leaving an imbroglio over his estate that could threaten Maeght's own affairs. In March, Maeght traveled to Algiers, where he met Bonnard's beloved niece Madeleine, an important ally in the legal battles to come. The city had been the harbinger of Europe's liberation and a conduit, Maeght sensed, to much of what was interesting in art and literature. He needed to meet with Jean Peyrissac, a painter and sculptor who was making original work in wire and steel, small masterpieces of philosophical rigor. Peyrissac lived in a sumptuous Turkish villa overlooking the water, and there they began making plans for a show.

Peyrissac was a generous man. He was determined that Maeght see the work of a young Muslim artist, a child really, whom they called simply "Baya." André Gide had been to see Baya, and so had his

friend the Kabyle poet Jean Amrouche and the man of letters Max-Pol Fouchet. Everyone was talking about her gouaches and clay figures. Everyone knew the gossip, too. Baya had been living with a couple, the British artist Frank McEwen and his French wife, Marguerite. Now she was living alone with Marguerite in a rambling apartment on the rue d'Isly full of art supplies and gouaches tacked up on the walls. Marguerite doted on the girl.

Baya's paintings excited Maeght the moment he saw them, the colors unexpected yet pleasingly combined, the figures naive yet arranged with a perfect sense of scale. He wrote to Marguerite as soon as he returned to Paris to say how surprised he was that a new artist could touch him.

Now Aimé Maeght is overcome with pride in what he's accomplished. He's had Baya's paintings secured, crated, and flown in from Algiers, and the clay figures, too, though to his great dismay some of them have arrived shattered. He casts his eye around the room. A gallery owner knows how to watch people at an opening without their feeling watched, learns how to discern glances portending a sale. He's brought the perfect mix of political figures, writers, journalists, society people, and collectors to the gallery. In a corner, deep in conversation with Albert Camus is André Breton. Camus vibrates with thin intensity, gesturing with his perpetual cigarette.

Camus and Breton are friendly on the surface; they met in New York the previous year, when Breton was still in exile and Camus arrived to launch the American edition of *The Stranger*. Four years from now, in *The Rebel*, Camus will attack Breton for his infamous line from the Second Surrealist Manifesto: "The simplest Surrealist act consists of dashing down the street, pistol in hand, and firing blindly, as fast as you can pull the trigger, into the crowd."

Everything Camus experienced in the war—the Nazi terror, the loss of his comrades, the horrible truth of the camps that emerged with the Liberation—has made him distrust any glorification of violence. When it came time to punish the collaborators, Camus was tempted by the prospect of a death penalty. But that, too, was short-

lived. Today, if he needed a reminder, there across the crowded room is François Mauriac, the sharp-faced Catholic novelist and *Figaro* columnist. Mauriac thought Nazi collaborators deserved charity; Camus believed they ought to be judged. A year after their debate, in a speech at a Dominican convent, he took it back. "Monsieur François Mauriac was right," he said.

Breton has long been in the habit of promoting figures who correspond to his surrealist concept of spontaneous genius, starting with Nadja, the lost soul who wandered with him through the streets of Paris. Baya is the queen of beginnings, he writes in *Derrière le miroir*, the exhibition brochure decorated with Baya's red and purple figurines. She is "freshness of inspiration" yoked to "conceptual daring"; she harnesses all that Kabylia owes ancient Egypt. Other, more intimate factors might have drawn Breton to Baya: his twelve-year-old daughter Aube, far away at boarding school in Vermont, wrote to him about her collection of butterflies; he writes back about his plans to publish an almanac of "Art brut." "Art brut," he explains, means paintings by people who aren't artists: "a plumber, a gardener, a butcher, a madman."

But Breton doesn't mention Baya's paintings in his letters to Aube. He doesn't even mention them in his essay for Baya's show. He lends his name, creates a magnificent demonstration of a cultural phenomenon, with just the right touch of grandeur. Maeght has just curated the show on surrealism in July, and it's the least Breton can do to thank him. There's pressure from another direction, too. The pope of surrealism is back in town, only to discover that Paris has fallen for existentialism. He needs to keep his movement in the news.

As for his existentialist rival Camus, a closer look might have revealed the sorrow behind his dashing figure. Since the publication of *The Plague* last summer, Camus has been complaining to his friends that he has no more time for writing. Between his two-year-old twins, his work at the publishing house Gallimard and the demands of fame, everyone wants a piece of him. He's gotten letters from a contact in the Muslim community in Algiers saying please keep an eye on Baya and make sure she's safe in this Parisian caul-

dron. No matter how far Albert Camus travels from Algiers, the call of home catches up with him.

In one corner of the gallery, led by François Mauriac, a pack of journalists surrounds Baya, ethereal in her white gown. Mauriac is the first person to interview her: "Why did you put this little animal on top of this sculpture?" he asks, and she answers, "I don't know." He persists: "Is it an animal?" and she repeats, "I don't know." Other journalists follow suit; they want to know whether she dreams her paintings. They want to know how she finds the themes for her art. They want to know how long she's been working—a strange question to which she also answers, "I don't know." She'll be sixteen in a month, but they say "tu" to her, as if she were a child.

There's a proverb in Arabic: "Saying 'I don't know' is half of the knowledge." There are two opposing forces at work at the exhibition opening: on the one hand, the dogged insensitivity of the press corps which thinks they know all and project their own fantasies onto Baya; on the other hand, the young artist's obstinate resistance.

Then there is Christian "Bébé" Bérard, painter, set designer, and man-about-town, who falls to his knees in the crowded room, and if we are to believe the press, cries out, "Here I've wracked my brain to find the right color combinations and this little girl invents them without thinking about it!" Save for later the phrase "without thinking about it." He won't be the only one to use it.

MAEGHT IS NOT a political man, but he understands that this exhibition is not just about art. There is trouble in Algeria. The rector of the Great Mosque of Paris is in the room, and with him Yves Chataigneau, the governor general of Algeria. Last week, Maeght sent an invitation to Michelle Auriol, wife of the president of the Republic.

He crafted it carefully:

Next Friday, November 21 at 4 p.m., there will take place in this Gallery, in the presence of His Excellency Si Kaddour Ben Ghabrit, the opening of an exhibition of gouaches and sculptures by a fourteen-year-old girl from Kabylia, Baya. Her spontaneous art, whose rich

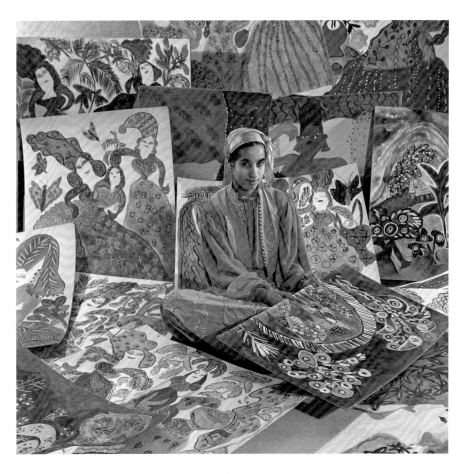

FIGURE 1: Willy Maywald's photograph of Baya sitting among her paintings at the Maeght Gallery (1947). Photograph: © 2024 Association Willy Maywald. Artists Rights Society, New York / ADAGP, Paris. Photography by Charles Maze Photographe.

and grave essence expresses the unity of an exceptional personality, and her authentic representation of the genius of her race, has astonished the greatest authorities of the art world.

Little Baya has come to Paris with the express permission of the Grand Mufti of Algiers. The Muslim community attaches enormous importance to this event, which it considers a form of cultural diplomacy. They write to us that "the sign of interest shown to the little

orphan Baya creates for all of us the right to a recognition of Muslim Algeria in its entirety."

Your visit would provide a precious encouragement to our Gallery and to all the painters it represents, among which we count the purest glories of French art: Henri MATISSE, Georges BRAQUE, and the late Pierre BONNARD.

The purest glories are right there: Braque and Matisse pose for photos with Baya. Next Michelle arrives, Madame President Auriol. So does her glamorous daughter-in-law Jacqueline, her hair swept off her high forehead, her smile electric. She's an extraordinary woman, only recently a member of the Resistance, training to become an aviator, yet she wears the New Look to perfection. She's holding hands with her boys, six-year-old Jean-Paul and nine-year-old Jean-Claude. Baya has given them a statuette and a landscape painting, presented by Maeght as symbolic gifts to all the children of France.

Surely Madame McEwen, lover of art and supporter of Baya, would have delighted in such moments, but she's refused to leave Algiers to accompany the young artist to Paris. Instead she's sending Maeght one anxious letter after another. A woman with no child of her own, deeply devoted to the girl and consumed with worry would, in theory, have insisted on staying by her side. When Peyrissac had pressed her, she said only that she wanted no credit for Baya's triumph. But Aimé Maeght thinks he knows why she won't come to Paris. It's a matter of pride that will go forever unnamed between them.

Marguerite has sent Maeght several lists of people to invite. She's turned out to be even more connected than Maeght could have guessed, through her brother-in-law, Henri Farges, with his Resistance circles in Algiers, through her own networks in Toulon, where she used to be a student and a librarian, and then in Algiers, where all the artists and writers and politicians seem to know one another. A few of the people on her list are milling about the gallery.

The prosecutor who asked for a death sentence for Robert Brasillach, a literary translator (Marguerite's high school English teacher), the director of civil aeronautics, the general secretary of a charitable organization, a former constitutional judge, a high-up in the Ministry of Telecommunications, a chief engineer of the navy, a former president of the provisional government and his wife, another Toulon connection.

Ministers, writers, socialites, artists: all are glued to the paintings. On this gray November afternoon, one in a month of gray afternoons under what Breton has dubbed "the anxious sky of a November 1947 in Paris," Baya's saturated colors and bold shapes invite them to rediscover the world. They don't walk by, they draw near, stand still, soaking in the vision. Baya conquers their impatience, and for a moment they forget where they are. In every painting there are women and children, children and birds, birds and flowers, blending, yet holding their own.

There are skirts anchoring nearly every painting.

Baya's skirts! Fabric spreading from one edge of the painting to the other in green, blue, yellow, while the other figures in the composition, snakes, birds, butterflies, and flowers, nestle around them. Each skirt is a vessel into which the artist has poured her blossoms and branches, her checks and circles. Skirts are in the news: long skirts with stiletto heels, skirts in satin, in taffeta, in velvet. Dior has just launched his New Look, marking the return of unabashed luxury to the Parisian elites. Aimé's wife, Marguerite (everyone calls her Guiguite), attends the fashion shows—Givenchy and Balenciaga and Fath. Claude Staron, the fabric king who supplies the couture houses, will purchase thirteen of Baya's paintings that week. He'll give Baya a gift of fabric to make an outfit. As for the young artist, she is wearing a white satin *djellaba* with a veil. She stands arrow-straight, as if she's surrounded by a force field.

Among the paintings that Aimé Maeght will keep for his own collection, there is a woman grimacing, her midnight-blue skirt filled with light blue circles surrounded in yellow.

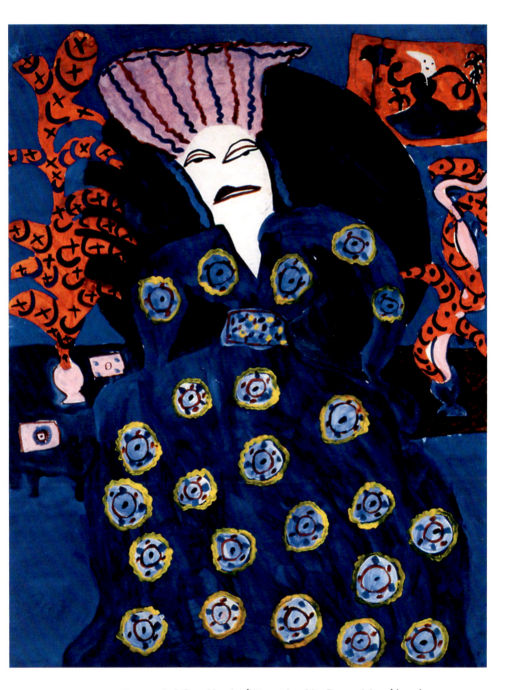

FIGURE 2: *Femme robe à fleurs blanches* [Woman in white flowered dress] (1947). By permission of the Children of Baya Mahieddine. Photograph: © 2024 Maeght.

On the upper right is a painting within the painting: a tiny female figure in a dark blue dress, her arms undulating like ribbons, her face chalk white with a yellow cone head. A dancing ghost. Below her is a red snake wrapped around what looks like a tongue emerging from a vase; on the right, emerging from another vase, is a red plant decorated with checks and crescents. There seems to be a deck of cards on a table. Two women—the small ghost framed in red and the larger-than-life figure sitting on a black throne—animate the picture. The field is flat, as in Matisse's portraits, only the figure anchoring the composition is tilted, clownlike. The designs on the dress are so deliberate that they stand out, taking on a life of their own. You can play with the switch of perspective, fixing the bluish white circles, then the blue dress, foreground and background, until you're dizzy.

OH TO BE the ghost in Baya's painting that night, one eye turned to the crowd!

3

Marguerite Caminat

MARGUERITE HAS SPENT MONTHS in Algiers making the arrangements, only to skip the event. She's grateful that Jean Peyrissac has agreed to attend to so many of the practical details. As for Paris, she wants no part of it.

Among the paintings she's shipped to the gallery is one that depicts a woman standing between two yellow curtains. Her face is unpainted, punctuated by red lips and two faded eyes, and topped with blue hair. Above the woman's head, Baya has placed an empty pot surrounded by flowers on a red rug. She'll often create paintings inside her painting, in this case a smaller image above the main figure, giving a second field of meaning to an apparently flat universe.

The blue-haired woman holds apart the curtains. She's smiling, looking out a window. Welcoming Baya.

Baya was ten when she met Marguerite. She had survived a mournful, unstable childhood. She'd grown up with her parents and her little brother Ali in the Sidi M'Hamed tribe, the native district on the outskirts of the small colonial town called Retour de la Chasse—literally "Return from the Hunt"—a place where weary, satisfied hunters stopped for refreshments after a day shooting game in the surrounding marshlands and fields. She was six when her father died in an accident.

Her mother soon remarried and moved with Baya some thirty miles east to Dellys, perched on the northernmost coast of moun-

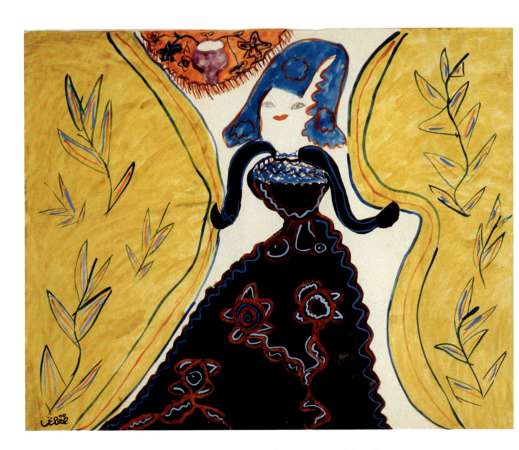

FIGURE 3: *Rideaux jaunes* [Yellow curtains] (1947). By permission of the Children of Baya Mahieddine. Photograph: © Philippe Maillard / Musée de l'Insitut du monde arabe, Paris.

tainous Kabylia. There was a new stepfather to get used to, a new household, and many stepsiblings. Two years later, her mother died from complications following childbirth. As she lay dying, Baya stayed close by her side. She was nine.

As soon as her grandmother got the news, she traveled to Dellys to fetch Baya. She didn't recognize her and asked her in Arabic whether she knew a little girl named Baya. Baya, at that age where languages come easily, was speaking Berber after her time in Kabylia, and the two didn't understand each other. The grandmother made room for her back in Sidi M'Hamed, where she and Baya's uncle, his

wife, their children, and Baya's brother Ali were crowded into the one-room earthen house. Back to Algerian Arabic and to the requisite French with the European farmers.

Six miles to the north of Sidi M'Hamed, the wealthy colonial town of Fort-de-l'Eau peered out over the Mediterranean. Fort-de-l'Eau boasted a casino and a glamorous beach with changing cabins and *chaises longues* along its waterfront. Inland were the farms. Baya's family came here from Sidi M'Hamed to offer themselves up to one farmer or another as day laborers, from planting season through harvest. They ended up working on Henri Farges's flower farm.

Henri Farges had arrived in Algiers in the 1920s with his bride Simone, eager to start a new life far from the killing fields of Europe where he'd earned his Croix de Guerre. He rented a two-story stone farmhouse with six acres of land and found his niche in the local economy. In addition to a variety of showy flower bulbs and roses, the Fargeses specialized in strelitzia rhizomes imported from the French West Indies. They're easy to divide and plant; they grow into thick bushes as high as fifty feet. In family photos, the Farges daughters pose in overalls behind their wheelbarrows, the tall flower stalks proof of their labor.

Up close, strelitzia have long gray-green stems that produce sharp pink and orange sepals the color of mango fruit with thin blue matchstick petals inside. They're known as "bird of paradise flowers." Tall with pointy heads, they've earned another bird name, too: crane flowers. As if they might suddenly take flight, fueled by their saturated colors, engineered by their aviary forms. The art historian Anissa Bouayed sees in these nicknames for strelitzia an example of the same metamorphosis, flower to bird, that Baya achieved in her art.

On the rue Michelet near the entrance to the University of Algiers, Simone Farges works in their shop, "Isly Fleurs," alongside her daughter Mireille. Simone, blond wavy hair à la Simone Signoret and her youngest daughter, Mireille, the black-haired beauty with a winning smile, ambassadors of the bouquet.

When I meet Mireille's daughter Sibylle at the Sofitel in Marseille

in May 2022, she's smiling because the lobby of the hotel is decorated with strelitzia, which have always evoked her grandparents' world, and Baya's. We sit high up on a patio overlooking the harbor as she tells me her story. She shares photos of life on the farm: Mireille and her sisters Yvonne and Renée, who died too young; the famous family friends, like Félix Gouin, head of the provisional French government and his wife, Laure. I ask Sibylle questions about what I'd gleaned from the local newspapers of the 1940s and 1950s: *L'Écho d'Alger* and the progressive *Alger Républicain*. I've found her grandfather Henri's name scattered in the columns of both newspapers. President of the rowing club of Algiers—his daughter Mireille, too, will become an expert rower—member of the city council, and secretary of La France Combattante, representative of the French Resistance in Allied Algeria. He has enough energy for multiple lives as farmer, politician, athlete, family man. From the beginning, Henri defines himself politically on the left. He's joined a coalition of communists and socialists: Sportisse, Aboulker, Ouzagane. They'll have plenty to fight for, the men and women who aspire to the union of all the people of Algeria, regardless of race or religion. As a farmer who relies on local labor, Henri knows better than many of his politically enlightened comrades that the war has made conditions in Algeria much more miserable for the indigenous population than for the Europeans.

Baya's description of life before her arrival at the Farges farm evokes those conditions with a musical refrain: "cold, hunger, lice, cold, hunger, lice . . ." Marguerite takes down her words on pages of cramped handwriting I take pains to transcribe.

For Baya and her grandmother, work at the farm brought relative stability. Her grandmother cooked for Henri and Simone Farges and their daughters. Baya ate warm soup and hid the soup bones in her pockets for her little brother. She worked inside and out, tending to the flower fields, cleaning up the house, serving the meals.

BUT WHOSE MEMORIES am I transcribing? I imagine Marguerite, thirty years later, retired to the family village of Cuers in southeast-

ern France, gathering her notes and letters, adding recollections of her own. She can recall the moment of her first encounter with Baya in all its texture, the way you remember a dream. She notes carefully that they met in Fort-de-l'Eau, on her sister's farm. Through a window in the farmhouse, Marguerite saw a young girl staking the carnations with thread. But what she writes is that Baya walked by the window, looked into the farmhouse and saw her, Marguerite, framed by billowing drapes, as she arranged flowers in a vase with Laure Gouin. Curtains, says André Breton in those same years, are emblems of a new world after the war, of the passage from past to present. No one as yet has noticed Baya's presence, Marguerite writes; no one knows that Baya is getting closer. Getting closer to her, presumably. Marguerite remembers her as a magical apparition. The switch in point of view is jolting: Marguerite remembers that Baya saw her, but wasn't it she who saw Baya? Or was she remembering the painting rather than the scene?

Who saw the other first? Baya's painting of the yellow curtains shows Marguerite looking out at the viewer. Baya painted Marguerite looking through the window and seeing something or someone outside. The question of who can capture Baya's gaze, and her talent, will be at the heart of many controversies to come.

Marguerite describes another day at the farmhouse, when, passing through the back of the kitchen, she heard a clinking of china. She noticed Baya, her hands in the dishwater, cleaning a little blue-and-gold demitasse. She looked a little closer. Baya was so young—to Marguerite, she looked barely seven. Baya's eyes were lowered, never gazing back.

"Absolutely self-contained, mute, opaque," Marguerite writes. She notes that the girl has Nefertiti's chin. She describes Baya with the cultural allusions familiar to her: Baya the enigma, the Egyptian sphinx. Later, the essayist Sara Mychkine will write that Baya has been confined to "the shadows of the imaginary museum of colonialism." A vast museum of the European mind.

A surviving photo of the Farges farm shows a July 14 gathering from 1943 or 1944. Baya and her brother Ali have been invited to join

the picture. He's crouching in the front row and she's kneeling next to him, her knees cut off by the camera. By one reading, the presence of Baya and her brother in that photo is a sign of the Fargeses' nonconformism, their friendliness toward two children whose work has made this party, and many other parties, possible. Maybe Baya has already moved to Marguerite's and is coming back for Bastille Day, one of many weekends she spends with Marguerite on the farm. By now, she's used to smiling for a camera. Marguerite stands behind her, dressed like a Bloomsbury artist with a tie dangling from her neck, a white blouse. Her eyes bulge, giving the impression that she sees more than other people, at the same time making her elegantly homely. Henri Farges stands behind her, and on the left an imposing Félix Gouin and his wife, Laure. Mireille and her sisters, Yvonne and Renée Farges, stand together on the right. Mireille is last in line, her hair braided with flowers pinned above her forehead. No flowers for Baya. She was wearing the cotton rag, the *maharma*, intended to protect employers from finding their servants' hair in their soup, or, given the conditions in which they're made to work, from catching lice. Marguerite Caminat McEwen, adjusting to life on her sister's farm, holds one hand to her forehead to block the sun.

MARGUERITE NEVER DREAMED she would leave Toulon, where she had become a librarian and an amateur painter. Enter Frank McEwen. The mysterious artist living along the Chemin de l'Hubac was offering a painting workshop. I can only guess that she fell in love with the tall, bearded man who was clad in the aura of the Parisian art world and seemed to carry the history of modern art in his genes. Marguerite's sense of organization, her spirit, her practicality, were attractive to everyone who knew her. She was a problem solver. Was it then or only later that she learned how desperate Frank's situation was, how unhappy his struggle to make a living and maintain the veneer of a society artist? He wanted nothing more than to be rescued. She and Frank married in Toulon on September 6, 1939, three days after France had declared war on Germany. By then she

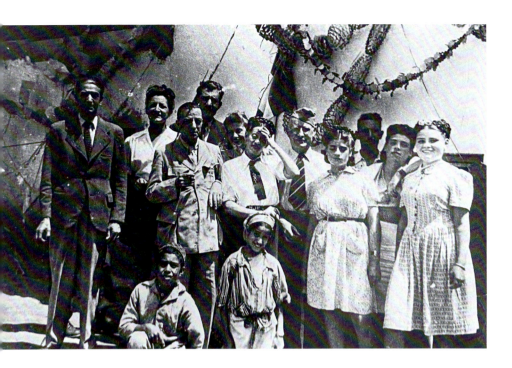

FIGURE 4: A summer gathering at the Farges farm (ca. 1943–44). Photograph: © Collection Sibylle de Maisonseul.

must have known that he was the nephew of Lucien Pissarro and that the legal name on his British passport was Francis Jack Levy Bensusan—a Jewish name. When he was four his parents divorced and his mother married Stewart McEwen, whose name he made his own. It was certainly easier in those days, in England and in France, to be a McEwen than a Bensusan. They lived for a year in that state of advanced psychosis known as the phony war, the *drôle de guerre*, waiting for the coming disaster.

Then came the horrible day in June 1940 when the Nazis invaded and France fell. Marguerite and Frank wanted to leave France before it became Hitler's France. That very June, four months before the first anti-Jewish statute of October 1940, they sailed across the Mediterranean to French Algeria. Some accounts say Frank made the trip in a fishing boat. Marguerite may have been waiting for him.

Marguerite Caminat | 23

In Algiers, the nightmare continued. Vichy's anti-Jewish legislation had a special consequence for Algerian Jews, who were stripped of the French citizenship they'd acquired in 1870. Frank had only two Jewish grandparents, and besides, as a British citizen, he wasn't subject to French racial legislation. Yet there was a constant reminder, a pressure.

Fortunately, Marguerite's sister Simone and her husband, Henri, offered them a refuge. Frank and Marguerite told them that Algiers was only a stopping point en route to a safer life in the Americas. Instead they stayed. They lived in the rambling farmhouse in Fort-de-l'Eau before renting their own flat. The comfort of being near her sister and nieces sustained Marguerite. Frank had square meals and the affection of an entire family. Once in Algeria, Marguerite never considered herself a colonist. She was a bohemian, exempt from the rules. Then Baya came into her life.

Baya will be her maid, her child, the painter she never became, and the subject of an archival passion. Much of what I've learned about Baya's young life comes from Marguerite's scattered notes and parental memoir. And so I write, "Marguerite recalls" or "Years later, settled in France, Marguerite writes." Marguerite sees Baya through the blur of memory. She doesn't see herself.

Marguerite doesn't dwell on the story of how Baya passed into her care. She says only that she asked Baya's grandmother *if she could have her*, and *Baya was given to her* with nothing more than a few grimaces. "She was given to me"—Marguerite uses the vocabulary of possession: I ask, I get. Marguerite notes that Baya, barely eleven years old, appears to have no regrets as she heads to the city with strangers. But how would Marguerite know, how would she have measured the lack of regret? She's caught in a contradiction. She notes what Baya was supposedly thinking, feeling, all the while insisting that she can't know, that part of Baya's strength consists in the way she keeps her thoughts and feelings to herself. "They tell me I'm crazy," she adds. Crazy, I imagine, not because she's taken the girl into town to work as her servant—nothing could have been more

FIGURE 5: Marcel Wertheimer's photograph of Baya on the Farges farm (n.d.). By permission of the Children of Baya Mahieddine. Photograph: © Collection Agnès Wertheimer. Photography by Alberto Ricci.

normal in her world—crazy that she seems to care so much, crazy that she has dreams for Baya, artistic dreams. Extreme behavior of a childless mother? Delusional romanticism? Her family wondered what she'd gotten herself into.

Marguerite arranged to take Baya to the city as a maid, not a daughter. Those were the codes they all lived by, as she saw it, the only codes the grandmother could understand. Marguerite paid the grandmother every month, in lieu of Baya's wages. A straightforward arrangement. But Marguerite knew what mattered: she had a glimmer of what life had been like for Baya in the tribu. And she'd seen the girl's drawings, she was aware of her talent. Frank, who considered himself an expert in artistic expression, expounded upon his theory, dear to surrealists and to the British philosophers of art he considered his mentors, that all children enjoy a phase of artistic genius. He believed that Baya was living, temporarily, in that phase.

Baya traveled from the Farges farm in Fort-de-l'Eau to Marguerite and Frank's apartment in the official vehicle of the provisional government of the French Republic. She sat in Félix Gouin's lap. Marguerite delights in the scene, which in her mind, is not in the least untoward, but, *au contraire,* means that Baya is sitting in the lap of history, for Félix is the president of the Committee of Free France, charged with reconstructing the republic. If you believe Marguerite's account, France is on the verge of liberation, and now, apparently, so is Baya.

Their destination is the rue Elisée Reclus, a dead-end street off Algiers's steepest thoroughfare, the rue Michelet. As Marguerite tells it, the threesome no sooner enter the elevator than Baya settles into a corner, mistaking the tiny space for her new home. She doesn't know that she's about to go up five floors. In the apartment, the sound of the toilet flushing disturbs her. She's accustomed to outhouses. In her employment as a maid in the city, she cooks, sets tables, mops floors. She dumps her buckets of dirty water over the balcony until Marguerite corrects her. She's never known such elevation.

The stories Marguerite tells about Baya in the city belong in a European tradition. There's a portrait of Marguerite on the living room wall, painted by Frank McEwen, probably one of the commissions he mentions in his correspondence with his aunt and uncle, a paltry source of income that kept him from starving in Toulon. The portrait becomes the centerpiece of a fairy tale Marguerite tells about Baya's first days in Algiers. The story goes like this: Whenever Marguerite leaves the apartment, Baya asks her why she's staying inside her portrait. The girl seems afraid. After a few days, Baya speaks to the portrait. She asks if she should peel the vegetables. She insists, repeats her question. But as soon as she touches the dress painted in oil, she stops wondering. She looks behind the canvas and sees that nothing is there.

In the center of a town I once visited, a large picture window in a vintage furniture store was staged to look like a living room. A plastic mannequin, clad in a glamorous scarf and gown, was sitting on a 1950s Danish fauteuil next to a low coffee table. As I entered the space, I noticed a girl about ten, standing next to the mannequin, engaging in a serious conversation with it—or her. When the girl saw me looking, she seemed embarrassed. I'd caught her playing in her own doll house. She knew the mannequin wasn't real, but that didn't prevent her from talking to her.

Biographers can seldom resist constitutive moments in their subjects' lives, and Marguerite is no exception. She embraces the idea that her brilliant child believes Frank's portrait is real—a trope of Western art, from Zeuxis to Mary Poppins—and tries to reason with it. Only Marguerite doesn't interpret the scene she describes. Does she think Baya believes the portrait is alive because she's a child, because she's an uneducated farmhand ("a simple heart"), or because she's an artist? Someone else—Frank, for instance—might have countered that only an idiot with no ability to tell the difference between images and reality would think the portrait was real.

There are many possible versions of this story. Little Baya, a playful creative soul, liked to talk to Marguerite's portrait, entertaining

Marguerite and entertaining herself. She might have looked up at the painting and said, "So, am I going to peel the vegetables today?" She's touched the dress, felt the texture of the paint. She is just beginning to use her thick watercolors; she wants to see how oil dries. Is she afraid of the portrait, as Marguerite says, or only a little embarrassed when Marguerite hears her talking? Marguerite has no idea what Baya believes, feels, or thinks, but she loves a mystery. Maybe Baya believes in ghosts and in magic. That would explain a lot. Frank, like the Farges, probably thinks it's his wife who's prone to fantasy. He's growing tired of her ways.

Marguerite's memory of Baya's first days in the apartment make one thing clear: Baya does not live at Marguerite and Frank's as an artist-in-residence. She has come to work as their cook and maid, mopping the floor, peeling the vegetables. She paints when her work is done. From the time she left the farm until she leaves for Paris, Baya will become an artist but remains a servant.

In 1944, Baya's life changes again. Frank leaves Marguerite. Marguerite moves Baya into a new apartment, perfect for an artist: a top floor set back from the rest of the building with large windows open to the sea air and overhanging wooden rafters to deflect the heat. A bohemian penthouse. With its imposing carved door, 5 rue d'Isly stands proudly between the opera house on the Square Bresson and the neo-Moorish emporium "Galeries de France" closer to the Grande Poste. It's a quick walk from number 5 to the Casbah, where Marguerite finds work as the archivist for social programs at the Office of French Charities. Her notes describe the time at the rue d'Isly: "Very beautiful period for creation, painting and sculpture," she writes, and adds that Baya has lunch ready for her when she comes home from work. Even in her dry chronology, Marguerite delights in describing a comforting world for herself and her ward, a doll house full of paintings and tables, rugs and books. The perfect setting for Aimé Maeght's discovery of Baya's art.

Outside the doll house, the rue d'Isly has its own décor and its own state of mind, about to be put sorely to the test. On May 1, 1945,

several thousand demonstrators from Messali Hadj's Parti Populaire Algérien claim a space in the annual worker's parade. Twenty-two-year-old Mohamed "El Haffaf" (the barber) El Gazali heads the procession, carrying a red, white, and green banner, ancestor of the Algerian national flag. Words never before heard on that street fill the air: "Independence for Algeria! Down with colonialism! Long live free Algeria!" Angry neighbors close their shutters tight, but as the demonstrators pass the Galeries de France and approach Marguerite's building, a few of the residents step out onto their balconies with rifles and take aim at the marchers below. *L'Écho d'Alger* will report "groups foreign to the worker's unions"; the headline in *La Dépêche* reads: "Troubled elements provoke disorder." They mean the demonstrators, not the men who fired on the crowd.

Nothing in Marguerite's notes from 1945 tells us whether either she or Baya were home. They may already have gathered at the Grande Poste, where Henri Farges was scheduled to speak on behalf of La France Combattante. He speaks in the name of the Resistance, honoring the people of France who must, as his comrade General Paul Tubert puts it, "express their concern and their will." Today, two marble plaques on either side of the rue d'Isly mark the places where three young patriots were killed in the May 1, 1945, demonstrations. It was the dress rehearsal for an even more dire, and longer, series of events that began a week later at another rally, in Sétif.

I DISCOVERED THOSE PLAQUES by accident on a hot summer night as I was walking down the rue d'Isly with a friend. The sight of them touched me all the more because I'd found almost nothing in the daily newspapers from May 1945 about what happened. We spoke with a young man standing on the threshold of number 5. He explained the situation in the building. Many of the apartments have been empty for years and so the *djinns*—the spirits—have moved in. Now no one wants to live there because the *djinns* are set in their ways. He can hear them at night.

4

Baya Begins to Make Art

BACK ON THE FARM, in a bedroom fragrant with cut roses and lilies and the tender blossoms of white carnations, Mireille Farges loves to dress up. She poses for the camera against thick curtains, wearing an off-the-shoulder white gown, its flouncy skirt in layers and layers of white tulle. Around her waist she's tied a lace scarf, matching her velvet opera gloves and the velvet ribbon around her neck. A bouquet of hydrangea hangs from a wide silver bracelet on her wrist; her hair is swept up in a tight chignon; a single rose crowns her forehead. To complete the picture, she holds a tiny lace parasol. Scarlett O'Hara in Fort-de-l'Eau.

Millions of adolescent girls around the world were inspired by Scarlett, who made her ball gown out of an old pair of velvet curtains, the only decent fabric to be found in the splendid Tara Plantation, sacked by General Sherman and his Union troops. *Gone with the Wind*, now considered an object lesson in racist fantasy, was the cult underground novel of occupied France, banned by the Nazis who considered it an American incitement to resistance. The girls of Fort-de-l'Eau could identify with occupation, with privation, with systems for making do, such as how to make a gown when there's no fabric available. The deeper connection, to an economy that depended upon slave labor, was buried deep beneath the surface of consciousness.

Mireille's father gave her a green Singer sewing machine for her

FIGURE 6: Mireille Farges as the "Belle of the Ball" (studio photograph, n.d.). Photograph: © Collection Sibylle de Maisonseul.

FIGURE 7: Cover of *Modes et travaux* magazine (May 1941). Baya began painting by tracing, then decorating, the voluminous skirts she saw in Mireille Farges's 1940s sewing magazines.

birthday. Mireille learned to sew, to cut out a pattern, to pin it together, to make the fabric embrace her forms. She filled the house with fashion magazines—*Modes et travaux*, *Le petit écho de la mode*, *Marie-Claire*—illustrated with drawings of women in the latest fashions and the patterns to make those fashions real. You could see her, when she wasn't working in the florist shop, bent over her tracing paper with white chalk, pushing the wheel of her machine as she made the stitches start and stop, such an agreeable sound. She quickly became an expert seamstress, producing flowery tunics in white silk, gandouras made from African wax cottons, delicately tailored shirts. She's unstoppable—the girl who can do anything.

Five years separated quiet, delicate, self-contained Baya and plump Mireille with her deep red lipstick and thick black eyebrows, her coquettish charm. Imagine a novel about these two girls, the cook's granddaughter and the young mistress of the household caught between her feelings of charitable affection and jealousy when the poor little native girl captures the heart of her beloved Aunt Marguerite. A questionable novel full of colonial cliché. And the native girl? When her grandmother doesn't need her to help dust the furniture or sweep the floor, she turns the pages of Mireille's magazines, losing herself in dreams of gowns.

She begins to copy the dresses, filling the outlines of the skirts with flowers, birds, and leaves, so that the outdoors comes inside; the skirts shelter nature and geometry. Years later, in the quiet of a hotel room in Toulon, she'll tell her daughter-in-law Salima that those magazines were the beginning of her life as a painter.

In every family I've ever known, children draw. Parents marvel over their artworks, tacking them to the refrigerator with magnets, framing them. A five-year-old I know in Algiers loves to run around the room waving a piece of paper like a flag and shouting to her public (whoever is in the room), "I'm done! I finished my drawing!" We receive our children's drawings with love, we don't grade them or judge them, they're all great—unless there's something in them that is truly remarkable, that opens our eyes to an enhanced reality. Was

it Marguerite who saw, Marguerite who herself dabbled in painting, or was it Frank, who'd been trained to evaluate children's art? One legend has it that Marguerite and Frank first observed Baya's talent on a beach in Fort-de-l'Eau, watching her draw in the sand. What made them see that hers was no ordinary drawing, made them say, "Oh my, there's something here that is more than a charming child's scribbles? Father, look, sister look, mother look! We are impressed, we are enchanted, she needs to do this again, and again, and again, we need to help her do it."

About Baya's sculptures, Marguerite says only that Baya began to make them in secret, putting the first ones in a fireplace to harden overnight. Once her secret was out, Marguerite took the next clay creatures to the local baker to be fired in his hottest oven.

5

Behind the Curtains of the European Museum

REMEMBER, THOUGH, that this story of drawing in the sand, of copying magazines, of molding clay, doesn't mark the beginning of Baya's consciousness of art. Before the Farges farm, before the solicitous Europeans, when she was a six-year-old girl living with her mother's second husband in Dellys, Kabylia, Baya encountered the world through her senses. Shapes and colors enchanted her, freed her from the doldrums. The sublime ordinary: a butterfly settling on a leaf, the gnarled root of a tree, a bird's layered feathers, her mother's skirts. Baya looked and absorbed long before she picked up her first paintbrush at the Farges farm. As a young orphan in Dellys, she took in the local shapes and hues and crafts and stories she would bring to her art.

THE DRESSES OF KABYLIA are unique in Algeria: stripes in brown and green and yellow, in red and black. The women's dresses in her earliest paintings from the mid-1940s play with those colors; their skirts are filled with the same checks and circles you see painted on the traditional jugs, jars, and pitchers of Kabylia, or carved into wooden chests, those masterpieces of the region's craft. In traditional Kabyle villages, she'd seen women making clay pottery and painting the walls of their homes.

In one of her early gouaches on paper, *Woman with Three Rugs*,

FIGURE 8: *Femme aux trois tapis* [Woman with three rugs, a.k.a. Woman with three cushions] (n.d.). By permission of the Children of Baya Mahieddine. Private collection. Photograph: © 2024 Maeght.

Baya portrays a young woman with ink-black hair and red lipstick and shiny white teeth. Unlike Baya, day laborer, then maid, this young woman is at leisure, posing on her side like Ingres's odalisque, like Manet's Olympia. Let's call her Mireille. Baya uses a Kabyle palette for her dress, green with yellow-and-burgundy stripes, with contrasting patterns of squares and checks on the curved arms in a pleasing up-down symmetry.

The background of the painting is filled with rugs and pillows: three pillows line up along the edge of mottled blue rug; another, brown with white foliage, lies under the woman's long head. The woman smiles broadly at the viewer; she's coquettish, glamorous. It

FIGURE 9: Mohammed Racim (attrib.), *Al-Bouraq*, a representation of the Prophet Mohammed's celestial steed (ca. 1915). Mohammed and Omar Racim's postcards were published by the Bonesteve Company in Algiers. Photograph: © 2024 Studio Ayadat.

looks to me as though Baya has given Mireille the orientalist pose of countless European paintings, then surrounded her with ordinary objects from a Berber home.

But there's more, still more, beyond the Berber shapes and colors I think I'm seeing. In the flowers and fauna and peacocks, the musical instruments, and the female figures in her paintings, I imagine the vestiges of Islamic miniatures and affinities with a pan-Arabic tradition of ceramic tableaux. Anissa Bouayed's work on the interaction of European and indigenous artists in twentieth-century Algeria leads me to Mohammed Racim, who with his brother Omar ran a school for Algerian miniature art not far from the Winter Palace in the Casbah where Marguerite Caminat went to work every day. Racim's postcard of the Prophet Mohammed's celestial steed, "Al-Bouraq," uncannily modern, uses all the traditional elements: a woman's face, a horse's body, and an angel's wings. He's placed the

Behind the Curtains of the European Museum | 37

FIGURE 10: (Anon.), *Joute poétique* [Poetic jousting] (mid-seventeenth century). Ceramic art from Isfahan, Iran. Department of Islamic Arts, Musée du Louvre. Photograph: Wikimedia Commons.

fantastic creature in a landscape strewn with flowers and a background filled with calligraphy and artful swirls—elements that remind me of Baya's own pictorial language.

If there were any doubt that Baya was exposed to Racim's work, the December 1944 exhibition of Muslim painters and miniaturists at the Cercle Franco-Musulman puts it to rest. It featured Racim and his students. Marguerite would never have missed a chance to take Baya.

Much like Baya's influences, Racim's were multidirectional. He studied with the French orientalist painter Nasreddine Dinet, a convert to Islam, who urged him to incorporate the essence of ancient Persian and Turkish art into his work. A seventeenth-century Iranian ceramic mural belongs to the Islamic collection at the Louvre, where

Racim spent many hours during his Paris stay in the 1920s. Once I saw this mural, I couldn't look at Baya's women in gardens the same way. In the harmony of colors and the decorative intensity, in the arrangement of the female figures, their perfect symmetry, their pose, a template for her landscapes comes into focus.

The more I learn about art on both sides of the Mediterranean, the more I understand what Nadira Laggoune-Aklouche, writing about Racim, describes as "transfers and appropriations and re-appropriations and grafts," and what curator Natasha Boas, talking about Baya, calls "a mashup of Kabyle, Arab, Islamic and French cultural heritage." The Berber stripes and checks, the traditional Islamic layouts, the Parisian blocks of color celebrated at the Maeght Gallery exist together in her gouaches. She's wandered through the Palais Oriental in the Casbah with its colorful tiles portraying animals and humans. She's accompanied Marguerite to her office at the Palais d'Hiver in the lower Casbah, the same nineteenth-century Turkish palace where Yves Chataigneau, governor general of Algeria, has his offices and where Marguerite and the Cadi Benhoura work in separate social services for the European and Muslim communities. A showplace of orientalism, the Palace's sumptuous reception hall was decorated in lacelike carvings, Arabic arches, and intricate ceramics. Delighted by an artistic culture she's experiencing for the first time, curious and inventive, Marguerite, too, starts to paint Islamic-style miniatures of women and flowers and birds in their apartment on the rue d'Isly; in interviews, Baya will recall her early memories of Marguerite painting on silk lampshades.

But when Baya moves into the world of Parisian galleries, she joins an international art market where she's only legible as a descendant of Matisse and Picasso. She'll remain the little Muslim girl, the little Kabyle, but her bold shapes and fantastic bestiaries will lose their vital connection to an Islamic tradition considered minor or decorative or too colorful to count as serious art.

6

Frank McEwen

HOW MANY LUNCHES had Baya served Frank and Marguerite before he left for good in 1944? How many secrets did he take with him?

Frank McEwen was always a man with secrets. He was descended from the twelfth-century Moroccan Bensusans. His grandfather was a feather merchant who moved to England from Gibraltar. His father Moses, a businessman, collected art in Mexico, where Frank was born. Back in England, his famous uncle Samuel Bensusan wrote volumes about his travels, about artists the world over, and edited *The Jewish World*. His aunt Esther, a painter, married another painter, Lucien Pissarro, who had an even more famous impressionist father, Camille Pissarro. It was a heavy mantle for an aspiring artist.

Lucien and Esther Bensusan Pissarro were Frank's mentors and protectors long after he left the name Bensusan behind. In the tradition of his uncle Lucien, he had studied art at the Sorbonne. When his career as a painter didn't catch fire, he started a painting restoration business to make ends meet. By the 1930s, McEwen was in dire straits, barely eking out a living through the occasional sale of a portrait or a commission to restore a painting. His marriage to the Italian artist Maria-Teresa Longo, a person he would come to describe in panicked letters as demanding and dishonest, was on the skids. In Paris, he began a new romance with the American painter Frances Wood, with whom he had a child in 1934. He moved back

and forth between the capital and a Pissarro family property in the hills above Toulon, a savage and beautiful spot on the Chemin de l'Hubac, looking out at Mont Faron. Later, Frances and the baby joined him.

He was hopelessly dependent on the Pissarro-Bensusans. Every week he sent emergency requests for money to Esther and Lucien in England. His wealthy uncle Samuel Bensusan sent the occasional check after Frank's stepfather, Stewart McEwen, washed his hands of his irresponsible stepson. He made extra money trimming the olive trees on the Chemin de l'Hubac property, and he attempted with some success to impress upon the high society of Toulon his talents as portraitist, restorer, and man-about-town.

Through a stroke of luck, he discovered a painting by John Singleton Copley in the Toulon flea market. He restored it, then partnered with a local antique dealer for the sale: the two men signed a contract to split the profits, which they expected to be considerable. While the painting was exhibited in London, waiting for an offer, they began to fight. The antique dealer spread the word in Toulon that it was he, and he alone, who discovered the painting. Frank McEwen's affairs were rarely simple.

His letters paint the picture of a man on the edge of physical and mental breakdown. Even as he plans an exhibition to which he will invite the seventy-five most important people he knows in Toulon, even as he hobnobs with local royalty, he suffers from a hundred ailments: a hernia, jaundice, depression, weight loss, skin disease, hunger. Grandiose expressions of his need for solitary independence alternate with constant demands for money. Only the arrival of Frances and their child in his life brought him some happiness, but in 1937 she left for the United States, where a sister could help support her and her baby. In a letter to Aunt Esther, he bemoans the fact that without a divorce, he cannot legally recognize little Francis or give him his name. He dreams of making a name for himself in New York, joining Frances and Francis, and in the meantime, profiting from the boom in elite tourism in nearby Nice. "I make every-

body think I am very prosperous," he writes to Lucien and Esther, "but things are very hard."

In spring 1937, his plans bore fruit. In the local arts magazine, *Littoral*, he is celebrated variously as a genius painter, restorer, and bohemian. A cover story by the Provençal poet Léon Vérane about Frank's restoration work includes a photo of Frank posing in his studio, tall, lean, and bearded, a beautiful man in a double-breasted suit. Another admiring article is devoted to the "La Fête Bohème chez Frank McEwen": "What society! What a scene! An artful mix, as artful as the gourmet cuisine in its variety: aristocrats, gangsters, soldiers, *carabinieri*, members of the petite and the grande bourgeoisie! Artists, doctors, the brawny and the delicate together, forming one solid block of fun."

Somewhere in the crowd at that party was a spot for Marguerite Caminat. The thirty-one-year-old librarian with a bookish look, still unmarried, fell in thrall to this handsome man of talent. Frank wrote wearily to his uncle Lucien in January of that year that he'd spent all day with the two students in his "Techniques of Painting, Ancient and Modern" because he figured the lessons might bring in as much as two hundred francs a month: "It is astounding what progress in leaps and bounds they have made now after 4 lessons," and adds, churlishly, "But I don't like to give away what years of analyzing old painting has given me." He was not a generous spirit. If I had to guess, I'd venture that Marguerite Caminat was one of the two.

FOR ALL ITS DANGERS in 1940, Algiers was a reprieve for Frank McEwen. After his years of subsistence living and his bohemian masquerade, he arrived on a farm where maids served him breakfast. One of his several future wives would say that he looked like King François I of France, known for his beautiful hawklike profile. Frank cut a figure. Baya told Marguerite she was terrified when she first saw him climbing a tree on the Farges farm to reach the first-floor window of the farmhouse. She thought he was an animal. Until the Allied invasion made Algiers safe for him, Frank could at least

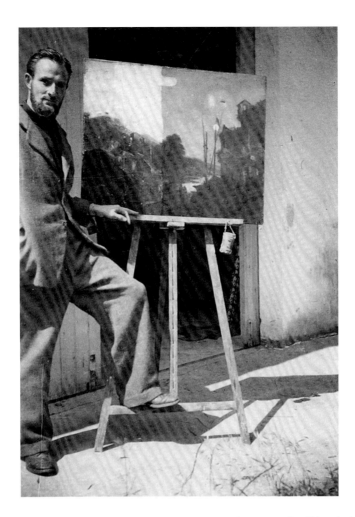

FIGURE 11: Frank McEwen posing next to his easel with an example of his painting restoration work (ca. 1938). Esther and Lucien Pissarro Archives, Ashmolean Museum, University of Oxford. Photograph: © Ashmolean Museum, Oxford.

walk the city streets relieved to be a McEwen, knowing that the familiar Algerian name Bensusan would have marked him as a Jew. He also enjoyed the privilege of his artistic pedigree: the Sorbonne, his teacher Henri Focillon, and his family calling card, Pissarro, although he remained strangely close-mouthed about his family tie to the Pissarros, as if, in artistic terms, he wanted to be known as a

self-made man, or as if he preferred to forget the years of begging them for funds.

In his last letter to Uncle Lucien, in 1939, the year of his marriage to Marguerite, he doesn't say he'd met anyone, but for once he doesn't ask for money. "Come what may," he writes, "I am finding an abode of intense peaceful happiness, like a happy dream from which one never wishes to wake up."

Life with Marguerite *is* a happy dream for a man who's been living from hand to mouth. He has a good run in Algiers; he grows in confidence and bluster. After the Allied landing in November 1942, he joins the British war effort as an assistant to the British general Innes Irons and the labor board. Newness excites him. Maybe he's lived in too many places: Mexico, England, Paris, Toulon. Maybe he's been with too many women, or not enough of them, or Algiers begins to seem provincial. He wants to be back in the center of artistic life, in Paris, with people worth the effort.

In 1945 he gets his wish. He's invited to join the British Council in Paris. The organization is looking for ways to remind the French that English art will rise from its ashes. Ever astute, Frank organizes a postwar exhibition of English children's painting that travels around France. Children's art, the art of the future, points hopefully in the direction of English creativity as it tugs at the heartstrings of French viewers.

Frank McEwen wouldn't be the first man to feel dispossessed of his kingdom by a woman passionately focused on a child, nor the first man to leave a woman who isn't paying as much attention to him as he might like. Hard to know what came first, his jealousy of Baya or the allure of a charming artist he meets in the social whirlpool of Algiers. Around the time he appears to lose interest in Baya's art, he begins to play Pygmalion to a woman named Denise Chesnay, sixteen years younger than he, born Denise Bensimon Marchina to a wealthy Jewish family in Algiers. She is so devoted to her art that she greets the anti-Jewish statutes, which force her to leave school, as a chance to paint full time. Frank is smitten with doe-eyed, sensual Denise whose painting has promise, if only she's willing to work.

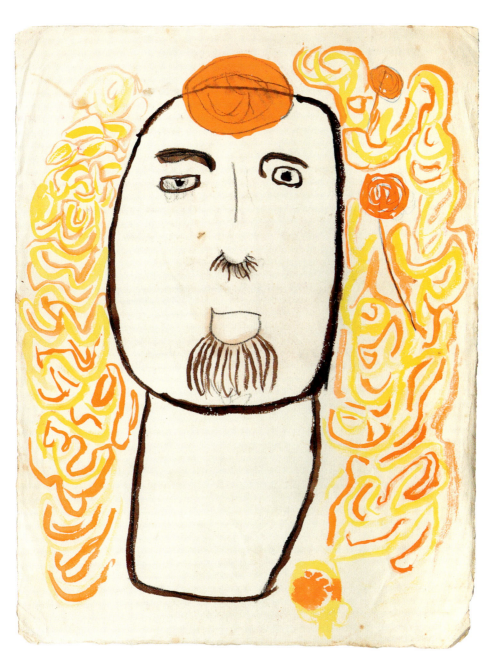

FIGURE 12: Baya's early drawing of Frank McEwen (ca. 1944).
By permission of the Children of Baya Mahieddine.
Private collection. Photograph: © Gabrielle Voinot.

He tells her he can make her career; he knows everyone who counts. After he settles in Paris, he finds her a rare spot on an army transport ship so she can join him. McEwen's artistic cause has been the promotion of child artists, yet out of a not quite mid-life passion (he's thirty-eight), he's abandoned the child artist living in his midst.

At age fourteen, Baya finds herself alone with Marguerite on the rue d'Isly, while Frank remakes his life in the metropolis with his glamorous new partner. Marguerite goes to work in the French welfare offices (Bureau d'entraide), located in the same nineteenth-century Moorish palace in the lower Casbah as Cadi Benhoura's Office of Muslim Charities. She's in charge of documentation. Baya stays home, keeps house, and paints with the supplies Frank and Marguerite have given her.

Settling in Paris, in his new position at the British Council, Frank asks the art critic Herbert Read to contribute an introduction to his exhibition of paintings by English children. "The children who have created these works," Read writes, "will be adults in the post-war world; we'd like to believe that this sense of beauty, this joie de vivre they have expressed in their childhood may continue to develop in a world forever free from the tyranny and abomination of war."

Herbert Read and McEwen were not alone, in 1945, in championing children as symbols of a European future. In *Rome, Open City*, Roberto Rossellini's masterpiece of neorealism, a band of children gathered behind a high metal fence observe the execution of their beloved Resistance priest; they serenade him, whistling the song of partisans, disturbing the fascists who are preparing to fire. The children hang their heads in grief, but as soon as the priest is dead, they start to walk together along a path that skirts the heights of the city. They descend into the city, into the future. In René Clément's 1952 film *Forbidden Games*, a young girl sees her parents and her beloved dog killed in a German air attack during the 1940 exodus. She wanders in the countryside until she is discovered by a peasant boy who takes her home. Together they invent a game: killing little animals—moles and beetles and ants—and burying them in elaborate ceremonies. Taking charge of death. It's impossible to under-

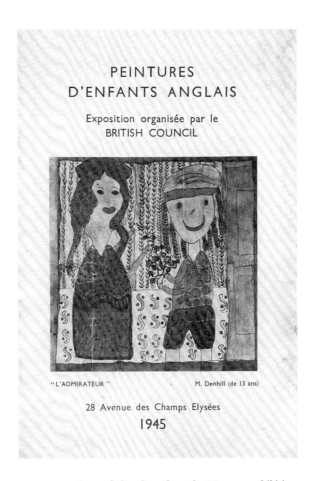

FIGURE 13: Cover of a brochure from the May 1945 exhibition *Paintings by English Children*, curated by Frank McEwen for the British Council in Paris. Photograph: © Alberto Ricci.

stand the success of Baya without understanding these children, witnesses to the violence of war who will determine what comes next, after the bodies are buried. Baya was not a direct witness to war, but she'd experienced the famine that the war created. Occasionally, soldiers show up in the stories Marguerite transcribes, and we're reminded that American troops have been stationed in Algiers.

Before he disappears from Marguerite and Baya's life for good, Frank McEwen makes a final gesture. He sends the catalog from the English children's painting exhibition to Marguerite and Baya on

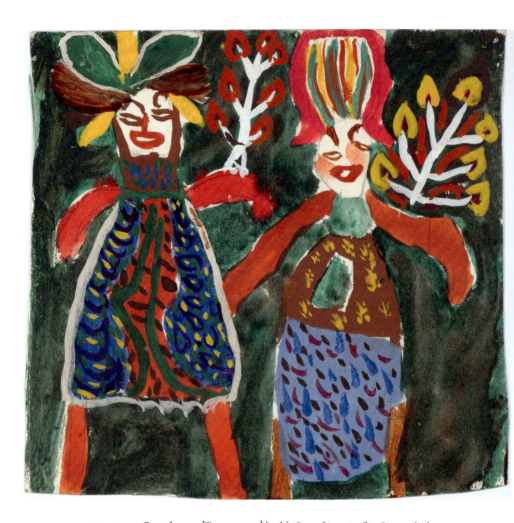

FIGURE 14: *Deux femmes* [Two women] (n.d.). One of twenty-five Baya paintings donated by Marguerite Caminat and acquired by Jean Dubuffet and Michel Thévoz for their museum of outsider art in Lausanne. By permission of the Children of Baya Mahieddine. Photograph: © Collection de l'Art Brut, Lausanne.

the rue d'Isly. As if to say, Baya, you are not the only child making art! The catalog—more like a pamphlet—is very small, four by six inches. On the cover, two figures on a flat field, a matronly woman and a boyish figure in pants and pigtails who holds a bouquet in one hand. The title of the cover painting is *The Admirer*, attributed to "M. Denhill age 13."

48 | *Chapter Six*

Baya starts to copy *The Admirer*. Marguerite admonishes her: Never copy! Be true to yourself! But what artist doesn't begin by copying? In this black-and-white rendering, so different with its courtly bouquet from Baya's female-on-female world, we see what must have appealed to her: the woman's patterned skirt, the squiggles on the rug, the leafy patterned wallpaper. Another teenager, in another country, a boy barely younger than she, made a painting that was chosen for an exhibition and reproduced on the cover of a brochure.

Baya, looking at Frank's catalog, tries out forms, experiments with strong colors. Even her earliest paintings have a sense of proportion, a sophistication, a harmony, that leaves the English teenager far behind. She's advancing quickly now.

7

Love

MARGUERITE LOVES BAYA with the passion of a new mother, noting every reaction, every gesture. With Frank's betrayal, she grows all the more devoted to the girl who inspires and consoles her for her loss. In the twilight of her life, she creates file folders: Baya speaks; Spontaneous Baya; Return to the tribal village, after her parents die; In Frank and Marguerite's house; Imagination, visions, encounters. She constructs a chronology of the life of her would-be daughter, now a famous artist.

In her notes are memories of sitting with Baya for hours, listening. Baya's grandmother warned her when she made her bargain with Marguerite that the girl was "impossible, opaque." And at first Baya was mute, as expected. Then she began to tell story after story, and Marguerite wrote the stories down. There's no way of knowing exactly what Marguerite changed or embroidered, or how Baya shaped what she told to please or entertain her guardian. Baya, at age eleven, twelve, fifteen, had every reason to want to secure her place in Marguerite's heart. She was Scheherazade, telling her tales to survive.

Marguerite stitches together the pieces of stories that have the shape and the music of fables, so that they feel outside time. The voice isn't stable. Marguerite quotes Baya's speech, or Marguerite speaks about Baya, transforming the girl's words through her own understanding. In the archive there are loose-leaf pages scrawled in

pencil, now yellowed with time and illegible, and grid paper filled with pages of her dense handwriting.

Baya begins to talk about her parents. Her father was tall with a beautiful mustache. He wore ample blue trousers. Her mother was tall and thin and beautiful, and she sang Baya to sleep with a lullaby: "Butterfly, where shall I put you? The bee flies and flies and lands. Go to sleep, with the good Lord's help, I'll tuck you in." So there was a time of happy innocence. Baya got into mischief, had adventures, held hands with her father, ran back to the comfort of her mother's domestic sphere like an ordinary little girl.

Baya speaks of happy parents, of the table her mother set as she waited with a cloth to clean her husband's feet after he returned from working in the fields. One night her mother went dancing without her father's permission. When she came home, he hit her so hard that he hurt his wrist. The local healer came with a hot iron, which, instead of healing him, killed him. The fall was swift and unexpected, the violence strains belief. Fairy-tale happiness turned to horror in the space of an evening. Baya twice becomes a fugitive, first from her mother's second husband in Kabylia, then from her grandmother. She runs away to her Aunt Radoudia's, hides in the bushes from American soldiers shining their flashlights on the road; she runs and runs and knocks at the first door. A kind woman opens, a good woman without children who feeds her, washes her, marks her hand with henna for good fortune and sends her on her way to her aunt's. A good woman on the road; a precursor to Marguerite. At Aunt Radoudia's, Baya is surrounded by women who see her bruises from her grandmother's beatings. They tell her to repeat five times the magic formula "You are no longer my grandmother." When her grandmother arrives with the police, Baya stands in front of her and cries out, "You are no longer my grandmother." But the magic formula doesn't work, and Baya goes back to the *gourbi*.

The scene is rich with detail—the hedges, the darkness, then the soldiers' flashlights, the woman protecting little Baya with the mark of henna. The spell that fails. Baya's sense of humor surfaces in mid-

trauma: if only it were that easy to get rid of her grandmother! All the pacing and the rhythms of a tale.

Next come details of Baya's labor and her suffering. Baya is cruelly punished for her escapade. Her grandmother admonishes her, slaps her. Baya draws water from the well, she lights the fire, she sweeps and washes the dishes while the household sleeps. She carries the children on her back. They pull her hair. She shucks the corn beneath a burning sun. In winter, with frostbitten hands, she pulls carrots from the hard, frozen soil. There's an outdoor terracotta stove to warm her hands, a *kanoûn*. "Carrots, *kanoûn*, carrots, *kanoûn*," Baya chants for Marguerite. Mean boys working in the garden throw stones at her. She's the only little girl working the fields. The story is written as if Marguerite has been reading *Les Misérables*, casting Baya as Cosette and herself as Jean Valjean.

Marguerite's writing about Baya's grandmother reaches operatic heights: "Rare is the intelligence of the grandmother. Intolerable, the power of the gaze on her sorceress's face. She dominates the entire house. Her lies are frightening. She casts spells on her entire family, on her employers. She brags that she caused the death of a neighbor, a Spanish farmer. She's afraid of nothing, of no one." "Rare is the intelligence": The figure of the grandmother must have seemed so grandiose, so violent, Marguerite couldn't resist a literary flourish. Did she think the sorceress's face meant that Baya's grandmother actually was a witch? Did it occur to her that the phrase "the face of a witch" in Baya's story might have been a figure of speech, the way someone might say about a woman who frightens them, "she's a real witch"? Marguerite has heard of the Berber practice of casting spells, a version of making wishes, part of the culture of Kabylia that the French in Algeria found so charming. When Baya goes to Paris, the press will transform this ordinary phrase, "the face of a witch," into an identity. Headlines and captions will announce that the artist Baya is the granddaughter of a witch.

8

Dream of the Mother

THE DATES ARE HARD to calculate, but Marguerite's notes suggest that Baya began to speak in earnest about her childhood in 1944, just before Frank left the household. Baya told Frank and Marguerite the story of the grandmother's hovel in Sidi M'Hamed and her return from Kabylia after her mother's death. Along the way, she communicated through her paintings.

Salima and Bachir Mahieddine, Baya's son, meet me on the terrace of the Hotel Saint-George on a warm July afternoon in 2022. Bachir has his mother's eyes, in fact he looks so much like her that at first I'm stunned. I know those eyes from looking at her pictures when she's a young girl in Paris, posing for the journalists, and again when she's a sixty-year-old woman in Blida. One of her collectors in Hydra speaks to me about Baya's "diamond eyes," and the phrase has stayed with me. Her son has her eyes and her silence—a confident, comfortable silence. I bring a catalog of Baya's paintings from the 1940s, and we turn the pages until we get to a painting from the 1940s that's different from the others. Baya never gave titles to her paintings—her dealers and collectors and mentors labeled her work when they needed to exhibit or sell it. But she always spoke fondly of this particular painting as a dream about her mother, and she treasured it. She painted two very similar versions of the dream. One is in Algeria, with Baya's family, one in France, with Marguerite's. A tall, slender woman gazes down at her daughter, identical to her

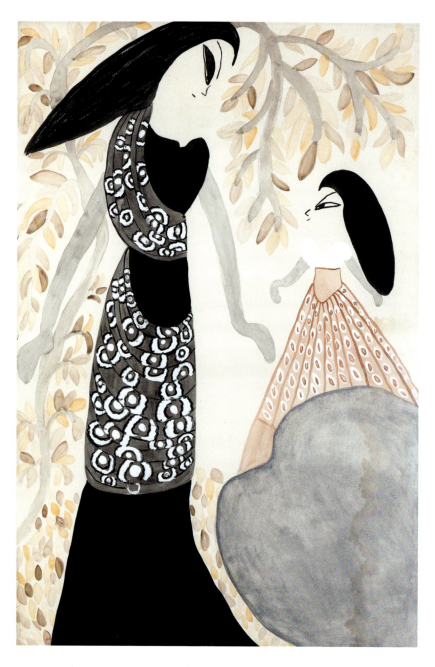

FIGURE 15: *Rêve de la mère* [Dream of the mother] (1947). One of two versions of Baya's dream painting. By permission of the Children of Baya Mahieddine. Private collection. Photograph: © Gabrielle Voinot.

but tiny, remote, as if she's standing miles away on a distant shore. Black and white are the dominant colors, as if she has drained her palette for the dream space. There's a rock in the foreground—a dull round shape, the faded color rarely seen in her paintings. The rock as obstacle: as if the dreamer would have to climb over it to get to her mother. Mother and daughter have matching faces and almond eyes that fix one another. Each wears a lushly patterned skirt; the mother's dark blue skirt has peacock eyes in white; the child's skirt has orange stripes. "Tall, beautiful, slender": those were the words Baya always used to describe her birth mother, and here she is, in paint, tall, beautiful, and slender. I hear Baudelaire, "longue, mince, en grand deuil" (tall, slender, deep in mourning). Her arms are ghostly arms, painted in a nearly transparent gray, unlike the arms of Baya's usual female figures, curving apertures in saturated colors. The tiny daughter stands under a tree. Its branch, its orange and yellow fall leaves curve around her, protecting her.

SALIMA, BAYA'S DAUGHTER-IN-LAW, who was so close to the woman she calls "Maman," guides me through the painting, and I feel connected to a genealogy of love between mothers and daughters.

9

Who Is Speaking?
(Part I)

NINE MONTHS BEFORE the Maeght Gallery opening, Baya testified before a judge, requesting her legal emancipation. She recounted the death of her parents, her grandmother's severity, the brutal tasks demanded of her, the behavior of her violent uncle, often inebriated. She had been visiting them on the weekends since she'd gone to live with Marguerite and Frank. When she returned to her grandmother's for the November 1946 Eid holiday, her uncle beat her so badly that she fled to nearby Fort-de-l'Eau, to the Farges farm, for help. Marguerite took her to a doctor, who certified her wounds and bruises in an official medical report, evidenced in her official hearing. Baya told the judge that she no longer wished to return to her grandmother's house. The judge declared that Baya could continue to live under the protection of Madame McEwen, who was to report regularly to Cadi Benhoura, associate director of the Office of Muslim Charities. Above him, the Caïd of Algiers, Ibrahim Slimane Chanderli, represented by a substitute, approved and signed.

"The aforesaid father and mother"; "As I once did of my own will"; "The aforementioned Madame McEwen." None of this language sounds remotely like Baya's. Who is speaking then? The legal document conserves for our memory, translated into administrative-speak, an extraordinary act of will, a rare instance of a rural Alge-

rian child prey to family violence insisting on her rights: "I refuse formally . . ."; "I even refuse to go . . ."

Baya is now subject to Muslim personal law, under which there is no adoption but rather a regime of protection, known as "kafala," which lasts until the child reaches adulthood at age twenty-one. Cadi Benhoura, "legal tutor of all the incapacitated," has become Baya's tutor, and Marguerite McEwen gets temporary custody of Baya, on the condition that she report to Benhoura. The document alters the unofficial arrangement that Marguerite made with Baya's grandmother five years earlier whereby Baya lived with her as her maid, in exchange for wages.

It's impossible to separate Baya's suffering in Sidi M'Hamed—"cold, hunger, lice"—with her rescue in Fort-de-l'Eau. Both spaces were governed by colonial assumptions about land and about people. The cadi, part of a vast French administration of colonized communities, represents a go-between, reinforcing Muslim tradition within French law. When Marguerite appeals to him to help Baya, he launches the procedure and regularizes her situation. In 1947, nine months before Baya leaves for Paris for her exhibition, she enters an official regime of protection. Her grandmother will not profit from the coming sales of Baya's art.

Marguerite, like so many parents I know who've adopted a child whose race or ethnicity differs from theirs, does not try to Europeanize her—not completely. Baya receives a Muslim religious education, spending weekends with devout families, wearing a veil. Even when she no longer visits her grandmother, she celebrates the Muslim holidays, learns the ways of prayer. At the same time, she learns to write in French. Once Baya is settled in the apartment, Marguerite tries to sign her up to attend a school in Algiers. The school refuses to take her. She wasn't excluded as an *indigène*—that would no longer have been the case in Algiers after 1944—but at twelve years old, with no previous schooling, she would have had to attend first grade with six-year-olds. It's important to remember that her situation was not unusual: only an estimated two percent of Muslim girls in colonial Algeria in 1945 were schooled.

The school recommends an old spinstress, Mademoiselle Bureau (could that really be her name?), who has helped many Arabic and Kabyle-speaking children learn French. Mademoiselle comes regularly to the rue d'Isly to give lessons to Baya. The great Algerian writer Assia Djebar will publish an essay in *Le Nouvel Observateur* in 1985 extolling Baya's "flower gaze"; her text is followed by this biographical note: "Orphaned at a young age, Baya will learn neither to read nor to write." Marguerite writes to correct the record: Baya read with ease and she wrote basic French—but only basic. Later she began to write the way she painted, with swooping curves. Still later, she dictated letters to her children to send to Marguerite and to Mireille. But in 1945, she was pressing down hard under Mademoiselle Bureau's attentive gaze, using the same Sergeant Major penholder that generations of French students have used to form letters on graph paper, practicing their *P*'s and *Q*'s carefully.

She writes to Mireille to tell her that she and Marguerite have washed their hair and are letting it dry in the open window. They're watching the workers. The birds are singing. Baya writes phonetically. The birds are "les zoiseau,"—a pidgin spelling Maeght found so charming that he would use it for the title of the folk tale by Baya included in *Derrière le miroir*.

Marguerite keeps the letter, dating it "early 1945." People are constantly speaking for Baya, but in these few lines, she paints a portrait in words of two women standing in front of a window, the shutters flung open. No photograph of Marguerite and Baya on the rue d'Isly has survived, if there ever was one. This letter will have to do. Remember that their fifth-floor apartment, squat by comparison to the lower floors, is set back so that windows give out onto a terrace that runs the length of the building. Their luxury. They can see the port of Algiers from that terrace, and the fresh sea breeze helps dry their hair. They look down at the life below. The morning is peaceful, uneventful. A worker sweeps the street. A garbage truck stops to empty the trash bins, a food delivery truck heads toward the Tantonville café, a chauffeur in a DS—a cicada on wheels—takes a politician to the Assemblée Constituante. The street is too far below for

FIGURE 16: Portrait of Baya as a teenager (n.d.). By permission of the Children of Baya Mahieddine. Photograph: © Children of Baya Mahieddine.

them to be bothered by the buzz of those vehicles. Instead, up in the clouds, with the gulls sweeping above them, they hear birds—birds that will be everywhere in Baya's paintings. Of course Baya's letter to Mireille has to have birds in it.

Baya has entered as a servant into the world of progressive Europeans, the people Albert Memmi bitterly called "the colonizers of

FIGURE 17: *L'âne bleu* [The blue donkey] (1950). By permission of the Children of Baya Mahieddine. Courtesy of the Kamel Lazaar Foundation. Photograph: © AGUTTES / Rodolphe Alepuz.

good will," but with a margin of freedom. She paints. She's about to go to Paris, about to meet everyone who matters in European modernism. Witness to this situation, ever vigilant, is the Cadi Benhoura, associate director of the Office of Muslim Charities. "I am the Cadi who liberated Baya from her family," he wrote with pride to Albert Camus. Not only is he in charge of Baya's welfare, as a Muslim judge in the colonial administration; he is falling in love with Madame McEwen, who loves him back. She loves him through Baya, loves his care for Baya, loves him as the man who guarantees Baya's welfare. A conflict of interest, in other words. A romance between a European woman and a Muslim man was rare in those years. But Marguerite didn't grow up in that colonial atmosphere, she came straight from the mainland. Her sister married Henri, a member of the Resistance, secretary of La France Combattante, and a fervent supporter of rights for Muslims. She'd married Frank, an Englishman—but also a stealth Jew. She identifies as an artist, a free spirit. She's not going to let conventions stop her. But the steps she takes lead her inexorably into a colonial system that is sick at its roots.

WHO WAS MOHAMED BENHOURA? Whereas Frank was an adventurer, alienated from home and family, Marguerite's new companion is a major political figure in late colonial Algeria. A World War I veteran who supported the Croix de Feu movement; a journalist who turned from that movement's anti-Semitic rhetoric to support for the Popular Front—because after all, they were the only party interested in Muslim rights; a reformer of Muslim law, working alongside the legendary reformer Cheik El Okbi at the Cercle du progrès, Benhoura would be entrusted with special missions in the Middle East by the French Ministry of the Interior; in 1950, he and El Okbi traveled together to Jerusalem on a humanitarian mission in support of Palestinian refugees. As Baya's exhibition approaches, he reminds himself that good works and good behavior on the part of an extraordinary individual can lead to full rights for all the Muslims of Algeria. He is fully invested in Baya's success in Paris, terrified that something might go wrong. He takes his responsibilities seriously.

10

Baya Goes to Paris

I IMAGINE THE MEETINGS, the planning, the analysis, Marguerite and the Cadi Benhoura huddling in consultation in the Palais d'Hiver, their affection and solidarity growing.

Once the paintings and statuettes were shipped by air to Paris, there remained the question of Baya herself. They understand that she will be scrutinized in Paris just as much as her art. Baya as a Muslim, Baya as a Kabyle, Baya as an Arab, Baya as a prodigy, and finally, they hope, Baya as an artist. The Cadi Benhoura asks Marguerite for the strictest guarantees of the young woman's security in the capital. He needs her to determine and control exactly what contacts Baya is to have with the Parisian public. He also insists that the young woman be dressed at all times—Marguerite specifies—in "oriental costume."

Jean Peyrissac, the man who introduced Aimé Maeght to Baya's work, assists with this task, just as he has assisted with every aspect of the preparation. He writes an essay for *Derrière le miroir*; he provides an inventory of 149 watercolors and 10 terra-cotta figurines, he arranges for licensing and air freight. Now he is tasked by Marguerite and Benhoura with commissioning the most authentic, most beautiful handmade garments from the best artisans in Algiers. Schools and workshops of native embroiderers and seamstresses existed throughout colonial Algeria, including the famous rug and design workshops of Peyrissac's friend Marie Cuttoli. Would Peyrissac have sought Marie Cuttoli's advice? In the 1920s and '30s Marie

commissioned Algerian seamstresses to make gowns and tapestries for her Myrbor boutique on the rue du Faubourg Saint-Honoré. At the northernmost height of the Casbah, the "Palais Oriental" had instructed native girls in the art of embroidery since the late nineteenth century.

The seamstresses and embroiderers Peyrissac chose produced a beautiful velvet karakou vest, a gold-and-red striped *sarouel* (harem pants), a white silk gown delicately embroidered with a matching foulard, and a violet striped dress in velvet and silk, traditional yet modern. Jean Peyrissac wrote Maeght a month before the show to announce, "a magnificently colored assemblage. Baya will be beautiful!" In Paris, the fashion-setting *Elle* magazine will take notice: "Baya has an extraordinary collection of embroidered outfits, as luminous as her paintings."

The suitcases are packed with care. Marguerite rehearses every detail of the itinerary. Depending upon which flight Baya takes, she'll land at either Orly or Le Bourget. Marguerite arranges for a stewardess to look after Baya, and Baya alone—because there might be a stopover in Marseille, although she won't know until the last minute. She promises to call Maeght as soon as she does. She gives him the phone number and address in Neuilly of a Madame Wertheimer, who will lodge Baya: he's to communicate with Madame Wertheimer regarding all the arrangements. She needs to make sure that Maeght will be there to meet Baya when the plane lands. She lets Maeght know to whom she is accountable: "I am terribly distraught and I must reassure the Cadi who is most alarmed." She signs off, as she often did, nervously: "My worry about everything is great, and I'm counting on you, hoping that Baya will be well protected and guarded." Nothing can assuage her anxiety. But even in her care and worry, a phrase like "well protected and guarded" points to a different sentiment. Coexisting with her passion and her devotion is her sense of Baya's value. The categories by which she understands her charge are confused: her beloved Baya is a native girl, a maid, an artist, and now a performer.

She is still signing her letters "Marguerite Caminat McEwen."

Frank McEwen has been gone from her life for two years. And since he's left, her bond with Baya has strengthened. She says goodbye to her at the Maison Blanche airport on November 10, 1947, returns to her empty apartment, and picks up pen and paper to write Maeght again. In Baya's absence, the shock of what she's done hits home. She's sent her to live among strangers in the capital of high art and fashion she's refused for herself: "As I write you, at this very moment, Baya is in Paris and won't leave my thoughts, the child who left this morning, so oblivious, having so totally surrendered herself to our decisions, that never have I felt my responsibility more acutely." It's one of the rare places in her correspondence where her worry surfaces about what Benhoura referred to proudly as his liberation of Baya from her family. Alone in Algiers, she senses, if only in passing, the dark side of her rescue.

BAYA MOUNTS THE STEEP STAIRWAY to the airplane, a DC 4. She's wearing her embroidered *karakou* vest with its gold embroidery against black. Gone is the maid's tightly wound cotton *maharma*. She's tucked her hair into an artistically knotted silk scarf. She travels all day, from Algiers to Marseille, from Marseille to Paris. On the last leg of the trip the woman sitting next to her vomits into her handkerchief and Baya gags and vomits, too. Not because she's sick, she explains to a friend of Marguerite's in Paris, but because her neighbor vomited. A show of empathy.

When she lands at the Bourget airport, the journalists are ready with their flashbulbs, their questions. Maeght has alerted them.

At 7:35 p.m. on November 10, 1947, Aimé Maeght sends a telegram to Marguerite McEwen: "Baya arrived without incident."

11

Baya's Hosts

BY LODGING BAYA, Madame Rosita Wertheimer is returning the hospitality paid to her boys on Simone and Henri Farges's farm. Her sons were welcomed in Fort-de-l'Eau, and she is eager to welcome one of their daughters. Instead, this little Arab girl, the adopted daughter of Simone's sister Marguerite, is coming to stay in her poorly heated house in Neuilly. She's nervous.

UNLOCKING ROSITA WERTHEIMER'S STORY means walking a fine line between family lore and fiction. I've transcribed in my notebook words of wisdom from Philippe Lançon: In fiction, our readers believe what we tell them, because it's all they have. In nonfiction, we owe those readers an account of what really happened and what people really thought. But no matter how much information we gather, what *really happened* will always remain just beyond reach. And so I keep checking and double-checking, eliminating a mistake here, an inaccuracy there, leaving room to imagine what I can't know, because information, however invigorating, is never enough. I hold the details in my hands like so much sand.

After a long quest (law offices, wedding announcements, a cousin in New York . . .) leads me to Rosita Wertheimer's granddaughter Agnès, a door opens. Agnès is the historian of the Wertheimer family; her curiosity is a good match for my own. I start to imagine with her what it was like for Rosita to welcome Baya to Neuilly, and what

it was like for Baya to find herself in Madame Wertheimer's house on the boulevard Victor Hugo.

From the detailed letters that Rosita sent Marguerite in the fall of 1947, it's easy to picture a rule-bound, morally rigorous, and anxious person. The opposite of Rosita's own mother, Madame Diaz, who'd fled an unhappy marriage in Argentina to lead a wild life in Paris, while she sent Rosita and her sister to be educated by the nuns.

When Rosita fell in love with René Wertheimer (in one family story she met him dancing), he was a man of considerable means: a patron of the arts, a patron of the press, a real estate investor and a lawyer. The grandchildren have always heard he left his first wife because she couldn't bear him children, and set her up in a chateau. Rosita gave birth to four children in short order, beginning in 1920: Philippe, Marcel, Françoise, and Rosine. In 1930, when René divorced Jacqueline, the children he had with Rosita were baptized and legally recognized. Rosita's life as the lawfully wedded wife of an affluent businessman lasted barely six years—René died in 1936, leaving his assets in several Swiss bank accounts.

When France fell to the Nazis in 1940, Rosita, her mother, and her children fled their apartment at 244 rue de Rivoli. It was the worst possible place to be in occupied Paris, down the street from the Hotel Meurice and in the thick of a neighborhood that would soon be crawling with high-ranking Nazis.

Rosita and her children joined the eight million French people who made the great exodus south. There were only a few ways to travel: a rare empty seat on the train, a *traction-avant* with household goods strapped to the roof. First to Bordeaux, where Marcel continued his schooling, then to Cap d'Ail, near Monaco, a glamorous seaside resort town where villa after villa stood behind high walls. The Wertheimers lived with friends in a community of affluent exiles that included André Malraux and his mistress. Cap d'Ail transitioned from a free zone to an Italian zone to a German zone of occupation. Half their building was requisitioned by German officers. But the Wertheimers survived.

WE KNOW THAT STORIES of survival are unpredictable. Could the Wertheimers, with a name so recognizably Jewish, have made their way through the occupation years without false papers? Another educated guess: their apartment on the rue de Rivoli with its vast salons and servants' quarters was likely requisitioned first by the Nazis, then by the new Gaullist government.

After the Liberation, the Wertheimers move to Neuilly-sur-Seine, the wealthy suburb, to a house on the boulevard Victor Hugo. Rosita, fifty-six years old (she would die three years later), suffers from insomnia and fights to keep her aged mother comfortable in the cold rooms. Her husband's bank accounts, suspended in 1942, lie dormant in Switzerland.

Back in Fort-de-l'Eau, Henri Farges's farmhouse expands to host her sons. Marcel Wertheimer, twenty-three years old, left Bordeaux, then Cap d'Ail, to continue his education at the Agricultural Institute of Algeria, not far from Fort-de-l'Eau. In 1942, after the Allied landing in Algiers, the school closed and Marcel was drafted into the African Army. During one of his training maneuvers, a cannon exploded. His shattered leg had to be amputated. He recuperated at the Farges farm and reentered the school when it opened its doors in 1945. He never complained about his handicap and threw himself wholeheartedly into the study of land use and farming in Algeria. Henri Farges was a mentor and a partner in vital conversations. So began Marcel Wertheimer's brilliant career as an agronomist, in which he would author an important study of land reform in Kabylia. His brother Philippe joined him in Fort-de-l'Eau, transitioning from his stint in the air force to a job in commercial aviation.

They're the new technocrats of the postwar world, still in their twenties, exulting in the North African sunlight. Philippe is the worrier; Marcel, the eternal optimist. They're both in love with Mireille Farges.

WHEN IT BECOMES CLEAR that Baya will need a place to stay in Paris, Simone and Henri put Marguerite in touch with Madame Rosita Wertheimer, who agrees to lodge the girl in Neuilly. By 1947

the Wertheimers have settled down. At last they're secure enough to offer their own hospitality. Whatever their worries in occupied France, the family now has the luxury of attending to the banal problems of 1947—the shortage of gasoline, the transport and postal strikes, and the challenge of putting food on the table. Madame Wertheimer views the arrival of Baya with trepidation. She asks Philippe to bring rice and couscous and olive oil back from Algeria; Baya, she suggests to Marguerite, will need to pack woolens and an extra blanket.

In a letter to Marguerite before Baya's arrival, Rosita tries to articulate her moral concerns about her guest. Has the girl reached puberty yet? The one time Rosita Wertheimer saw Baya in Algiers, she was a child (a trip to see her son after his injury?), but aren't young Arab women supposed to mature quickly? Paris can be dangerous in its sensuousness! She arranges to meet Maeght to gauge his values. He passes the test. She promises Marguerite that if Baya goes to the Maeghts during the day and returns to Neuilly at night, she'll be safe. Her attitude toward Baya betrays strange assumptions—one wonders how she decided that Arab girls tended to grow up too fast. At the same time, she's impressed by Baya's great talent, believes it will endure, if only the girl can be kept away from the Quran. Her first letters express a fear of otherness; later, with the help of her children, more open to the world, she brings Baya closer to her heart.

A few days after Baya arrives in Neuilly from Algiers, Philippe returns from Fort-de-l'Eau. He's said goodbye to Mireille Farges with chocolates, and now he's writing an awkward but tender letter about his nostalgia for Algiers in the filthy, humid cold of Paris. He reminds her that she called him a young idiot. He's smitten. Not just with Mireille, with the whole family, with the house and farm. He will never forget them, a true family, a part of his heart. Here in his mother's house, he writes Mireille, Baya seems so comfortable, as if she's always been there. Perhaps Philippe and his sisters compensated for their mother's fretful nature. Baya enjoys attending a performance by Rosine Wertheimer in *Bluebeard* at an amateur theater. Next Rosine takes her to the Invalides to see the gravesite of General

Leclerc, hero of the liberation of Paris who has only just perished in a plane accident in Algeria.

During her first weeks in Paris, Baya shuttles back and forth between two households: the Wertheimers in Neuilly and the Maeghts near the Parc Monceau. With the transport strikes, it becomes too difficult to arrange for daily taxis from Neuilly to central Paris. Baya is worn out. Preparing the elaborate costumes further complicates her daily preparations, just as Marguerite feared. Finally she leaves the Wertheimers' house to stay at the Maeghts'. Madame Wertheimer fears that Marguerite will think she's abandoned her responsibility, since her letter to Marguerite asking permission for Baya to move to the Maeghts is held up by yet another strike. So far, she's fulfilled her end of the bargain, reporting in great detail, attending to Baya's cleanliness, her fingernails, her laundry, even writing to Marguerite when Baya gets her period. She reassures her. Baya's mood, her table manners, her behavior are impeccable. Most importantly, her fame doesn't appear to have gone to her head. But perhaps the Parisian visit shouldn't be prolonged too much, Rosita Wertheimer writes on December 10, for it might become difficult for Baya to return to life as she knew it previously.

In the long run, Baya prefers life at the Maeghts to the house in Neuilly. She never says that Madame Wertheimer is a challenging host. How can she, when her letters are always written by other people, supposedly dictated by her. But the main reason she likes the Maeght household better is a five-year-old boy named Bernard. They play together at Maeght's house, they go to the Parc Monceau, full of children. Bernard calls Baya his "poisson d'or," his goldfish. When she scratches him by mistake with a fingernail, he grows angry but comes around and hugs her: "Forgive me, little goldfish."

Rosita Wertheimer, slow to warm to the girl, sympathizes more and more. "She's tired and annoyed by the journalists and photographers and filmmakers, by the idiotic questions that try to make her say what she's never thought about while she was creating," she writes to Marguerite, "Can we really know what she's thinking?" She understands that she doesn't understand.

12

Nelly Vigilante

IF MARGUERITE HAS BEEN tempted even for a moment to come to Paris for Baya's show, the letters she has been receiving from her friend Nelly must stop her cold.

Nelly Marez-Darley and Frank McEwen have traveled along parallel paths. They both started out studying in Paris, in different art schools; they both moved to Algiers after the fall of France, with similar illusions of escaping the war. Then, with Marguerite, they were part of a cohort that included the man of letters Max-Pol Fouchet, the sculptor Peyrissac, the painter Louis Bénisti, and of course Albert Camus. Nelly exhibited in Oran at the Colline Gallery owned by a cousin of Camus's wife Francine Faure. In 1944, Nelly and Frank even exhibited together in Algiers. But Frank was showing old work; he had already changed course. In 1943 he joined the headquarters of a general in the British Army, part of the labor service. Army intelligence suited him, and there was a rumor going around Algiers that he was some kind of a spy. It's not clear whether he was discreet about his new love affair or whether he flaunted it.

Marguerite still dabbled, but the paintings produced in the home she shares with Frank are Baya's. After Germany surrenders, Nelly becomes the French army's official painter in Baden-Baden. She moves back to Paris and sets up her studio on the rue Campagne Première in Montparnasse around the same time that Frank leaves Algiers, Marguerite, and Baya to work as a curator at the British Council on the Champs Élysées. From Nelly's point of view, Frank

is no longer a painter. She imagines he hated her for it. She's an uneasy contender in the art world.

Nelly has heard that Marguerite is heartbroken, that she's wasting away. She writes to her just before the opening. She alludes to Frank's new mistress without naming her. She's alarmed because he's going around town telling people that the Baya exhibition is a stupid idea, that the girl is no more talented than any other child artist. Frank, who has just curated the exhibition of English children's paintings, believes he understands the ephemeral nature of child genius.

Nelly claims that being in Paris has made Frank diabolical. She warns Marguerite: this demon has the potential to destroy the Baya exhibition with his put-downs. She imagines with equal dread that he might also approach Baya with open arms and charm her, taking all the credit for her success. He's bragged to Maeght that he's the one who discovered Baya. Maeght has even taken to referring to Baya as "la Kabyle de McEwen." (Or was he actually saying *Madame McEwen's Kabyle?*) She added that his sidekick was as treacherous as he is. Please, she wrote Marguerite, do not mention any of this! I have to swim in the same Paris waters as this man.

I imagine the misery such a letter produced in the already anxious Marguerite. Nelly vowed to counter McEwen's nefarious influence by bringing her own friends to the opening. She would arrive at the vernissage with Jeanne Modigliani, the painter's daughter, "an original, charming creature." She explains that she has had to make a new circle of friends after breaking off ties completely with "you know who."

After the opening, Nelly sends Marguerite a reassuring report. She observed Baya posing for photographs with Braque, Matisse, and Breton, casually indifferent to the historic scene. Baya looked perfectly noble and distant in her magnificent white outfit. She appeared to be deflecting the flattery aimed at her with an ironic distance. Nelly saw a lot of fakes at the opening, social climbers, politicians. And despite all her fears, she has to admit that McEwen seemed to have done no harm. He had shown up alone. He was green

with envy, but no one paid any attention to his grumbling. However, Marguerite must be sure to give the very strictest instruction to Baya so that nothing regrettable arises. What in Nelly's mind could possibly count as regrettable in a milieu she mistrusts this much?

At last she writes about Baya's art. The work brings out her kindness. She drops her suspicions, making room for her unmitigated esteem, painter to painter. Expecting to see the art of a child, she's discovered a role model. She speaks not only for herself but for all the artists in the room, astonished by the quality of Baya's paintings. She heard Baya's art compared to Minoan paintings. The clay figures remind her of the sculptures of the great Chinese dynasties. But especially, she is moved to see that Baya has understood the power of figurative and abstract art and honored both. She admires in the young artist her access to the unconscious, her ability to share that access with the viewer.

One painting comes to mind for just these qualities.

A mother, her enormous face and head crowned with pink and white and blue hair. Her skirts envelop a newborn who might almost be wiggling against her. The left eye of the mother and the right eye of the child match, two almonds with narrow arched eyebrows. The child has a tail rather than legs, like a mermaid or a seahorse swimming in the blue depths of the mother's skirt. The bodice of the mother's dress has stripes at the neckline, like the traditional dresses in Kabylia, and gives way to a wide skirt that occupies the entire bottom of the painting. There is a world of design inside that vast skirt, an abstract painting within the figurative one: red X's, red dots inside green circles, white dots inside red ones. The same shapes you see carved into chests or pottery in Kabylia: checks and circles, the shapes of Berber letters:

ⵍⵓⵜⵄⵉⵇⵓ ⵙⵉⵍ ⵍⵄⵉⵀⵍ

Nelly doesn't know Berber script; she sees geometric patterns. To the upper left of the mother's face, she sees a peacock, its thick tail waving proudly behind it, its head turned to one side, its eye

FIGURE 18: Willy Maywald's photograph of Baya in a *karakou* vest, holding one of her clay statuettes at the Maeght Gallery (1947). Photograph: © 2024 Association Willy Maywald / Artists Rights Society, New York / ADAGP, Paris. Photography by Charles Maze Photographe.

FIGURE 19: *Femme et enfant en bleu* [Woman and child in blue] (1947). By permission of the Children of Baya Mahieddine. Photograph: © 2024 Maeght.

nearly matching the woman and child's eyes, but turned away from them. The bird knows, omniscient bird in teal green.

This is a story of colors living together, the reciprocal strength of colors and forms. There are circles everywhere in the painting. To the left and the right of the woman's skirt, red, yellow, and white scattered shapes suggest flowers in a field. In later years, Baya will recall that the Farges flower farm had a rose garden, that the rose petals were harvested for perfumes, and that she used to sweep them up, soak the color out of them, and draw with their pigment. And when they were scattered to the wind, she would observe the patterns.

For an artist like Nelly, hesitating throughout her career between figurative and abstract painting, composition contains a riddle: Is the woman holding a child in her womb, or is she embracing a newborn infant? If you look closer, the riddle falls away and you see colors, and beyond those colors you see patterns—the circles, the abstracted petals.

13

The Shadow of Violence

YOU WOULDN'T HAVE HEARD the words "Sétif" or "Guelma" at Baya's opening; they are silent partners to the festivities. The massacre that began in May 1945 is usually referred to as "the events of Sétif," after the town in eastern Algeria where Algerian veterans (the "indigenous troops") marched on May 8, 1945, to celebrate their role in the liberation of France and their aspirations for a free Algeria. Nationalist marches of support and protest that had just taken place in major cities, including the one on Baya and Marguerite's street on May 1, had made the colonial government extremely nervous. They had exiled Messali Hadj, the national leader of the Algerian Peoples' Party, fearing he might lead the veterans in a seizure of power. His absence only encouraged protest—"Free Messali Hadj" and "Long Live the PPA!" became rallying cries. Bouzid Saâl, a twenty-six-year-old Muslim Scout, defied the government ban on flags, carrying an early version of the green-and-white silk rectangle with its red crescent that would become the flag of sovereign Algeria. A gendarme fired into the crowd, killing him. In an outpouring of rage and grief, angry Algerians murdered 102 Europeans.

Rumors reached fantastic proportions. One newspaper described professional agitators arriving from Algiers by taxi to push the crowd to violence. As if it was easier to imagine diabolical manipulations by one or another nationalist party than face the reality of spontaneous violence.

OF ALL THE MEN at the Maeght Gallery that evening, one in particular is tied to what happened in the months following the May 8, 1945, demonstration: Yves Chataigneau, governor general of Algeria and cosponsor of Baya's exhibition. De Gaulle would claim in his memoirs that Chataigneau, by his actions, had prevented an all-out Algerian insurrection against France in the summer of 1945. It was a poisonous compliment for this champion of reform, despised by the men on his staff, starting with his secretary general, who had countered Chataigneau's every decision with hard-line repression and vengeful law and order.

Chataigneau had arrived in Algeria two months after his son had been murdered in his Resistance maquis. He had taken up his post as Algeria's governor general after serving as a Free France delegate to Syria-Lebanon just as Lebanon was proclaiming its independence from France. And so he operated in a state of extreme vigilance, dreading yet expecting an insurrection. In the aftermath of May 8, Chataigneau studied the army reports listing each European casualty by initial with a detailed description of wounds. "L.V.", the judge who inspired Meursault's magistrate in Camus's novel *The Stranger*, had his skull crushed. Another man had his arm cut off. Others were eviscerated. Two of the victims were his friends. He established a state of emergency, using all the resources at his disposal: the army, the navy, the air force. He traveled twice to the region and formed two different commissions to investigate; one report was kept secret, the second commission was stopped in its tracks by order of de Gaulle.

The violence spread. In Guelma, one of Chataigneau's fiercest enemies, the subprefect André Achiary, encouraged French colonists who organized murderous rampages in the countryside. When the rioting spread to Guelma and throughout the Constantine district, Muslims died by the thousands. The army burned villages, dropped napalm by air; killed with bayonets, by air strike, by gunfire from a warship on the coast. Since the bodies were too numerous to bury, French militias dissolved the bones in lime kilns in the

countryside around Guelma during the same month that the front page of *Combat* showed a photograph of crematory ovens at Dachau. Throughout the summer of 1945, the French committed war crimes in the countryside around Sétif and Guelma.

The American army, still occupying the Algerian countryside three years after the Allied invasion of 1942, estimated 17,000 Muslim victims. Chataigneau's office gave the strangely specific figure of 1,340. The army reported that there were few indigenous deaths. General Duval complained that it was impossible to supply accurate numbers for the natives because they removed and buried their dead too quickly for them to be counted. And so a war of numbers began.

JOSÉ ABOULKER, ALGERIAN JEWISH hero of the liberation of North Africa whose father, Henri, is at the Maeght Gallery for Baya's opening, had stood up in the National Assembly in July 1945 to condemn the state violence: "Whatever the exact numbers of the repression, we must conclude that this collective repression has given birth to a collective panic in whose shadow is developing a vigorous, reactionary assault on the part of Algerian colonialism." He directed his remarks at Paul Cuttoli, Marie Cuttoli's ex-husband, who intones, in the chambers, that he was witness to what happened in Constantine and Guelma. Cuttoli accuses the Muslims in the countryside of doing exactly what the French militias were doing: "They pillaged, they stole, they set fire to isolated farms, to houses in the villages and even to entire hamlets."

It's impossible to say what Yves Chataigneau felt when he walked into the Maeght Gallery with the rector of the Great Mosque of Paris and shook Baya's hand. As a proreform liberal, Chataigneau believed that any separation of France and Algeria threatened the promotion of Muslim rights; he believed that his task, as governor general, was to encourage the most positive contact. Under his watch, Algeria went through the most hellish events imaginable. Reading the mixed messages in the documents coming out of his office helps us understand the extent to which his views were overridden. He had

failed. The decisions—the wrong decisions—were being taken day after day by the men surrounding him. Discouraged, harassed, silenced, he gave up.

Chataigneau pursued his campaign of colonial reform, the progress of Muslims toward full French citizenship foremost in his mind, but he had lost control of his administration. He made the requisite official visits throughout Algeria as the guarantor of security, the supporter of schools and hospitals. Baya's exhibition was one of many good deeds. Chataigneau was an intellectual, trained in geography and the law. He read and spoke Arabic fluently. The right-wingers called him "Mohamed" or "Yves-Mohamed, head gravedigger of Algeria." Twelve months after Baya's opening, he was dismissed, replaced by a hard-line proponent of eternal French Algeria—an "ultra."

SEEN AS A PIECE of a larger tactical mission, Baya's presence in Paris was designed to comfort French reformers in the idea that Franco-Muslim friendship endures. An ordinance of March 7, 1944, promising French Muslims all the rights and privileges of non-Muslim French had come to nothing. Now, in the fall of 1947, the gentlemen of the National Assembly returned to their desks to pass yet more symbolic legislation. The 1947 "Statut de l'Algérie" declared all Muslims citizens of France regardless of their fealty to Muslim religious law. This statute created an Algerian Assembly that was designed to unite French and Muslims in one electoral college authorized to vote on an annual budget for Algeria.

But instead of a single legislative body of equals, Charles de Gaulle insisted that the Algerian Assembly form as two separate and unequal bodies: a first college of sixty legislators, representing 1.5 million citizens—Europeans and a few thousand elite Muslims with French citizenship rights—and a second college of sixty legislators representing, in theory, 8 million Muslim voters. The consolidation of power by the European minority was flagrant. John F. Kennedy said it pretty well a decade later, shortly before the Assembly

was dissolved: "The result of this gap between word and deed, and the continued reluctance of the French to permit more than spasmodic and slight reforms at the expense of vested interests in France and Algeria, has been to alienate most sections of Algerian opinion so that assimilation is now a fruitless line of effort."

That alienation was as yet so invisible to the colonial administration that the prefect of the Algiers region had no compunction about making a speech the week of Baya's departure for Paris, praising the love between the French and the people they had colonized: "For Muslims to be happy, the settlers must be happy as well; for settlers to be happy, the Muslims need to be happy as well. This is how we build a marriage of reason. I invite you today to this marriage of reason, in the fervent wish that it may be transformed one day into a marriage of love."

When I came across this speech in the Archives nationales d'outre-mer, in the series "GGA" (governor general of Algeria), the vision came to me of Baya, the evening of her opening, dressed all in white silk as though she were the bride in a French-Muslim marriage ceremony. The decision to scrap a single electoral college was proof of an entirely different reality: the equitable union between colonizer and colonized, the so-called marriage of reason imagined by the prefect, will never take place.

Accompanying Chataigneau to the Maeght Gallery as cosponsor of Baya's exhibition and serving as her Muslim tutor during her weeks in Paris is Si Kaddour Ben Ghabrit, rector of the Great Mosque of Paris. Ben Ghabrit, Algerian-born, with diplomatic ties to the sultan of Morocco, serves as the official representative of the Muslim faith to the French government—the equivalent of the head of the Jewish consistory. Writer of licentious plays, a cosmopolitan cleric with deep culture and vast charms, he knows every layer of political and cultural life of Paris. Chataigneau and Ben Ghabrit, leaders of their respective faiths—Republicanism and Islam—are prominently featured in the newsreel of Baya's opening: Chataigneau, mid-fifties, with a military crewcut, a black overcoat, and the posture of a dec-

FIGURE 20: Newspaper photograph of Kaddour Ben Ghabrit, rector of the Great Mosque of Paris, and Yves Chataigneau, governor general of Algeria, with Baya at her Maeght Gallery opening. From *Alger-Soir* (November 27, 1947). Photograph: Bibliothèque nationale de France.

orated soldier; Ben Ghabrit, mid-seventies, regal in his imam's *qob* and flowing white *gandoura*. Though he's not on record responding to the events at Sétif and to the growing nationalism in Algeria, Ben Ghabrit remains a loyal servant of France (he died two weeks before the official war of liberation was launched). He had proved his diplomatic agility during the years of Nazi occupation. Asked by Vichy's commission on Jewish questions to serve as an expert for people who wanted to prove their Muslim—and not Jewish—identity, Ben Ghabrit suddenly found himself with life-and-death powers over the fate of Jewish Parisians. In at least one case, a man he refused to endorse as Muslim was deported, though he is said to have saved as many as 1,700 Jews by giving them Muslim identity papers, by hiding them, or by enabling their escape. He lobbied the occupiers to open the Muslim Hospital, posed for photos with Nazi

officers, then lobbied again so that the photographs of the official opening were not used for propaganda. He refused to write a thank-you letter to Hitler. In other words, he played a dangerous game.

By the fall of 1947, Ben Ghabrit's responsibilities seem, on the surface, less treacherous: meeting with the undersecretary of Muslim Affairs, and on August 20, for the celebration of Eid, joking over mint tea with President Vincent Auriol on his historic first visit to the Great Mosque of Paris. *L'Aurore* describes how "the unshakable and courteous Si Kaddour Ben Ghabrit, so dignified in his fine *gandoura*, his gestures slow, his affability easy . . . ignores the pack of photographers, ignores their flashbulbs and fulfills his duties as a host with noble conviviality." He appears at all times the perfect cosmopolitan, a living demonstration of serene Muslim spirituality, while a few miles west in the French National Assembly, deputies hotly debate the rights of the people they call "French Muslims."

Ben Ghabrit and Chataigneau, the living enactment of an impossible Franco-Muslim cooperation, were the hosts and sponsors of Baya's exhibition. As for the guests, there are no rebels at the Maeght Gallery on November 21, only reformers who differ in their understanding of a crisis.

Albert Camus and Henri Aboulker were outraged by the government repression that followed the riots of May 8, 1945. Camus had spent three weeks in the Algerian countryside that month and expressed his dismay in a series of editorials in *Combat*. He talked to enough people, Muslims and Europeans, to hear stories of unspeakable violence, of men and women whose bodies were never recovered. Camus believed that the underlying cause of Sétif wasn't politics—it was drought and famine. (He's begun to write "Arab" as an alternative to "French Muslims"—while the people of Algeria are proudly calling themselves Algerians.) "Arabs used to want to become [French] citizens but no longer do," he admits.

Yet somehow he still holds out hope for reform. Camus opposes Ferhat Abbas's plan for an autonomous Algeria, federated to France. To be sure, he acknowledges, there have been too many empty promises. Only if France grants true equal rights to the people of

Algeria instead of reacting to their demands with repression and arrests—then and only then will the Algerian people embrace the values of integration. He refers to this admittedly wild hope as a "second conquest" of Algeria. Problems are swirling around him that November afternoon: his debate with Mauriac over the recent scenes of vengeance and reprisal during the purge of collaborators; his political differences with Breton; his promise to Benhoura to make sure no harm will come to Baya. And the feeling, before which his ideals of justice and fairness are beginning to seem absurd, that Algeria is slipping away from him. By now, of course, he's reporting from Paris; he will visit often but never live in Algeria again. Through the lofty ideals of his rhetoric, his distance shows.

Unlike Camus, Dr. Henri Aboulker is living at ground zero of the crisis. Marguerite's old friend and former teacher, Marcelle Sibon, describes him in a letter to Marguerite as the "kindly white rat." A member of the Algiers city council and respected political figure on the left, Alboulker publishes editorials in *Alger Républicain* in the summer of 1945, asking for amnesty for the Muslim men who'd been jailed for their protests. His writing is both angrier and more pragmatic than Camus's *Combat* pieces. In "Dialogue with My Muslim Friend," he imagines a conversation with a Muslim intellectual, one of the few, he quips, who hasn't been put in jail. The man tells him, "They call us 'Muslim brothers,' especially in wartime. Then we turn into dirty Arabs [*sales bicots*] just like before. Apparently, our bodies don't feel the brutality and our hearts can't sense the disdain." As to whether economic improvements would make a difference: "We've been disappointed too often to believe that we might obtain our share of justice." In "Our Friends, the Colonizers," Aboulker imagines a dialogue with an outraged colonist; he writes this column from his own point of view: "Right now we're experiencing the lamentable and distressing effects of an acute crisis of Arabophobia: colonization. We all understand it's the backbone of this country."

NEITHER ALBERT CAMUS, nor Henri Aboulker, nor even Yves Chataigneau know that the Special Organization of Algerian revolu-

tionaries has already formed to dismantle that framework, readying itself to fight for all those men and women whose bodies feel the brutality and whose hearts sense the disdain. In February 1947 the O.S. begins to plan an armed rebellion against France. Unlike the riots of V-Day, their revolt will be organized, disciplined, and secret. Their war of liberation will transform Baya from a French Muslim, a subject of France, to a citizen of a sovereign Algeria.

Henri Aboulker and his son José, who led the first debate on Sétif in the National Assembly, do what they can. With a coalition of communists, radical socialists, and members of La France Combattante, they work through the system to liberate the thousands of imprisoned Muslim activists—men from Ferhat Abbas's party, from the Oulémas, a progressive religious organization, and from the organization of Muslim students. Among the most passionate members of this coalition is Marguerite Caminat's brother-in-law, Henri Farges, the flower farmer.

THAT WAS THE BARELY perceptible tragedy playing in the background as the elite who gathered at the Maeght Gallery exchanged handshakes, glances, and quips. A gallery opening was not the place to articulate their thinking about the military enforcement of French rule versus the critique of state violence in Algeria. More likely the polemics were far more innocent; existentialism versus surrealism; the "École de Paris" painters versus the American abstract expressionists. For in addition to everything that made Paris tremble that November 1947 afternoon, there was a growing consciousness of American rivals and the accompanying fear that New York was about to replace Paris as the center of modern culture.

Having newly returned to Paris from her assignment in Germany as the official painter of the French occupying forces and jockeying for recognition, Nelly Marez-Darley was worried about this next frontier: "I believe that Maeght will make a big effort on the American side. The American filmmakers and photographers were all there. He told me he's leaving shortly for the United States to see if 'the Baya case' is commercially viable. If he succeeds and if he's

honest, Baya may be very rich in a few months." America, for her, was not a locus of art; it was a market.

Every woman she knew was missing soap and thread and cotton and tea and coffee and pepper and sugar and chocolate and sanitary napkins and decent underwear and stockings. Marguerite's friend Marcelle Sibon, also a friend to Nelly, joked in a letter to the American writer she translated, Katherine Anne Porter, that the underwear situation in particular was so bad that you wouldn't want anyone to undress you. . . . Even the most elegant figures at Baya's vernissage were engaged to one extent or another in what Marcelle called "the sterile struggle" for material comfort. "I wonder whether you American people realize from such a distance the life we lead," she wrote to Porter. In 1947, with transport strikes and rationing dominating the news, with wood-soled shoes wearing thin, care packages continued to make their way from America to France, from artist to artist, writer to translator.

14

Marcelle Sibon

MARCELLE SIBON IS DISTURBED by letters she's getting from Marguerite Caminat. The woman she calls "Margot" was her student in English at the lycée in Toulon, though they are barely ten years apart in age. They haven't corresponded since she moved to Paris and Margot left Toulon for Algeria. She finds her friend's tone fearful, paranoid. She knows her, knows her longings and her fears. She understands right away that Margot is afraid to show her face in Paris because she dreads encountering Frank at the opening, or worse, she dreads encountering Frank with his new woman.

She writes Marguerite in the lead-up to the exhibition that she has no nefarious news: she's seen McEwen only two or three times at exhibitions or at British Council events she's attended as a translator. He said, "Marguerite appreciates you so much!" and about Baya, he remarked only that she had the kind of genius many children have. "Let's wait and see," he said. Nothing evil there, at least on the surface. McEwen was a cool operator, speaking casually about Marguerite and Baya. He wasn't embarrassed or apologetic. It was as if he had never lived with them, had never encouraged the girl's art—as if he'd never abandoned them.

Marcelle Sibon has found happiness in Paris. She's quit her job teaching high school English to devote herself to translating. She lives in an eccentric floor-through apartment on the quai Voltaire with a view of the Louvre out one window, an eighteenth-century courtyard out the other. It's so much better to be in Paris than in the

provinces! She's proud to be the exclusive translator of the charmingly enigmatic Graham Greene. She's been a member of Sylvia Beach's lending library on the rue de l'Odéon since she lived in Toulon, and now she's only a few minutes' walk away. Before the war, Sylvia connected her to the American writer Katherine Anne Porter, whose work she champions. Katherine Anne sends her regular supplies of coffee and soap and chocolate powder, and their epistolary friendship is growing more and more intense. Marcelle knows everyone who matters in Paris, but she loves her solitude, the hours spent bending over English novels, recreating them in French. She shares her life with two parakeets, green and yellow, and as she looks at the bright paintings lining the walls of the gallery, she tells herself that when the fuss dies down, she'll spend a day with Marguerite's little Baya, and that her birds will give them plenty to talk about.

MARCELLE SIBON GETS to the rue de Téhéran as soon as the doors open. She glances at her watch; she needs to be home before long to prepare dinner for her guests. Enter McEwen, ever the hunter, a smile frozen on his face. Nothing can soften that hawkish profile. He turns her way. A quick hello. He approaches Baya, asking in a stage whisper how Marguerite is doing. Baya, too, will write Marguerite to report that Frank came to the opening, that he came alone and asked after her. At fifteen going on sixteen, she knows a lot, already, about abandonment and heartbreak.

Margot will be fine, of course; she is strong and determined if always a bit nervous. But between Toulon and Algiers, she remains a provincial, and provincialism is dangerous. Taking on sociological airs, Marcelle writes to her friend after her dinner guests have gone home, dispensing wisdom. She knows Paris; she knows the world of literature, journalism and the arts; she knows gallery owners. Any scandal that can contribute to publicity is good enough for them. If they thought it would sell paintings to say that Marguerite's little girl had grown up in a whorehouse, they would.

She can reassure her: those lies are the only danger Baya faces in

Paris. But Marcelle is persuaded that there is no real danger because Baya doesn't take the tall tales seriously: "She told me, giggling, that they made her talk on the radio: 'They made me sing a little song' . . . and I could feel in her voice, and from the look she gave me, something that seemed to mean 'how little it takes to amuse them.'" Marcelle stood by Baya's side as the journalists pounded the young artist with questions. She's appalled by the lack of respect they showed. She reports Baya's strategic "I don't knows." She's excited by what she has seen on the walls of the Maeght Gallery: images of her friend! "As I walked around the gallery, faced with Baya's astonishing creations, I came face to face with you, everywhere. I don't mean that I see your own paintings in hers, rather that, for anyone who knew your childhood, there is, let's say, an encounter that is not merely accidental. Those greens and those blues are yours. And that smooth face, the immense eyes, the lips so precisely drawn, that is your face. Not to mention your mane of hair."

Marcelle is right. If Marguerite had been there, people would have noticed immediately. The "immense" eyes—the sign of her chronic thyroid condition—the red lips, and the thick reddish hair in so many of Baya's earliest paintings can't be anyone else's. In Baya's work from the mid-1940s leading up to the Maeght show, she paints two kinds of eyes. For her birth family, angular almond eyes, stylized, the eyes that become her trademark in independent Algeria. For her adoptive family, rounder eyes and cupid lips. And for those in the know, two recognizable, iconic figures appear and reappear: Mireille with her black hair and red lips, often painted lying down, and Marguerite, queenly, upright, with a flock of red or blue hair or wearing enormous pillbox hats that grow to the size of a crown. Marcelle imagines she would hate being exposed. It's as likely that when Marguerite read the letter from her old friend, she felt acknowledged and wistful and regretted she hadn't come to the opening.

Don't be too hard on the Maeghts, Marcelle tells Marguerite, yet she predicts that Baya will not profit from the sale of her art.

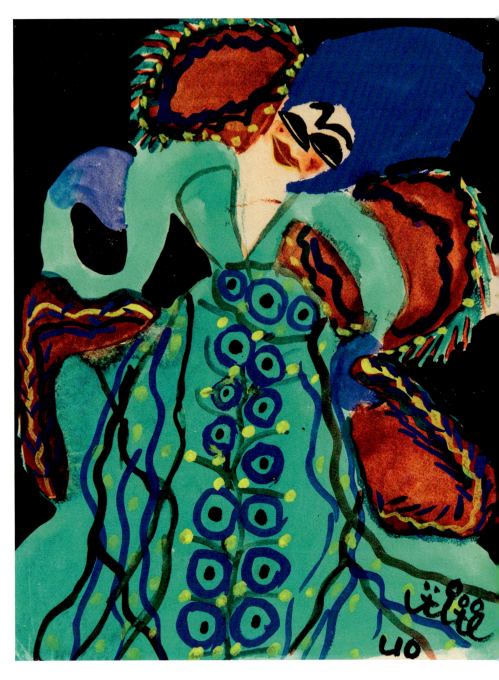

FIGURE 21: *Femme aux cheveux bleus* [Woman with blue hair] (n.d.). By permission of the Children of Baya Mahieddine. Photograph: © 2024 Maeght.

All the gallery owners (without counting all the editors) use this power. The best among them, and I mean the best, would recount the worst horrors about their own mother, if it could help their publicity. Not consciously—I was disgusted at first, of course, but by now I've decided that it doesn't matter. All those stories pass by, like on the walls—one publicity poster covered by the next. And Baya's art will merrily survive, though Maeght will have made money . . . I continue to believe that this exhibition will not bring much, neither to the little one, nor to her family.

What Parisian hasn't watched a worker with his bucket of glue stand on a ladder resting against the wall of a Paris metro station, slapping giant pieces of a new advertisement over the old one, smoothing it out with his wand? Sibon's metaphor for publicity still works in the age of Twitter: flash after flash of information, immediately replaced by the next.

Even if she concludes that the idiotic publicity will do no harm, Marcelle leaves Marguerite with the notion of a discouraging bottom line. Baya will triumph in Paris, and at the same time, if Marcelle and Nelly are right, she will not triumph financially. Marcelle Sibon doesn't know, or doesn't mention, the longer story. Baya has no mother or father, only a grandmother from whom she's been legally emancipated. That emancipation and the fact that she is still a minor mean that her guardians are in charge of any money she makes.

MARCELLE AND NELLY are of one mind. They beg Marguerite to come up to Paris, fight back against the press, defend Baya's interest with the Maeghts. No one could have predicted a future in which Marguerite would eventually move to Paris, marry an Algerian Muslim and work as an archivist for the Maeght Gallery. For now she is staying in the shadows, caring for Baya at a distance, making social connections, never taking credit as her mentor. Yet she's everywhere, a figure on the gallery walls.

15

"Magnificent, but in rags"

MARGUERITE HAS TENDED to every aspect of Baya's journey, confident that her protégée will be perfect in word and deed. Sincere to a fault, naive, trusting, she's shocked and angry when her efforts to convey Baya's tragic childhood backfire.

Baya arrived in Paris on November 10, and as soon as her plane touched down, the ink began to spill. René Guilly filed a front-page article for *Combat*, whose headline sets the tone for the articles to follow: "Baya, the granddaughter of a witch." "Baya, standing tall in her beautiful embroidered clothes, exited the airplane at Bourget field. She came straight from her little village in Kabylia, 60 kilometers from Algiers, which she was leaving for the first time. She is 14. We asked her what she thought about her plane ride: she thought nothing. Nothing special about an airplane. The smallest creature in the universe where Baya lives is infinitely more interesting." Only she wasn't coming straight from a village in Kabylia, she hadn't been in Dellys since her mother died when she was nine. The beautiful embroidered outfit she wore on the plane was not from Kabylia; her *karakou* was made for her in the style of Algiers. Baya lived with Marguerite in the commercial center of the city. As for her being unimpressed by her airplane ride, how would he know?

Celebrity journalism, private-life scoops, are beginning to dominate the press after the life-or-death commitments of journalism during the Nazi occupation. Guilly covered Parisian art and culture for *Combat*. He was an ambitious twenty-six-year-old. One day he'd

FIGURE 22: "Baya, granddaughter of a witch, has astonished the greatest French painters." From a front-page article in *Combat*, November 14, 1947. Photograph: Bibliothèque nationale de France.

become the chief curator of the Museums of France and a full professor at the École du Louvre. But not yet. His newspaper isn't Camus's *Combat*, that clarion of the Resistance, but a degraded *Combat* that would soon fall under the direction of businessman Henri Smadja, so stingy that his employees gave him the nickname "the fear of wages"—a play on the title of the popular movie *The Wages of Fear*. With the Liberation, Camus and his team of writers vowed that the spirit of the Resistance would transform civil society. By 1947 reality had set in. The provisional government had given way to the Fourth Republic, charged with economic recovery and the defense of an empire heading toward failure. Camus sounded the alarm in 1939 in his series of articles on poverty in Kabylia, warning the French they would lose Algeria unless they woke up to the conditions they were

"Magnificent, but in rags" | 93

perpetuating. The title of one of those articles was "Greece in Rags": now Guilly was dressing Baya in those rags, better to elevate her to glory in Paris.

> In 1943, an English painter and his wife set up house in a small village in Kabylia. Children came constantly to beg for a piece of bread. On their doorstep sat a ten-year-old girl, magnificent, but in rags. She never begged but stayed there from morning until evening. Her name was Baya. Her father and her mother, a woman of the street, were dead. Her grandmother exercised the awesome profession of witchcraft, trading in philters, spells, voodoo, and exorcisms.
>
> One day, the painter and his wife left for Algiers. When they returned the next day, they found all the walls of the house covered in mysterious and bold colors: Baya had discovered the paint box. They gave her paper: she began to create watercolors, astonishingly inventive in form and color.

"It's all wrong" Marguerite wrote in red pen on a list of rectifications of this article and many others, "wrong, wrong, wrong!"

Soon the lies in Guilly's article mushroomed. In *Elle*, a new magazine and the success story of the postwar feminine press, Guilly's themes were reshuffled with new dialogues, a different tone, and a change of venue from Kabylia to the Casbah in Algiers. Abuse of dialogue, of place and detail: every kind of fantasy was on display. The long article is worth quoting at length, if only to marvel at the extent of the distortions:

> The story begins in 1942, in Algiers. The Allies have landed; a French woman, Marguerite Carmina [sic], press secretary for the American army, sets up her office in the Casbah. With every step a swarm of children surrounds her, screaming and begging. Only one little girl says nothing, she holds out her hand.
>
> —Where do you live, little girl?
>
> The child leads her to a miserable hovel, where an old lady greets them by spitting and kicking.

Horrified, the French woman brings the child to her home. One day, as she returns to the house, she finds the walls decorated with strange forms and colors.

—Baya, where did you learn to draw. . . .

Baya has never learned anything, not even French, which she barely speaks. Nonetheless, little by little, she tells her story.

—My grandmother is a witch in the village of Fort-de-l'Eau. She beat me with an iron rod. When I was five, I ran away and hid with my mother in the Casbah. Mother was very ill. One night, she went to sleep. I stayed three days by her side, she was still sleeping. Some men came and took me away. I never saw Maman again. Now I know I never will. I had to return to my grandmother's.

Marguerite Carmina gave the little girl a lovely box of paints and papers.

—Draw whatever you want and have fun.

Baya draws and has fun. Some Roumis (Europeans) come to see her. There is a lovely lady with two little boys, it's Madame Paul Auriol.

"Baya has never learned anything": the prodigy is reduced to an *idiot savant*. At the same time, she's said to have boasted that she had the same witchcraft powers as her grandmother. *Elle* puts words in her mouth:

Baya models "sweet statuettes."

—Whenever someone is mean, I make a mean statuette, I pierce the eyes. The person feels it, I assure you.

This fall, in North Africa, the owner of the Maeght Gallery sees an extraordinary painter at a friend's house.

—It's Baya, he's told, a fourteen-year-old child who has never taken a single painting lesson. Monsieur Maeght assembles the paintings to exhibit them in Paris.

He obtains the authorization of the Committee for the Protection of Minors to bring Baya to Paris.

Baya is here with her Kabyle dresses and her stories of witches.

But she only makes friendly statuettes. And in a few months, she will leave for America.

Baya is clay, squashed and shaped into a legend. She emerges from a swarm of screaming beggars. She finds a box of paint and covers the walls with images. She's a witch, her grandmother is a witch. Her mother was a streetwalker, "a public woman," the greatest possible insult in Algerian society. She ate with dogs, slept with goats. She can barely speak, though she is able to tell this shocking story. And what in the world is Jacqueline Auriol doing in this story?

It took Marguerite Caminat many months to earn Baya's trust, and when at last the girl began to talk, whispering the stories of her childhood, Marguerite lovingly transcribed them. She had no training in oral history, but she had always been a passionate listener. She encouraged Baya to tell her what really happened in her family, and she encouraged her flights of fancy, her version of the legends for which Kabylia was famous. The tales and the stories of childhood blended, until Baya's childhood confessions began to resemble fairy tales. Amazed by Baya's courage and by the particular charm of her descriptions, Marguerite repeated the stories to her entourage, to the artists and writers in her circle of friends, to Frank McEwen, and to Maeght. There's no press release in the archive that can tell us exactly what information the press had to work with, but it's easy to imagine.

And there's nothing to tell me, as I contemplate these signs and wonders, which fantasies had a basis in a truly different kind of knowledge, no way to measure the role of willful charm and seduction in the stories Baya dictated to Marguerite. Xavier Le Clerc, a French writer born Hamid Ait Taleb, remembers his Kabyle father telling him a story about a beloved bird in the woods. The bird became a companion to whom his father pledged lifelong friendship. "His story seemed like a Berber tale, and when I was a child, listening carefully to my father, I could perceive a hazy border between magic and his memories. Enchantment had allowed him to

survive—unless he had invented it to appease me." Every bird in every one of Baya's paintings carries enchantment. And aren't we as eager today as Marguerite Caminat was in 1947 to find an alternative to our stale ways of knowing?

Marguerite receives Baya's press from a service, "L'Argus de la Presse," and carefully files each review of the show. She makes lists of lies and rectifications.

"She can't read or write": she can.

"She paints the walls": never, never, never.

"She casts evil spells": completely wrong.

"She punished her enemies with a needle": wrong again.

"Baya doesn't know what art is": this is a pack of lies.

And to the most absurd comment of all, "eating with dogs, sleeping with goats": false.

This last distortion is easy to trace. Maeght learned on his first visit to the rue d'Isly that Baya loved to paint and make up stories in the spirit of her paintings. He asked Marguerite to send a few of them for the exhibition. He includes Baya's *Le grand zoiseau* in *Derrière le miroir*. Baya creates a world where animals are capable of the most vengeful violence; where one woman smashes a plate in awe of the beauty of another woman; where a dog drinks an entire river and a husband throws his wife into a pot of boiling water. All in the course of two pages. The girl in *Le grand zoiseau* lives with a woman who mistreats her: "And this little girl was always unhappy in this lady's house, for she ate with the dogs and she slept with the goats . . ." The journalist who wrote that Baya "ate with dogs" had merely lifted the sentence from *Le grand zoiseau* and applied it to Baya's real life.

Edmonde Charles-Roux, writing several decades later, will remember Baya's aura: "She seemed to me like a mythical character, half-girl, half-bird, escaped from one of her paintings or one of her fairy tales of which she had the secret and which came from who knows where." This vision of Baya as half-girl, half-bird, emerging from one of her paintings, or from the legend that Maeght included in his exhibition catalog, took hold, until, as Charles-Roux says,

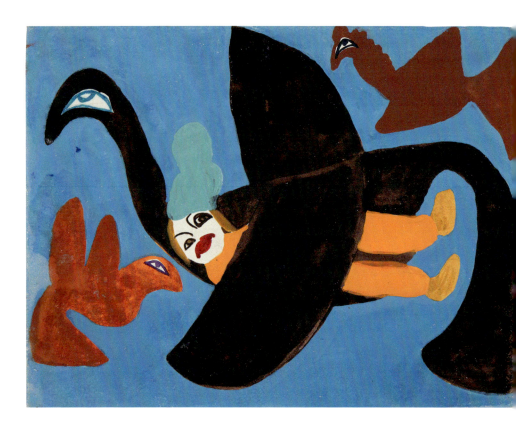

FIGURE 23: *Le grand oiseau, conte no. 9* [The big bird, tale no. 9] (1947). One of Baya's illustrations from her series of Berber tales, commissioned by Aimé Maeght, but never published. By permission of the Children of Baya Mahieddine. Aix-en-Provence, Archives nationales d'outre-mer. Photograph: © Children of Baya Mahieddine.

"Baya was one with her work." She became a living statue, a moving, breathing folk tale.

Peyrissac, in his essay for the catalog, synthesizes episodes from Marguerite's earliest notes on Baya's life in a mix of horror story and fairy tale: "Baya, fragile and transparent, draws water from the well, lights the fire, tends the sheep barefoot in the snow. Shadowy stories, stories of implacable, mute men, stories of sorceresses, of murderous spells, of theft, of gambling dens and bloody brawls, headlong pursuits in the night by the intrepid diabolical old witch,

terrified of her own people and of the police. But Baya is always protected by [divine] providence . . ."

A sorceress grandmother, a prostitute mother, a box of paints in Kabylia or in the Casbah. What is dark and vulnerable in Baya's own account is easily harnessed by the journalists, and to a nobler extent by Peyrissac, to create a character. Marguerite learns from the newspapers that Baya's childhood can be twisted with contempt, mockery, exoticism, always for the same purpose: titillation and publicity. In their letters to Marguerite in Algiers, Nelly Marez-Darley, Marcelle Sibon, and Rosita Wertheimer are outraged by the articles they read; they assume that the fantastic tales of Baya's childhood were invented whole cloth. Nelly ventures it's a good thing Baya can't read (she's wrong about that); Marcelle says the press is shameful. Rosita Wertheimer believes she's found the source of the lies. She writes to Marguerite, "The many articles that have appeared with photos say things that are idiotic and inexact. I said so to Maeght, who must surely be paying them but who says they're inspired by McEwen! A pack of lies, meant to beat the drums and that only imbeciles must read."

McEwen might well have contributed to the word of mouth. But the problem is larger than the bad faith of one man. Marguerite has written about her adopted daughter, "There are also numerous visions, apparitions in Baya's childhood." She believes that Baya has access to a reality that exceeded hers, a magical reality. She's fascinated and moved by every story Baya tells her in the intimacy of their apartment. She respects her difference. And then comes success. The fairy tales are part of the appeal. Would Maeght have invited her to Paris without them? The marketing of Baya's exoticism works all too well. The press, like the Grand Zoiseau of Baya's story, gobbles up what Marguerite holds most dear about her child and spits it back.

16

Who Is Speaking? (Part II)

BOTH MADAME WERTHEIMER and Madame Maeght are happy to write to Marguerite in Baya's first person, in a language that sounds mostly like theirs, with occasional flashes of Baya's joie de vivre, her sense of humor. The letters start "Chère Marguerite." Sometimes Baya adds her signature and a flower or decorates the margins of the paper with multicolored designs. There are letters to Marguerite from "Baya" in Rosita Wertheimer's hand and in Guiguite Maeght's hand.

Baya reports in Madame Maeght's hand that the opening will be Friday. That she's being photographed for the newspapers. She visited the Paris Museum of Modern Art and prefers the Matisses to all the rest. She's met Breton and Braque, who compliment her about her work. She's going to see Si Kaddour Ben Ghabrit at the mosque. He'll be at the opening, as will Madame Auriol and her grandchildren, to whom she's supposed to give one of her paintings. Monsieur André Breton has written a text for her catalog. She's going to speak and sing on the radio on Wednesday; the show, called *Arts and Letters*, will be broadcast Friday at 10:45 a.m. She's happy in Paris though it rains all the time, the houses are black and the sky is always gray, the sun "all golden with leaves." Everyone likes her outfits. At Monsieur Maeght's there's a little boy, Bernard, whom she likes very

FIGURE 24: An example of Baya's decorations in the margins of her letters to Marguerite Caminat. By permission of the Children of Baya Mahieddine. Aix-en-Provence, Archives nationales d'outre-mer. Photograph: © Children of Baya Mahieddine.

much and with whom she has fun. She takes note of opinions, offers subtle commentary: "Nelly likes my golden costume a lot." "Madame Wertheimer is nice, Monsieur and Madame Maeght are very nice, they're coming to get me." The distinction between "nice" and "very nice" shows how little she can reveal through dictated letters.

On November 21, Aimé Maeght wires Marguerite: "Today the vernissage was a total success. Listen to Baya on the national radio at 10h15. Amitiés, MAEGHT."

Madame Maeght sends to Marguerite what is meant to be Baya's own account of the opening:

> *Dearest Marguerite,*
>
> *My opening was even more extraordinary than anything we imagined, there were a lot of very chic people, Si Kaddour Ben Ghabrit came with Monsieur Chataigneau [governor general of Algeria], then all the Parisians, the artists, Mr. Frank [McEwen] came, he*

Who Is Speaking? (Part II) | 101

> said "Bonjour Baya," he asked for news of Marguerite, he came alone and congratulated me, the newsreels filmed us, it will be shown as of next Thursday, in all the movie houses that show "éclair journal," they took a huge number of photos, I'll bring some back to Algiers, they photographed me in color in all my costumes for a five-page article in Vogue that they'll send us. Monsieur Maeght sold twenty of my drawings. I see a little more of Paris every day, the bird market, and all of that is very beautiful. M. Maeght is leaving for America but I'll stay with Madame Maeght whom I like a lot and I have a lot of fun with Bernard. Monsieur Maeght will return very soon. André Breton, Monsieur Braque came, there's a guest book that everyone signed and I'll bring it. I'm doing fine and it's not at all cold.

Young Adrien Maeght, "Dédé," writes the next paragraph in Baya's first person:

> I'm happy, I go out every day and Thursday I went to the ballet on the Champs Elysees, I liked it a lot. I took the metro. Many photographers took pictures of me, and they are all annoying. Friday I spoke and sang on the radio, I hope you heard me and that you liked it. I'll leave you now because it's late and I need to go back to Madame Wertheimer's. Hugs and kisses to you and also to Mireille.

Then Guiguite Maeght comments:

> PS. my son will finish Baya's letter. I'll send you a long letter tomorrow, we've been completely overwhelmed.
>
> I really do love Baya, she's a darling child. Amitiés.

Impatient with photographers and famous artists flattering her, Baya finds two friends—the Maeghts' sons, teenager Dédé (Adrien) who helps with her letters, and his little brother Bernard, five years old, the sweet child who in five years would succumb to leukemia. Bernard teases Baya, showers her with affection.

The newsreel where she's featured is showing in the Paris movie houses. Marguerite is able to see the same newsreel in Algiers that Baya saw in Paris a few days after the opening. Baya was struck by this world in which you can see your Wednesday self on Friday: "I'll find it very strange to see myself later." The newsreel passes quickly over black-and-white closeups of the paintings of birds and women and vegetation, the clay creatures Marguerite sent to Paris, with brief sequences of the crowd at the opening—Baya flanked by Chataigneau and Ben Ghabrit and, for a second, we can barely perceive a younger man with black hair, hidden behind another body. The film cuts to Baya's paintings and then to Baya, dressed in her burgundy silk velvet tunic, leaning over a canvas. The camera zeroes in precisely on her brush, her black curving line. The newsreel ends with the young artist turning one cheek to the camera with a smile in which it's tempting to read an air of amused triumph.

Baya's hosts do their utmost to introduce her to the cultural life of Paris. She misses Marguerite, misses going to the theater with her, but she goes to a play with Madame Maeght, wearing her violet dress. Leaving the theater, they happen upon a street fair. They fish for plastic ducks and Baya wins one, though it breaks when she gets back to the house. Guiguite Maeght writes home in Baya's voice about Saint Catherine's Day. For Baya, this French Catholic Saint's Day when unmarried women over twenty-five don a special hat and pray for a husband seems funny and also bizarre. She's amused when she's mistaken for a "Catherinette" in her velvet dress. Madame Maeght takes her to see the lovely mannequins at Christian Dior's. And in the middle of her own dictated story, Guiguite adds, in her own voice, "she was the prettiest in her violet dress." Everyone has their favorite costume: if Nelly likes the gold, Monsieur and Madame Maeght prefer the violet, and André Breton the white desert costume. In a December letter, at the end of Baya's Paris stay, Rosita Wertheimer makes a fashion prediction: Baya's outfits have created such a sensation that Parisian fashion in the coming years will surely be inspired, especially after the photographs taken by *Vogue*. She predicts—tongue in cheek?—that birds and butterflies will soon

FIGURE 25: Baya Mahieddine standing in her striped velvet dress, holding her gray beast statuette (1947). Photograph: © 2024 by André Ostier / Association des amis d'André Ostier.

appear on Parisian dresses, under the influence of Baya's sumptuous colors and the tasteful way she paints women's dresses. *Le Monde* also predicts that Baya's painting will inspire fabric designers and suggests that the charm of Baya's colors alone is a tonic for the morose youth of the day. For nearly every idealization of Baya, there's a corresponding debasement. Journalist Robert Charroux twists the same fashion prediction, reducing the artist to a laborer of the low-

est caste: "The Prodigal Child Baya (Sorcerer): the little untouchable will probably design clothes and sketch fashion plates for Christian Dior."

An unsuspecting influence on high fashion, Baya is still working as a cook and housekeeper. She helps the servant at the Wertheimers', tired out by a pregnancy. She makes a *blanquette de veau* for the Maeghts but complains to Marguerite that it turned out too watery. She helps at the office, but Maeght's secretary Hélène makes sure she doesn't work too hard.

That week, Albert Camus sends a charming letter to Cadi Benhoura. He writes that Baya is in very good hands and that the success of her exhibition is richly deserved. As always, he feels the emotion of the situation, sums up mood and character with brilliant concision, expressing, in a few lines, the fear in the air in Paris, the miracle of Baya's work, her dignity:

> *Dear Friend,*
>
> *Baya is in very good hands. Her exhibition is a success and a well-deserved one. I greatly admired a kind of miracle to which each of her works attests. In this black, frightened Paris, this is a joy for the eyes and the heart. I also admired the dignity she maintained in the crowd at the opening: she was the princess among the barbarians.*
>
> *I thank you in any case for having allowed me to know her. For the rest, you need not worry.*
>
> *Faithfully yours, Albert Camus*

"She was the princess among the barbarians": It's the best one-liner of the 1947 show. As he so often did when describing the absurdity of colonial prejudice, Camus reversed the terms, although the switch between the barbarians and the princess only emphasizes what he knows to be true: Baya is performing for *le tout Paris*.

Inspired by Camus's reassurance, Cadi Benhoura sends Baya his

congratulations on the official letterhead of the Office of Muslim Charities:

> NOVEMBER 28, 1947
>
> *My dear Baya*
>
> *We are all very happy with your success. Personally, I am proud of you and of the way you have behaved among the visitors who came to admire your exhibition. I know that you followed Madame McEwen's recommendations. You have shown that a little Muslim girl who behaves, inspires affection in the men and women who surround her, like Madame Maeght and Madame Wertheimer who consider you their own little girl because you have been well behaved and discreet, as always.*
>
> *You will thank them for all the care they've given you and you will tell them that the Muslim women of Algiers and elsewhere will never forget what they have done for you, the little Muslim girl.*
>
> *We await your return to celebrate and congratulate you as you deserve.*
>
> *Children and grownups send their greetings. Benhoura.*

Baya is graded with every step she makes, expected to represent her people through her posture, her nails, the way she holds herself at the dinner table. A token, charged with burnishing the image of all the Muslim girls of Algiers. She's earned a straight-A in behavior for the entire time she's in Paris. As a child she was beaten and bruised; now she is constantly on display. Camus wielded his irony with great aplomb, telling Benhoura that it was the French socialites at the gallery who were the savages, and Baya the princess. But Benhoura can't indulge in irony. He's an earnest colonial official, defending the dignity of Algerian Muslims. He knows what's at stake for French-Muslim relations in 1947: his people need Baya's genius.

MARGUERITE WORRIES THAT Baya is in danger on the streets of Paris, but in fact the true danger comes from the surveillance, from the pressure, from her meteoric success. Few people can survive a success such as the one Baya experienced in Paris in 1947. Camus knew something about the problem. Again and again, Baya's hosts write that she is a love of a child, that she takes everything in stride. She has access to a zone of freedom in her practice of art, and a combination of skill and imagination allows her to express the depth of her sorrow and joy through painting. With this access—the true magic in her life—the opinion of others doesn't matter. She fills her gouaches with the family she lost, with her new mother (Marguerite) and her almost sister (Mireille), with unborn children. She chooses, with each painting, to represent the world she was born into, or to portray the *Roumis*, the Europeans, in her new French world.

IN EARLY DECEMBER, Aimé Maeght travels to the United States on the Holland Line, leaving his wife to look after Baya. Rumors circulate in Paris that he is going to place Baya's work with a New York gallery or find a publisher for the illustrated Berber tales; he lists his profession on the ship's log as "publisher."

The waves are slapping against the ship, and he's fighting nausea as he writes Marguerite with plans for Baya's future, expressing his intention to consolidate their business arrangement:

> Forgive my handwriting and my style, the weather is terrible and I'm a little seasick and everything is falling off the table, everything is swaying like crazy. But we are happy with the result of the sales, which my wife will report to you, and the accounts will be given to Baya for her return. I will send you a check for the balance. Since I haven't designed this exhibition to make a profit, I may not recover the expenses I've incurred, not this time; perhaps you ought to assure me by return mail that I have exclusive rights to her work.

Maeght sums up Baya's Paris activities: she's been to the Louvre, to the Paris Museum of Modern Art; to Notre-Dame and the Bois

FIGURE 26: *Femme debout et femme couchée* [Woman standing and woman lying down] (ca. 1947). By permission of the Children of Baya Mahieddine. Villeneuve d'Ascq, Lille Métropole musée d'art moderne, d'art contemporain et d'art brut, donation de L'Aracine en 1999. Photograph: © Nicolas Dewitte / LaM.

de Boulogne. Her favorite spot of all is the bird market; they've reserved two exotic "red and black" birds for her to bring back to Algiers. He tells her that the day he left for America, Baya wanted to work. He bought her papers and brushes and gouache paint. "We left her extremely free to do what she wants and even to do nothing at all." He declares his hopes for the future. Baya has only to pursue her "graphic dream" under Marguerite's attentive and generous wing so she can progress in her art. He is sorry that Algiers is so far from Paris, where he could more easily help her achieve her artistic destiny. "Count on my help," he writes, "Baya deserves all the attention we give her, her interior richness is great and authentic; she can overcome her crisis of 'adulthood,' I wish it for her with all my heart."

The "adult" crisis he refers to is a mystery, other than what we know from Rosita Wertheimer: Baya has reached womanhood. Like a ballet dancer whose body is no longer sylphlike, or a boy treble whose voice has changed, her genius is threatened by adulthood— but only if you believe men like Frank McEwen or the critic André Chastel, who describes her entry into the art world by way of the Maeght Gallery as "gratuitous, unexpected and doubtless with no future," and adds, in an evaluation whose logic escapes me: "instinct takes the same route [in Baya's art] as does exact science in Matisse."

But Maeght doesn't think that Baya is an "accidental" Matisse. He recognizes her internal strength, her authenticity. He thanks Marguerite on behalf of art itself.

Then there's the question of profit, a source of worry and doubt for Marcelle Sibon, who suspects the motives of everyone in the culture business, and for Nelly Marez-Darley, who's never met an art dealer she can trust. Marguerite trusted the Maeghts from the beginning. They send lists of the buyers and the prices paid. Claude Staron, the fabric king, buys thirteen paintings—and offers Baya five meters of his best cloth for a dress. Maeght takes a commission of fifty percent for every painting sold. So when the buyer listed as "Mme Guggenheim" buys *Woman with Yellow Vase between the Curtains* for 15,000 old francs, Baya is meant to receive 7,500.

After the expenses of the show are paid, Maeght sends Marguerite two money orders for 100,000.00 francs each with 60,000 francs more promised after the recalcitrant buyers pay up. My best guess is that Marguerite was obligated to give the money to Baya's legal guardian, the Caïd Chanderli. In 1947 a married French woman (Marguerite was still married to Frank) could not sign a check, but she did have the right to deposit money or spend money in the interests of her household (buying furniture, paying rent, and so on). Did Marguerite think about cashing the money orders and giving Baya a purse filled with francs? I spend an afternoon in Algiers in conversation with Baya's son and daughter-in-law, trying to make sense of what happened. A note in Marguerite's chronology of Baya's career says that in December 1961, Baya calls Marguerite from the Farges farm, asking for Chanderli to disburse her earnings. And on May 24, 1962, Baya writes to Marguerite thanking her profusely for the money she has finally gotten from Chanderli. Fourteen years after the Maeght show, he gave Baya a check for 200,000 plus 30,000 francs—with no interest.

I DREAM, TOO, about following one of Baya's paintings, finding a chain of sales and inheritances from 1947 to today and tracking the prices, to see how the value of her art has accrued. In art historical terms, 1947 is not so long ago, and many of the paintings from the Maeght show remain with the Maeghts or with Marguerite Caminat's family or with Baya's children. Jean Peyrissac's grandchildren treasure the Baya paintings he left them. They know the story of their grandfather's support of Baya and the role he played in bringing her work to Paris.

We're only two generations removed from Baya's contemporaries. Maeght sent Marguerite a list of the people who bought paintings at the 1947 show, many of them prominent, and so I began to look for their children, their grandchildren. One constant: Baya didn't give titles to her art; dealers and collectors always named them for her. Since the themes repeat, the titles sound alike: women in

yellow dresses, women with blue hair, three women and an orange tree, two women at the table, woman with pitcher, woman with peacock. The painting listed on Maeght's sales account as *Woman with a Yellow Vase between the Curtains*, under the name "Mme Guggenheim" is not the same as the 1947 painting at the Institut du monde arabe called *The Yellow Curtains*. The Guggenheim archive in Venice has no record of a Baya having ever been owned by Peggy Guggenheim. There were surely other Madame Guggenheims buying art in Paris in 1947, but how to find their families? Or did Guggenheim acquire *Woman with a Yellow Vase between the Curtains* on behalf of the modernist collectors Monsieur and Madame Deltcheff, whose names appear on another list as buyers of that same painting? Then there was the landscape painting and the statuette given to Vincent Auriol's grandchildren, Jean-Paul and Jean-Claude, both deceased. Their children, Auriol's great-grandchildren, have never heard of the gifts; nor were the works absorbed into the official warehouse of presidential gifts. The thirteen paintings purchased by Monsieur Claude Staron of Staron fabrics appear from a passing remark in Marguerite Maeght's letter to have gone directly to Christian Dior to inspire his designs. So I write to the Dior archive to see if there is correspondence between Claude Staron and Christian Dior about Dior's May 1948 exhibition. Or if, by some miracle, the Baya paintings went to the house of Dior. The head archivist for Dior answers. There is no record of a correspondence between Christian Dior and Claude Staron. There are no Baya paintings in their collection.

Once in a while I get lucky: in the Drouot auction gazette for December 2022, I come across a painting titled *Woman and Vegetation*, dated 1943–45, with the provenance noted: *Woman and Vegetation* was acquired by the artist Nelly Marez-Darley when she was a refugee in Algiers and sold by her heir in December 2022. The same Nelly who wrote to Marguerite, distressed about the diabolical Frank and his "sidekick." The auction house notes pinholes in the corner of the painting, and signs of wetness. The online photo strikes me as a formidable likeness of Marguerite, and I remember Marcelle Sibon's

words, "that smooth face, the immense eyes, the lips so precisely drawn.... That mane of hair." The pinholes give away the pre-1947 date: in 1943, 1944, 1945, Baya wasn't yet an exhibited artist, she was painting on large sheets of paper in Marguerite's flat. It would have been natural for Marguerite, or for Nelly, to pin her gouaches on the walls, the way parents display their children's art. Baya's gouaches weren't part of the art market yet.

I had given up on ever tracing another painting back to Baya's years with Marguerite when the online record of a Holocaust restitution of the Nazi-seized bank accounts belonging to the family of René and Rosita Wertheimer led me to a law firm and then to the familiar names of the Wertheimer children. Then, luckier still, I found Agnès Wertheimer, the designated family historian, one of Rosita and René's eight grandchildren. Agnès told me the story of her father's years in Algeria, first on the Farges farm, then as an agronomic engineer in Biskra and Kabylia, then in Algiers, where he worked as an expert while his wife collected crafts in Kabylia. They left Algeria in 1964.

Through all the family's moves, the Wertheimers never parted with Baya's painting, which now hangs in Agnès's apartment. The children have always loved it, without knowing much about the painter. Agnès sends me an iPhone photo, and I discover what looks like a watercolor in blues and greens with all of Baya's core elements: mother, bird, bush, and child.

Agnès grew up with this painting from earliest childhood the way I grew up with Franz Marc's *The Large Blue Horses*, only her painting wasn't in a museum; it was at home, part of her everyday life. The power of those blues and greens and purples, both soothing and commanding! "It looks a little like a Matisse," she told me the first time she mentioned it on the phone; it wasn't signed, but she knows it's a Baya. Her parents always treasured the painting as an emblem of their years in Algeria. The gouache is under glass and she doesn't dare remove the frame for fear of damaging the paper, so I may have to make do here with a description: a European woman's face, half-moon eyes and kewpie-doll lips, wearing a purple hat

FIGURE 27: *Femme et végétations* [Woman and vegetation] (1945). By permission of the Children of Baya Mahieddine. Acquired by Nelly Marez-Darley in Algiers in 1945. Private collection. Photograph: Diana Darley.

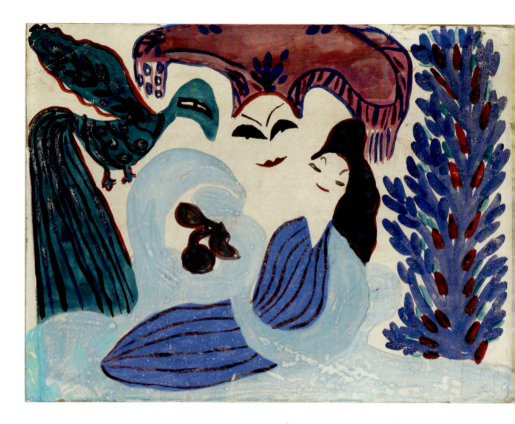

FIGURE 28: *Femme avec chapeau mauve* [Woman with purple hat] (n.d.). By permission of the Children of Baya Mahieddine. Photograph: © Collection Agnès Wertheimer. Photography by Alberto Ricci.

as big as a lampshade, with fringes. To the left, a bird stares at the woman and a happy child, her black hair flowing, an odalisque with a blue striped dress that looks like a sleeping bag. Is the girl inspired by Mireille, or by Baya herself, or is she a fusion of the two young girls? Around them is a foamy blue wash that might suggest a wave, or a flowing river, and to the right, a stylized bush in several colors, the same design Baya uses to decorate the margins of the letters she sends home to Marguerite in 1947. The painting makes me realize that none of Baya's female figures have visible legs; this one is cocooned. And I imagine Marcel Wertheimer, living with Baya's gift as his wounded leg heals.

114 | *Chapter Sixteen*

17

Photographs and Fabric

AIMÉ MAEGHT HAD LEFT nothing to chance. As soon as she landed in Paris, Baya had to endure the sigh of flashbulbs and the insatiable curiosity of journalists alerted to her presence.

The photographers, in particular, seemed never to leave her side. Guiguite Maeght praised Baya for her patience with them. Baya wrote to Marguerite to say how annoying they were. The photographers were irritating, but some of those photos, Rosita Wertheimer reported to Marguerite, were truly beautiful.

Maeght had arranged for the two great fashion photographers on the Paris scene, André Ostier and Willy Maywald, to come to the rue de Téhéran and take pictures of the artist, posing dutifully with her paintings and sculptures. Ostier's best-known photograph of Baya shows her wearing her striped velvet dress and holding her favorite "Gray Beast" statuette. Ostier was known for his work with Christian Dior and for his celebrity portraits of actors and artists. Less known is a genre he pursued throughout his career that most likely began with Baya that November: he invited Picasso, Chagall, and Dalí, among other important painters, to decorate his portraits of them. Willy Maywald happened to arrive at the gallery in time to capture Baya, dressed in white, in the act of painting the matboard around Ostier's photo.

Maywald captures the artist at work, her palette by her side, her paint tubes squeezed nearly empty. With playful confidence, she fills the space with her characteristic figures and colors: the bird, looking

FIGURE 29: Willy Maywald's photograph of Baya signing and decorating the mat of André Ostier's photographic portrait of her at the Maeght Gallery (1947). Photograph: © 2024 Association Willy Maywald / Artists Rights Society, New York / ADAGP, Paris. Photography by Charles Maze Photographe.

out in profile, its thick tail filled with designs; the vertical foliage. The whimsy, the sense of rhythm and movement she conveys, dwarf the photo itself. It's a powerful gesture: she's reappropriating her own publicity, emblazoning her image. The work is unknown, relegated to the photographer's private collection, and this is a shame. Maywald and Ostier's portraits of Baya, on the other hand, were made available to a host of newspapers and magazines and repro-

116 | *Chapter Seventeen*

duced nationally and internationally. No article was complete without an image of the artist herself.

Edmonde Charles-Roux's 1948 portrait of Baya in French *Vogue*, illustrated with an art photograph by Arik Nepo, one of the magazine's star photographers, is unlike any other record of Baya's show. The elaborate portrait was staged in November 1947 but the article appeared the following February. Baya, her hair in a ponytail, wears her gold-and-red striped *seroual* and her burgundy silk velvet tunic, whose sleeves and neckline are trimmed in gold. She stands against a backdrop of twelve paintings—three rows of four squares, a precious visual record of a dozen of the paintings on display at the Maeght show. In her right hand she dangles a flowered silk scarf; at her feet are two of her supernatural clay sculptures. She has a mischievous smile on her face. This is not the piercing somber Baya, the girl with the black diamond eyes pictured in her white veil at the opening. Baya here looks more like a young teen up from the provinces. The photo feels as fresh as if it were taken today.

Edmonde Charles-Roux, a decorated Resistance heroine and a gifted journalist who has begun to report on Paris life for the magazine, signs an essay accompanying the photo that she endows with a matching energy. Her evaluation of Baya's talent and its effect is lucid, synthetic: "Everyone recognized in her work something more than simple talent. An ability to invent, an innate sense of the relationship of colors to forms, a miraculous intuition in her knowledge of decorative art." The photo caption reads, "Baya, whose 15 sculptures and 85 gouaches were shown at the Maeght Gallery, is wearing one of the costumes made for her by the Muslim community in Algiers in honor of her trip to Paris." In her copy of the magazine, Marguerite has crossed out the sentence and written "wrong." I imagine she waited ten, twenty, thirty years after the events to spread out the mass of press clippings, absorb the mistakes, and grow angrier and angrier.

In the same February 1948 issue as the Baya portrait, *Vogue* publishes a sumptuous photographic essay on aristocratic grand-

FIGURE 30: Arik Nepo's portrait of Baya in *Vogue* (February 1948), to accompany Edmonde Charles-Roux's essay "Baya, Child Painter." Photograph: © 1948 by Arik Nepo.

mothers, mothers, and their infant daughters. Three generations of a super elite, idealized via the gauzy camera lens in their native habitat, château or townhouse. A youthful grandmother poses in her floor-length silk gown, the satin bodice and skirt printed with flowers and butterflies, yards of fabric that spill out over the settee: "Sophie with her mother, the Countess Olivier de la Baume, and her grandmother, the Countess André de Fels." The celebration of the aristocratic French family and the native girl, from gouache flowers and butterflies to silk flowers and butterflies, back-to-back. Visual proof of Rosita Wertheimer's whimsical prediction in her letter to Marguerite: "We will surely see birds and butterflies frolicking on our dresses."

Baya's designs were so appealing that Marguerite began to worry about unauthorized copies. Shortly after Baya's return to Algiers, she discovered that a store in Algiers called "Romance" was featuring a fabric named "Baya" and asked the Maeghts what legal action she could take. Guiguite tried to reassure her that they had given no rights to Baya's paintings to anyone. Only Staron asked verbal permission to reproduce Baya's design elements and colors for his most prestigious client, Christian Dior, who planned to integrate her spirit into his May 1948 collection. The boutique Romance claimed they had purchased the "Baya" fabric from a manufacturer in Paris, but the Maeghts were unable to locate any wholesale fabric named "Baya" on the Paris market. They figured that the merchant was exploiting Baya's fame to sell his goods.

18

Les Messieurs

THE GUEST BOOK FROM the 1947 *vernissage* may be lost in a pile of unmarked boxes in the Maeght Gallery warehouse in the south of Paris, or so I'm told. I volunteer to look myself and the kind man in charge of loans and rights whose afternoon's work I've interrupted, chuckles as if I've made a joke. He explains that the space is huge, crammed with box upon box, none of them labeled. It would take me days to find the guest book, and obviously they couldn't let me in, for reasons of security. Besides, he points out, according to one of the letters I've shown him, Baya told Marguerite she was bringing the guest book home herself. Some mysteries will have to remain unresolved: Who knows how many people at the opening actually signed that guest book? The most prominent guests might have snubbed it. It would have been interesting, but it's not the holy grail.

SO I GATHER ARTISTS' names from the press coverage. Maeght counted on the men in his stable to be there, some of whom had had their own Maeght shows that year: André Marchand (February–March); Georges Braque, a new client (summer of 1947); and the group of young painters Maeght dubbed "The Dazzling Hands," shown in three exhibitions from 1948 to 1951. Marchand writes to Marguerite in December 1948, "I've seen with my own eyes this serious, enchanting little Kabyle and her visionary work . . . the magical vision of a child facing the mysteries."

"From the look on the painters' faces it's a clear success and a pure

talent!" Madame Maeght tells Madame Wertheimer, who passes on her assessment to Marguerite. Madame Wertheimer deplores Marguerite's absence at the event: "You would have been happy to see your *oeuvre* crowned by the consecration of Paris." She reaches for grandiose language, but she's sincere. She understands Baya as "Marguerite's work of art." In Paris, dressed in her sumptuous costumes, Baya is on display as surely as her gouaches.

Artists go to an opening not only to see, but to be seen, to be caught in the act of looking. *The look on the painters' faces.* What did Guiguite Maeght see when she looked at Braque, Matisse, and Marchand looking at Baya, the men the Maeghts considered "the glories of French painting"? What did their faces express? Delight, rapture, recognition. A confirmation of their aesthetic principles. A breath of fresh air after the academic art they disdain. A shot in the arm for a frightened, morose city.

No Picasso quotation has been repeated more often than this one: "It took me four years to paint like a Raphael, it took me a lifetime to paint like a child." Picasso first made the remark to Herbert Read at the British Council children's painting exhibition curated by Frank McEwen. While this source, one degree of separation from Baya, has disappeared in the fog of time, the sentiment expressed outlived any single work in McEwen's 1945 show, becoming modernist dogma. When Picasso finally met Baya at the Vallauris pottery studios in the summer of 1948, he witnessed youthful creativity that was no longer generic but tied to a strong and original artist. Baya comforted him as well in another, related modernist belief—that the magic of creation exists most powerfully outside the metropolis, that there was inspiration to be found in the African artifacts that had made their way into French ethnographic museums.

Some argue that Picasso watched Baya with a purpose, that his own clay figures resembled hers, that she allowed him to enact his own ideal of childish freedom—though Baya was by now nearly seventeen. Picasso's *Women of Algiers* series was inspired by Delacroix's *Women of Algiers in Their Apartment*, but would he not also have been inspired by his hours with Baya? You can spin your wheels for a long

time, though, if you think that influence amounts to the deployment of specific images and techniques, finite and measurable, to a willful use of a precursor—the equivalent of a direct quotation. Baya, for her part, didn't need to quote Picasso. She already knew what kind of artist she was.

André Breton, who brought back from his American exile drawings by children from the Hopi Reservation, declared in a similar spirit that American Indians were the greatest artists in the world: "The children draw, paint, and sculpt with extraordinary fluency." In his essay on Baya, he footnotes Jean Piaget's *The Child's Conception of the World* on the magic of childish creation. He argues that Europe is tired, that races and castes are set against one another, and that the Muslim world, Baya's world, is "scandalously oppressed." Baya's indigenous art, like the art of the Hopi but coming from a world oppressed directly by his own people, the French, offered him something more than beauty.

Then there's Algeria, with its particular meaning for French painters, who since the nineteenth-century conquest have considered that the light, the landscape, the people of North Africa can lead to a discovery of the artistic self. The colonizers captured the land, the painters followed, capturing the landscape. Matisse brought to Baya's show his memory of the months he had spent in Biskra at the turn of the century. His 1909 orientalist portrait of an Algerian woman is made of blocks of color more primary than Baya's pastel greens and roses. Of the trio of great men at the Maeght Gallery, Matisse is the only one to have seen the Algerian light and landscape with his own eyes. But for all French modernists, Algeria has a meaning through the long tradition of orientalist precursors, the most celebrated being Delacroix's *Women of Algiers*. You go to Paris for technique and Africa for adventure, goes the cliché. Delacroix painted his harem women four months after France's conquest.

A FIERCE ARGUMENT about Baya is raging in 2022, during the months when I'm working on this book. The question is whether

Baya was influenced by Matisse and Picasso, or whether she influenced them. There are plenty of indications that she had absorbed a great deal of European modernism. She lived with the art books on Frank and Marguerite's bookshelves; she visited the Paris Museum of Modern Art in 1947; she mentions her preference for Matisse in letters and interviews. There's her intriguing letter to Marguerite about a dinner at the Maeghts in early December: "On Sunday night, Monsieur and Madame Rivier, Monsieur Peyrissac's sister from Algiers, came for supper at the Maeghts, they are really nice, they bought two of my big paintings. After we watched movies and I saw the films on Matisse, Picasso, Bonnard that Monsieur Maeght made." Maeght's documentaries are lessons for Baya in art history but also in painting as performance. He shows his artists in the act of painting, and when the men from Gaumont come to make their newsreel about Baya, they film her in the act of painting, following the curve of her brush soaked in black paint. She looks as comfortable and as practiced on screen as the greats.

In general, the critics of Baya's first exhibition were eager to inscribe her in a history of modernism. On the other side of the influence debate is a single article on Baya from *Alger-Soir*, "Baya or the Revelation of Muslim Art" (December 17, 1947)—a rare review, ahead of its time in its reversal of cause and effect: "When Parisian visitors identify Matisse's influence on Baya, they're reversing the terms of the problem of origins. Since it was on the North African banks of the Mediterranean that Matisse garnered the influences that made him purge his drawing and strip down his odalisques to monochrome, geometric elements. And Baya, nourished by these sources, didn't need Matisse to discover a style." Baya didn't need Matisse to influence her; it was Matisse who needed the Maghreb.

In this noisy orchestra of influences, one name is strangely missing. Not a single critic who wrote about Baya's opening mentioned Frida Kahlo, the Mexican artist whose 1938 show at the Julien Levy Gallery was arranged by none other than André Breton and who came to Paris the following year for a show called "Mexico" where

Les Messieurs | 123

her paintings were mixed with a hundred other art works, from the pre-Columbian era to the present.

The two artists could not have been more different in personality and aura—the thirty-one-year-old Kahlo, flamboyant and confessional; the fifteen-year-old Algerian Baya, elegant and discreet. Yet they were positioned similarly, painters from what we call today the Global South, performing their native cultures for eager European/American hosts. Like Baya, Kahlo appeared in public in lush traditional costumes mirrored in the bright reds and yellows of her paintings. Like Baya after her, Kahlo was consecrated in *Vogue*, and in similar terms: "herself a product of her art"; "spontaneous and personal"; practicing a "naive surrealism she invented for herself." Her New York opening, like Baya's Paris début, was attended by an excited crowd of artists and writers. Breton granted both artists secret powers. Whenever I tell Baya's story to a friend, there's often a sudden flash of recognition, "Ah! So she's the Frida Kahlo of Algeria!"

We don't know what Baya thought of Breton. She reported, deadpan, that he complimented her work. As for Kahlo, her disdain for the man and his surrealist friends has gone down in intellectual history, the revenge of a native woman artist against her Parisian appropriator: "They sit for hours in the cafés warming their precious behinds and talk without stopping about 'culture' 'art' 'revolution' and so on and so forth, thinking themselves the gods of the world, dreaming the most fantastic nonsenses and poisoning the air with theories and theories that never come true."

19

Baya Is Launched

AIMÉ MAEGHT AND HIS gallery assistants spend a week readying the two floors for the show. In the midst of a paper shortage, there are copies of *Derrière le miroir* to print, last-minute invitations to mail, the press to alert, the paintings to arrange in the right order, so that they, too, will tell a story. The terra-cotta sculptures are placed in glass cases throughout the gallery.

The day before the opening Baya is photographed staring at one of her gray clay beasts, its neck twisted and its eyes bulging from a head sprouting four proud fronds. She's painted other statuettes in enamel, tiny masterpieces that visitors to the Maeght Gallery will rush to purchase. The day of the opening, the guest book is placed on a stand at the gallery opening. The rue de Téhéran is ready once again to welcome "le tout Paris." As of this evening, Baya is launched onto the rough seas of interpretation. As they mill through the crowded gallery, visitors pick up copies of *Derrière le miroir* to read the informed opinions. The brochure celebrates and reassures. Peyrissac, for example, understands her art as a return from an underworld: "Baya has truly left hell. This is reflected neither in the faces she has painted nor in the great dark and tragic fresco. About the cruel times, she has retained only the perfume of the orchards, the pearly blond of the limestone. She honors her mother in the tender embrace of maternity. After her father's death, her mother lay dying and kept Baya at her side in death. For her, the universe consists of love: the harmonious marriage of vegetation, beasts and humans."

Peyrissac raises the specter of Baya's mother clinging to her daughter as she's dying, but for him, the artist has transcended sorrow with love. His investment in her happiness seems so great that he passes over the tragic notes in her earliest paintings—the grimaces of her maternal figures, their bitter slits for mouths, their piercing gazes; the threats from giant birds or the massive, protective birds that take little girls under their wings; the snakes wrapping themselves around innocent flowers; the constant metamorphosis of forms. Love and fusion, yes, but edged with danger. Every single person at the Maeght opening that evening has been scarred by two world wars. In the first war, Braque was wounded in the trenches, and Camus lost a father; in the second, Chataigneau lost a son; Camus and Jacqueline Auriol and Edmonde Charles-Roux, how many comrades? In Baya's pictures they can perceive every nuance of joy and disaster.

I LOOK ONCE AGAIN at Marguerite's chronology, which begins with the death of Baya's parents. Her father, Mohammed Haddad, died when she was seven. Her mother, Bahia Abdi, died when she was nine, following complications from childbirth. She was born Fatima Haddad on December 12, 1931, but for her entire life, she never answered to any other name but Baya. And suddenly I see it: Bahia Abdi, Baya Haddad. Baya was her mother's first name, which she took as her one and only name, her artist's name. Her art was many things, but first of all, it was a cenotaph.

To sign her paintings, she invented an icon that defies understanding, neither Kabyle nor Arabic, but a playful combination of forms she'll use throughout her career. Sometimes she liked to integrate the date of the painting into her symbol, drawing us to look closer. In later years she often signed "Baya" in a fluid script on the back of her rolled up gouaches on paper, to guarantee their authenticity.

The Parisian art world of 1947 was perplexed by Baya. They wanted to know whether her genius was due to her spontaneity, her

FIGURE 31: Baya Mahieddine's signatures, the icon version and the script. From an invitation to an exhibition of her work at the French Cultural Center of Algiers (March 8–29, 1979). By permission of the Children of Baya Mahieddine. Aix-en-Provence, Archives nationales d'outre-mer. Photograph: © Children of Baya Mahieddine.

access to her unconscious, or whether it emerged more slowly from a God-given talent nurtured by craft. Baya liked to say about herself, "When I paint, I'm happy and I forget everything." From the start, she was able to give herself to her painting, to achieve a state of perfect concentration, to remain *indifferent*, just as Breton had recommended in his instructions on automatic writing in the Surrealist Manifesto: "Forget about your genius, your talents and the talents of everyone else," and he might have added, "forget about the genius of the great men." Her indifference didn't prevent the great men from weighing in. Charles Estienne, a prominent postwar art critic, close to Breton, granted to Baya's work the intuition of a Matisse, the poetic sense of color of a Chagall, the "fairytale Orient" of

Baya Is Launched | 127

a Kandinsky and the power of prehistoric art. So close to her dreams, he wrote, that her decorative art approached abstraction. The surrealist art critic Paul Chadourne made a wish in his review of the Maeght show: "May she long retain that marvelous genius of childhood, which appears even more mysterious here because it's been nourished by visions of the Orient." The orientalist remark was as inevitable in 1947 as the references to her youth.

The idea of Baya as a self-educated artist is misleading, marshaled in different eras, for different political reasons, to consolidate the myth of a "primitive" artist, as Jean Dubuffet did by including her in his collection of "Art brut," or to categorize her as an autodidact, disconnected from the gallery of avant-garde "messieurs" who celebrated her. Baya's paintings contain multitudes—the patterns and colors of Kabylia, Islamic miniatures and Algerian ceramic art, the fashion magazine patterns, the English childrens' paintings, the portraits and reproductions in Marguerite's apartment, exhibition catalogs, originals by Braque and Picasso and Matisse (who admired her in turn), birds and flowers out her window that became in her hands as recognizable as her signature. It does her a disservice to control her borders.

20

Homecoming

GUIGUITE MAEGHT AND her son Bernard accompany Baya home to Algiers shortly after Christmas. *Alger Républicain* announces the triumphant return with one of Ostier's photos of Baya with "her best friend" Bernard by her side.

She brings home two little birds in a cage, a gift from the Maeghts, and a packet of letters from French schoolchildren. Interviewed once again, she says that her favorite French painter is Matisse and that her favorite entertainment is the circus. Marguerite claims that Paris hasn't changed Baya; she is the same as before she left. Once again, you can't tell who is speaking for whom. Who told the reporter that Baya enjoyed tending to the fireplace and doing her duties? Is it Baya who wants to go back to making sculptures, so many of which were damaged in the shipment to Paris, or is it Marguerite who wants her to?

Marguerite writes to Guiguite in March that she is alarmed by Baya's fatigue. The doctor has taken x-rays revealing traces of childhood tuberculosis; Baya's lungs are scarred. To help her rest, Marguerite decides to try "an experiment." She will say nothing to Baya about painting. She won't take out Baya's palette or brushes. For two months, she reports, Baya seems to have completely forgotten to work, as if she's never made a single drawing. She never speaks of Paris unless prompted.

An experiment designed to provide rest, really? Baya, after her

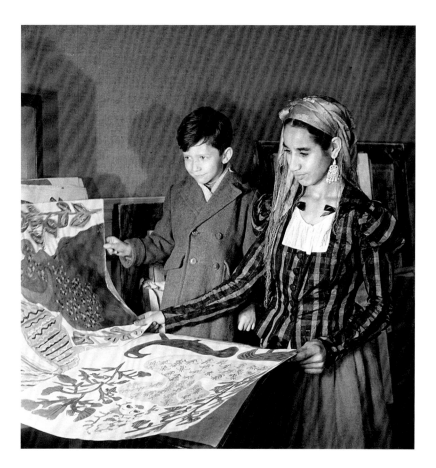

FIGURE 32: Baya with her beloved friend Bernard Maeght (1942–1953) (ca. 1947). Photograph: © 2024 by André Ostier / Association des amis d'André Ostier.

month of nonstop performance, retreats, and Marguerite is annoyed. But how restful can the experiment be when the parade of visitors doesn't stop: Chataigneau's wife comes for tea, and the prefect of Algiers, and then the wife of Jules Moch, minister of the interior, and the journalists from Sweden, deploying the flashbulbs she hates. Jean Dubuffet comes to examine her work, looking for outstanding examples of "Art brut" for his collection.

THE NEXT SUMMER MARGUERITE and Mireille accompany Baya to Vallauris in the South of France, where she's been invited to the

Madoura studios to work on her terra-cotta sculptures. Guiguite Maeght promised that the purer air will be good for Baya's lungs. She makes a friend of fellow artist Picasso. Sometimes he comes to her studio to see what she's doing; sometimes she goes to his. They share a lunch of couscous.

Letters to Marguerite from the owners of the Madoura workshop describe fifty or so clay figures she left behind that they eventually glaze and bake and finally return to the artist in the early 1980s. In 1948, Madame Maeght is not convinced that the clay figures are exhibition-ready. Baya needs to work harder, she writes Marguerite. And so the Maeghts' dream of a Baya, Miró, and Picasso pottery show comes to naught.

In the fall of 1950 Baya returns to France on her own. With her base at Maeghts' apartment on the Avenue Foch, she visits with rector Si Kaddour Ben Ghabrit at the Paris mosque and calls on Rosine Wertheimer, whose mother, Rosita, has only recently died; she travels with the Maeghts to Georges and Marcelle Braque's country house in Varengeville, near Dieppe. In October she returns to Paris with her hosts so that Aimé can prepare his latest exhibition. On three occasions from 1949 to 1951, he features the group of young artists he calls "The Dazzling Hands," an incubator for the major trends of postwar modernism: expressionism, surrealism, and abstraction. One of those artists is Denise Chesnay from Algiers, who traveled in the 1940s in the same artistic circles as Frank and Marguerite. She's in Paris now and so is Frank. And they are still together.

BY 1950, BAYA, no longer ventriloquized by Madame Maeght and Madame Wertheimer, having endured the lessons of Mademoiselle Bureau, writes her own letters to Marguerite. After the opening, she reports that she's seen Frank and Denise, and that "Denise is horrible." She adds that Frank claimed he'd tried writing to Marguerite in care of the Farges, but the letter was returned to him. Always the wounded party! She writes to Marguerite with sisterly love: "You can't know how much it pained me, but don't worry, she's suffering,

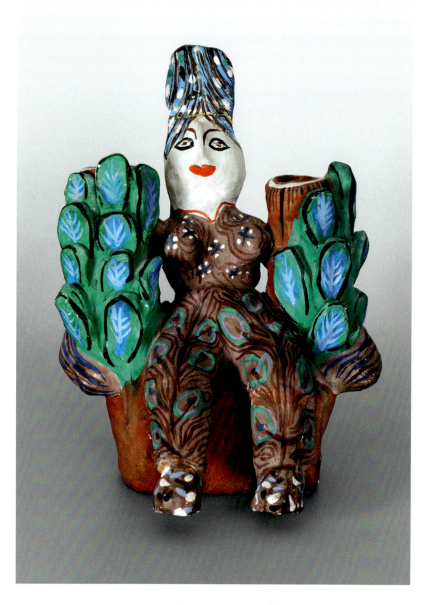

FIGURE 33: *Femme candelabre* [Candelabra woman] (ca. 1948). This statuette was made by Baya at the Madoura pottery workshop in Vallauris in 1948, but fired and painted after her departure, according to Guiguite Maeght's instructions. By permission of the Children of Baya Mahieddine. Photograph: © Gabrielle Voinot.

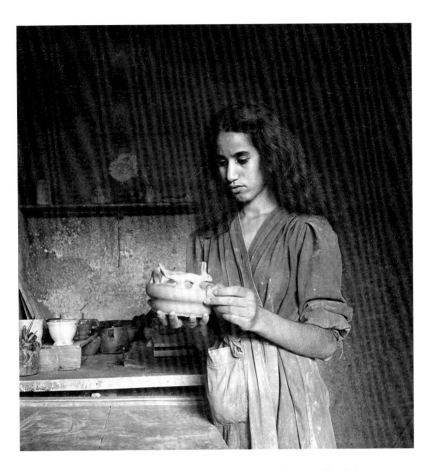

FIGURE 34: Baya at the Madoura pottery workshop in Vallauris in the summer of 1948. She and Pablo Picasso, working in neighboring studios, enjoyed each other's company. Photograph: © 2024 by André Ostier / Association des amis d'André Ostier.

too. She won't stay with him for long. I know this won't please you, but you know I don't hide anything from you." The Paris art world is small, Frank is a player, and Denise Chesnay, known for her allure and the strength of her personality, is making a name for herself with her abstract lyrical canvases. It must have stung Marguerite to the core. Baya, the protected child not permitted to speak for herself in 1947, now reveals herself as the protective and wiser friend. Perhaps she always was. She consoles Marguerite by reminding her that

Homecoming | 133

the two of them know well what Frank is capable of. If Marguerite was used and betrayed, Denise will be, too.

DENISE CHESNAY'S OWN FUTURE is worth a detour. With Frank's support, she'll have a brilliant run in Paris, at the Maeght Gallery, at the May salon, and at the gallery of Denise René, legendary godmother of abstract art; Frank includes her work in a traveling British Council exhibition titled *Young Painters of the Paris School*. Frank does make her suffer, as Baya predicted, and eventually she leaves him. When she's interviewed about her career as an artist and her arrival in Paris in 1945, she never mentions Frank McEwen's name. She published a novel based on the demise of their relationship, making her experience even more harrowing by telling the story from his point of view. After leaving the art world, she became Denise Desjardins, well known practitioner of Buddhism, writer, and founder of an ashram with her husband, Arnaud Desjardins. In a documentary devoted to her philosophy of life, she looks back at her early days in Paris from the wisdom of her eighty-four years:

> There was a lot of socializing, there were the big openings. I had many connections in these circuits, and since back then I was rather pretty and not too stupid, which the great men of this world appreciated. . . . I discovered that it all started to become rather artificial. That among the young painters it was a viper's nest like everywhere else. I started thinking, this wasn't what I was looking for. Of course I met Picasso, I met Braque, I met writers like Camus . . . these were people with extremely powerful interior lives, but I sensed in all these great men that they weren't free. So many motivations, so many desires, let's say sexual desires, why not, but also the desire to be the best, a competition.

At age eighteen, standing quietly on the ground floor of the Maeght Gallery, rue de Téhéran, Baya observed Frank and Denise and the viper's nest. In her own quiet way, she would reject this world as surely as Denise Chesnay did.

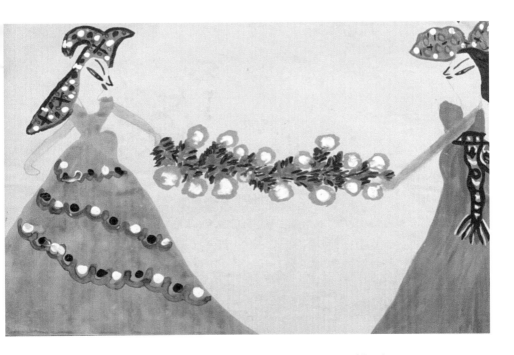

FIGURE 35: *Femmes à la guirlande* [Women with garland] (n.d.). By permission of the Children of Baya Mahieddine. Private Collection. Photograph: © Gabrielle Voinot.

21

Separation

NOTHING IN MARGUERITE'S CAREFUL chronology betrays the least shadow of a feeling about the event that disrupted the lives of both Marguerite and Baya. In an archive, the most consequential decisions, the rawest emotions, are often missing. I don't have her letters to Baya, to her sister Simone or to her niece Mireille, personal correspondence that might be more revealing. What I have are the facts: just as a legal judgment by the Caïd Chanderli had given Marguerite custody of Baya under the tutelage of Cadi Benhoura, his subsequent decision of 1952, when Baya turned twenty-one, removed her permanently from Marguerite's care. Marguerite noted, "The Caïd Chanderli entrusted Baya to Ould Ruis, professor at the French lycée. She moved in with his family in Blida."

From one day to the next, Baya finds herself living in a conservative scholarly household under the watchful eye of a professor of Arabic at the Franco-Muslim lycée of Algiers. The Ould Ruises are one of the great families of Blida. What room for maneuver did Marguerite have? In interviews, Baya would refer to Marguerite Caminat McEwen as her "adoptive mother," but in fact Marguerite was only given temporary, supervised custody. By law, a decision had to be made as to Baya's future as soon as she turned twenty-one. You have to wonder: Did Marguerite protest at all or did she immediately bend over backward to respect the court's ruling? Did she believe it was in Baya's interests to prepare for marriage in a traditional Mus-

lim family? Why did she, an unconventional woman in many ways, divorced, now the companion of Benhoura, childless at age forty-nine, feel bound to respect the domestic path chosen for Baya by Chanderli—and doubtless by Benhoura? Did she believe that she'd accomplished her mission, and that Baya was now ready to take up her destiny as wife and mother? How did she imagine Baya's artistic future in this new scenario? How much did it matter to her?

Ould Ruis, with whose family Baya now lived, planned to marry her to one of the sons of Mahfoud Mahieddine, a celebrated Andalusian musician in Blida. But when Mahfoud saw the sylphlike twenty-two-year-old Baya through a doorway, he decided he wanted to marry her himself. The marriage took place in 1953, when Baya was twenty-two years old. Mahfoud Mahieddine was fifty-two. No matter that he already had a first wife, the marriage was an extraordinary social promotion for an orphan with no formal education. And a terrible shock for the bride. Mahieddine had eight children from his first marriage. Baya gave birth to six more. Her married life included taking care of both households, until Mahfoud divorced his first wife in 1958. Constructing Baya's timeline many years later, Marguerite noted cryptically, "Communal life of the two spouses."

MARGUERITE'S ARCHIVE CONTAINS no letters from Baya for almost ten years, from the time Baya was taken to Blida in 1952 to the day in 1961 when, as Marguerite tells it, Baya called her from the Farges farm asking about proceeds from her art. Marguerite saved two letters, the first from Ould Ruis to Benhoura in 1953, arranging for Benhoura to return a radio and a photograph that Baya left behind; the second from 1954, after the marriage, thanking Marguerite for money from paintings she sold: "Baya was very touched and awaits impatiently for this sum. I thank you, too, in the name of Baya and in my own name for what you have just done. . . ." Baya was cut out of the communication. Was Baya inhabiting a new world of marriage and motherhood and determined to leave the past behind? Or was it Marguerite who stopped writing because it was too pain-

ful? Were the two women encouraged to cease contact; were they required to? There are too many unknowns. At the end of her life, Baya referred in the privacy of her family to the shock of that separation, which was as devastating to her in its own way as the loss of her biological mother.

Marguerite Caminat and Mohamed Benhoura were married in a Muslim religious ceremony in 1952. In 1957, settled in France five years before Algeria is liberated from French rule, they are married in a civil ceremony in the sixteenth arrondissement of Paris. As the wife of a Muslim, Marguerite was under no obligation to convert, and she remained a Catholic, expressing pride in the union of faiths her marriage represented. When a country priest hesitated to baptize her goddaughter because she, the godmother, had married outside the church, she convinced him otherwise. Her goddaughter Yoyo Maeght remembers Marguerite Benhoura's motto: "I do everything to unite the cross and the crescent."

From 1954 to 1962, the years of the revolution, Baya stopped painting and stopped showing her paintings in public. "The silence of Baya" has given rise to much commentary: Was it a political position? A form of patriotism, a refusal to make art for the French who were her collectors, as she waited for the Algerian nation to be born? Or was she simply overwhelmed? She told an interviewer that there wasn't enough green paint. Green: the color of Islam. The color of the Algerian flag, for which the scout at Sétif had died.

Another marriage weighs on this story: that of Jean de Maisonseul, urbanist, painter, and supporter of Algerian independence, to Mireille Farges, Marguerite's niece. In the intense days leading up to independence, Jean and Mireille de Maisonseul visit Baya in Blida and encourage her to start painting again. They bring her supplies. In the hair-trigger cultural politics of the newly born nation, de Maisonseul was sometimes credited with Baya's return, or discredited, as if his role meant she was still under the vassalage of the French. Jean de Maisonseul was a passionate supporter of Algeria who'd been arrested and imprisoned by the colonial government in

1956 and released only with the support of his friend Albert Camus. He was far from the sole instigator of Baya's second career. In letters and interviews, she describes her urge to make art again. Her husband, Mahfoud, brings her bags of clay and equipment and builds bookshelves for her sculptures. She begins working in clay. Then she takes up her brushes in earnest and paints for the rest of her days.

The de Maisonseuls encourage Baya's contact with Marguerite, who is now living in Paris and working at the Maeght Gallery. On December 11, 1961, Baya sends a letter to Marguerite. She decorates the margins of the stationery in five different watercolors. She writes that she's been afraid that Marguerite wouldn't respond, and when Marguerite's letter did arrive, she cried, and her heart melted. She writes: "Don't believe I've ever forgotten the past, it's carved in my heart, I've never forgotten you." She's told her husband about everything Marguerite did for her. Life is different now that she's married. She's already had three children, Rachid, Meriem, and Bachir. Marguerite's advice has helped her raise them. She dreams of her every night, thinks of her more than of her true mother, remembers the home where they lived, she will never forget. In her subsequent letters, and there were many, she describes her house in Blida and her life as a wife and mother. She thanks Marguerite for looking after her affairs, for negotiating the sale of her paintings and sending her money.

Marguerite, in those first years back in Paris, has been pursuing her passion for archives at the Maeght Gallery, where she's taken on the colossal task of organizing Joan Miró's prints. In the days before online catalogs, she invented a system of hieroglyphs all her own, involving triangles in various colors and labels within labels. Physically, she's an exaggerated version of her younger self, her thinning hair pulled back and knotted in a tight bun on top of her head, her eyes bulging, her gait awkward since she sees with greater and greater difficulty. After the death of her husband, she lives in a studio above the Maeght warehouse, with only a meager boundary between her life and her work. She is tough but fair with

FIGURE 36: Baya Mahieddine with her husband and five of their six children in Blida (ca. 1969): from left to right, Mahfoud Mahieddine, Bachir, Rachid, Salim, Baya, Omar, and Meriem. (Baya's sixth child, Othmane, was not yet born.) Private collection. Photograph: © Children of Baya Mahieddine.

the young women she supervises in the documentation service. Joan Miró rewards her with limited editions of each of his works on vellum, inscribing them, "To Marguerite, miraculous fairy of the archives," and "to Marguerite, the benevolent angel of my engravings."

She never again loses touch with Baya, who sends her letters addressed to "ma petite maman." Whenever there is trouble or financial worries, Marguerite gives advice and support. If, as I imagine every time I open her archive, Marguerite did consider writing a book about Baya, the project never amounted to anything more than voluminous papers, hyperorganized (by theme, by date, by number) and confusing. Her handwriting becomes less and less readable as the years go by. Yet she saves every clipping, every letter. Like any responsible biographer, she researches dates. She worries over details the way all biographers do: Which friend to reach out to, to establish exactly when André Gide might have visited her in Algiers and met Baya in her living room?

THE UNWRITTEN BOOK. What would it have been like for Marguerite Caminat to come to terms with what was surely the most important relationship of her life, to look back on her sense of responsibility, of loss, of promises broken, of amends made to the girl she'd described to Maeght in a rare moment of self-reflection, who "so totally surrendered herself to our decisions."

How would she have described those first days on the flower farm, the little girl seen beyond the curtains, Frank's departure, painting together on the rue d'Isly, the appearance of Maeght, Baya's fame. Could she have formally adopted her, brought her to France? Would that have been selfish, unfair to the girl? After a few years in France, her chronology shrinks to a few facts: the death of her husband, "Cadi Benhoura" in 1966; the birth of Baya's last children; the departure of Jean de Maisonseul and Mireille from Algeria in 1976; Baya's art exhibitions in different cities; a visit from Baya and her husband, who stop in Paris on their return from a pilgrimage to

Mecca. In 1984, 1985, the page is blank. She is eighty-one, eighty-two years old, her lifeline is fading, then it's too late. She dies in 1989.

AT INDEPENDENCE, Jean de Maisonseul chooses to remain in Algeria, and the first Algerian minister of education chooses de Maisonseul to steward the new nation's artistic heritage. Revenge of history: the great-grandson of the man who commanded the port of Algiers under Napoleon III becomes the inaugural director of the Musée des Beaux-Arts of the Democratic and Popular Algerian Republic. Unlike the French experts who arrived in Algeria from the metropolis to assist the new nation, Jean de Maisonseul has always lived there. As his first politically charged task, he negotiates with André Malraux for the return to Algiers of masterpieces by Monet, Renoir, Gauguin, Pissarro, Degas, Courbet, and Delacroix—over three hundred works the French had crated and shipped to the Louvre as part of their Algerian exodus. At the same time, he builds a permanent collection of Algerian art.

Friend, patron, supporter, he praises the direction Baya's work is taking: "Her return to art was hesitant at first; she quickly found her themes again, amplified them even more audaciously, inventing colors and patterns in larger and larger formats."

Marguerite, working for Maeght, inventories the paintings from the 1947 show that remain in Maeght's collection. She's the perfect broker for de Maisonseul. And that is how a dozen of the paintings Baya created during those first intense years with Marguerite—the gouaches that Jean Peyrissac had so carefully crated and shipped to the rue de Téhéran—make their way back home to Algiers. Jean de Maisonseul organizes a first exhibition in July 1963 to mark the reopening of the museum on the first anniversary of independence, and another in November of that year to commemorate the Algerian insurrection of November 1954. Baya's paintings are on display in the Salle Ibn Khaldoun with other artists who would never have had a place in the Beaux-arts palace of colonial Algeria: Baya shared

FIGURE 37: *Femme avec palmier* [Woman with palm tree] (n.d.). One of the first paintings acquired by Jean de Maisonseul for the Musée National des Beaux-Arts, Algiers, after independence. By permission of the Children of Baya Mahieddine. Photograph: © Le Musée National des Beaux-Arts, Algiers.

FIGURE 38: *Oiseau en cage entouré de deux femmes* [Caged bird surrounded by two women] (n.d.). By permission of the Children of Baya Mahieddine. Photograph: © Le Musée National des Beaux-Arts, Algiers.

the walls with Issiakhem, Khadda, Benaboura, providing a foundation for a national art history.

Baya writes to Marguerite to say how strange it feels to see her paintings on the walls. She's forgotten all of them and she is happy to discover them again.

She continues to paint from her home in Blida, to receive visitors, to give interviews, to exhibit around the world. One of those visitors, a heroine of the revolution named Zohra Sellami, reads Baya's past and present through her hands: "Baya's surprising hands. Long and thin, large and powerful. The hands of an artist and mother. Hands

Separation | 145

that handle the brush to forget the insult of detergent. Ruddy and soft and generous all at once." She sees Baya's story written on her body: frostbite from working the soil, cracked skin from washing the dishes and caring for the children. She sees the grace, the humor, and that touch of sorrow in her gaze, obvious to everyone who loves her. Bachir Mahieddine remembers his mother at the kitchen table, bending over her paper with perfect attention, her favorite brush in hand. In front of her house was her garden profuse with plants and flowers and pet birds. Walking through it, you were already in one of her paintings.

ONE OF THE STRANGEST destinies of the people connected to Baya's beginnings is Frank McEwen's. After his term at the British Council he was sent by the British government to Rhodesia to develop a fine art museum. In the next, most successful phase of his life, this curator for whom the Paris school modernists were cousins and friends, champions the Indigenous sculptors of the Shona tribes for their purity, their absolute autonomy from the West. "Issuing from within themselves," he wrote, "their art is not borrowed from anywhere; here is not the reflection of a reflection with which we are so familiar in recent Western art. Universal, radiant in life force, their work has none of the negative insecurity of Trivialism. To read its male message is to react to the brute essence of creativity." You can see McEwen in publicity photos, posing with the African artists, or showing Princess Margaret and other officials around his collections. As he described it, he'd merely given the Shona tribe artists sculpting tools and a workshop and placed their art in museums around the world. In 1963, just as Jean de Maisonseul was opening the Musée des Beaux-Arts of the Democratic and Popular Republic of Algeria, Frank McEwen was decorated an officer of the most excellent order of the British empire. He was forced to leave Rhodesia at the dawn of independence, though in contemporary Zimbabwe, the discovery of the Shona school of sculpture is still attributed to him.

Frank never mentioned his marriage to Marguerite, not in interviews, not even in response to an inquiry from Lucien Pissarro's biographer, to whom he responded only that he'd escaped from Toulon to Algiers in June 1940 at the German invasion and spent two and a half years "protected by wonderful friends." The war, which cut countries and people off from one another, enabled absolute breaks, new starts, canceled pasts. Like a character in a Patrick Modiano novel, McEwen rewrites his own story, casting his lot with a pure and virile African brutalism, "born directly, locally, from natural elements in the virgin ground." Shona art is a form of magic for him. It is hard to imagine what sympathy Frank McEwen could possibly have harbored for Baya's paintings of women and gardens and peacocks. From what I can gather from his 1994 obituaries, he was happiest in his boat on the open water. For him it was always easier to sail on.

TODAY, BAYA'S DEDICATED gallery space in the Musée des Beaux-Arts of Algiers is no more. Instead, her *Woman with Palm Tree* has pride of place in the first large gallery space on the upper level. Off the main corridor, in a beautiful wood-paneled library decorated in high art deco style, above bookcases full of historical tomes that climb halfway up palatially high ceilings, hang twenty more works by Baya, dated 1945 to 1987: the great bird, the blue woman with peacock, two women on a rug, a caged bird surrounded by two women. I've returned many times to that library, looked up, aimed my iPhone at the frames. Seeing them anew each time through the documents I discovered, seeing the fragments of a life, the stage set with attitudes of the people surrounding Baya, and with a history of postwar France inseparable from the history of Algeria.

As my work on Baya comes to a close, the name "Marcel Reboul" comes into focus as I look one last time at the long list of people Marguerite asked Maeght to invite to Baya's exhibition. He was a family friend from Toulon. He was also the government magistrate who prosecuted the fascist writer Robert Brasillach during the

FIGURE 39: Baya Mahieddine's paintings above the bookshelves in the Musée National des Beaux-Arts, Algiers (2023). Photograph: © Hamza Ayadat.

great purge of Nazi collaborators in 1945. By sheer coincidence, I've spent as much time with his papers as with Marguerite's, and I never could have predicted that these two people existed in the same universe. Reboul had hoped fervently that Brasillach's execution might heal the nation. And there he was at Baya's art opening, confident that France was free from the Nazi scourge. With him that evening, a French elite, artistic and political, basked in the euphoria of liberation. Whatever the problems of everyday life they were facing, however painful "the sterile struggle for material comfort," the guests on the rue de Téhéran believed they were living in the aftermath of war. Did they suspect they were taking part in a defensive skirmish of a very long war still to unfold? Camus, Chataigneau, and Aboulker certainly were beginning to see beneath the surface.

FOR SALIMA MAHIEDDINE, Baya's opening in Paris and her coming of age as an artist in colonial Algeria are painful reminders of ep-

isodes marred by possession and indifference in a world she's heard about all her life. In the kindest of ways, she represents to me Baya's work of repair, and ultimately, her triumph: "Finally she managed to construct an authentic life around her children and construct a relationship as true and sincere. For her they were what enabled her to mourn the presence of the 'others.' Her children belonged to her and she was no longer in danger of yet another abandonment. It was the same with her daughters-in-law. She integrated all of us into her 'tribe' and for her that sufficed. She was in peace. She was finally happy with all her children around her and her painting."

"Authentic" is a fighting word. I understand her to mean that Baya was used by the Europeans, used and discarded. That Baya had come into her own in Blida, with her large family, her garden, her gouaches and brushes and painting table. Salima and I are in another one of our intense conversations and I sense we've come full circle. I remind her of the day she showed me that shard of a greenhouse structure on the site of the former Farges farm—the detritus of colonial Algeria. We had a pact that I would get to the bottom of the colonial relationship to Baya—that I would excavate that stubborn piece of metal lodged in the dirt. We talk about Bachir's beautiful memory of his mother at home, moving seamlessly from cooking to paintings, from kitchen to workshop.

Throughout her life Baya was pushed and pulled, blown about by circumstance and by design. What I admire most about her is her unshakable core, despite the din that surrounded her. She knew even before she invented her own signature (that strange icon on nearly all her paintings) that she was an artist; she maintained a personal artistic vision, substantiated by the work itself. In 1947, everyone in Paris was speaking for her, but she told her story through her painting. After Algeria won its independence, Baya slowly reemerged as the country's national painter, her gouaches of women and children, birds and plants in magical symbiosis now outlined in fluid black paint. In 1969 she designed a stamp for the Algerian postal service to celebrate a government initiative, "Protection of the Mother and

FIGURE 40: Baya Mahieddine's postage stamp designs for the *Protection de la mère et de l'enfant* [Protection of the mother and the child] (1996). Aix-en-Provence, Archives nationales d'outre-mer.

the Child"—a moment of personal satisfaction for an artist who had survived childhood beatings, and an image that brought her art into countless homes.

The Algerian writer and publisher Sofiane Hadjadj put it this way: "Baya has been with us since we were children; her characters are part of our mental landscape." As though there is a Baya effect, an inner Baya—as though Algerians have absorbed her style into their own aesthetic, like the pop artist El Moustach who makes t-shirts and jackets styled on her familiar shapes and images. As if her paintings have slipped through the museum walls and entered into popular memory.

Baya's life, like her work, has lent itself to conflicting interpretations: For some she was a prisoner of the colonial gaze, then a wife and mother confined by Islamic patriarchy, a painter who is too pleasantly decorative or whose figures are too frightening. For others she was a luminous feminist who had emancipated herself from

her cruel origins and eschewed French exile for family life and faith and a pioneering artist who renewed a sluggish European modernism with popular and traditional Algerian forms. But her art, with its daring colors, its freedom of movement, and its playful mastery of styles and motifs from Kabylia to Paris, has always spoken its own language.

I CAN SEE more clearly now how thick the air in that gallery must have been—thick with misunderstandings, with projections and delusions, and how Baya's gouaches held their own. The eyes of a hundred painted birds and as many girls and women looked back at a gawking crowd, voraciously eager to unlock the secrets of her art. Freedom from their gaze would be a long time coming.

FIGURE 41: *Femme en vert au grand paon* [Woman in green with peacock] (n.d.). By permission of the Children of Baya Mahieddine. Photograph: © Le Musée National des Beaux-Arts, Algiers.

Acknowledgments

THE IDEA OF a book about Baya's arrival in Paris was born in conversation with Selma Hellal and with Sofiane Hadjadj. As always, Selma's critical insights and reading nourished my work. Visiting Natasha Boas's 2018 exhibition at the Grey Art Museum, New York University, *Baya: Woman of Algiers*, with Jill Jarvis, Walid Bouchakour, and Imane Terhmina opened my eyes to Baya's work, and the Baya-Benhoura holdings at the Archives nationales d'outre-mer (ANOM) in Aix-en-Provence allowed me to explore her beginnings. My grateful thanks go to Jakob Burnham, a specialist of French India and a Georgetown University doctoral student working at the ANOM, who was kind enough to provide me with scans of Marguerite Caminat's correspondence when I was unable to travel. Without his painstaking work, this book would not exist.

I thank the many people whose families were part of Baya's story: Rachid Benhoura and Abderrahmane Benhoura, grandson and great-grandson of Mohamed Benhoura; Diana Darley, daughter-in-law of Nelly Marez-Darley, and Mona Darley, his great-granddaughter; Murielle Massin and Emmanuelle Desjardins, daughter and son of Denise Chesnay; Yoyo Maeght, granddaughter of Aimé Maeght and goddaughter of Marguerite Caminat; Stéphanie and Caroline Peyrissac, granddaughters of Jean Peyrissac; Simon Shorvon for the Pissarro Estate; Claude Staron, son of Claude Staron; Philippe Vieil, nephew of Marcelle Sibon; Agnès Wertheimer, granddaughter of

Rosita Wertheimer and daughter of Marcel. I'm especially grateful to Sibylle de Maisonseul, daughter of Mireille de Maisonseul and grandniece of Marguerite Caminat, for her patient help over many months.

To Bachir Mahieddine and Salima Mahieddine, Baya's son and daughter-in-law and true partners in this adventure, my deepest thanks for their generous welcome in Algiers and for their invaluable perspective.

In Algiers, conversations with the late and dearly missed Ameziane Ferhani and with Samir Toumi, Frédéric Belaïche, Nathan Haïk, François Gouyette, Harrat Zoubir, Hajar Bali, and Aziza Lounis, enriched my work. I thank Elisabeth Leuvrey and Abed Abidat of the MaisonDAR for providing a space for writing and reflection in the heart of the city. I'm grateful to Khaled Bouzidi at the Rhizome Galerie in Algiers, to Wassyla Tamzali of Les Ateliers Sauvages, and to Tewfik Hakem for his radio documentary on Baya. Djamel Hachi was an invaluable support in navigating the city.

Anissa Bouayed, the leading scholar of Baya's work, generously shared her expertise and her deep knowledge of Baya's art and archive. Her research and scholarly exigence have been a constant source of inspiration.

I am grateful for Laura Marris's insights, especially in the planning stages, and also to James McAuley and Livia Bokor for theirs. I thank my editor Michael Shae and his assistant Sam Neddleman at the *New York Review of Books* for editing my review of Baya's Paris exhibition, *Seeing Baya Anew* (May 11, 2023), which has been revised and recast here.

At Yale University, Walid Bouchakour read and reread drafts of the manuscript and steered me toward greater historical understanding. Together with Hania Deriche, my trusted source for deciphering Marguerite Caminat's handwriting, they enabled me to see more.

Agnes Bolton, Jill Jarvis, Maurice Samuels, and Rachel Brownstein gave invaluable feedback at various stages. Anne F. Garréta

helped me grapple with the ethics and grammar of biography. Hannah Feldman's reader's report, along with reports from two anonymous readers for the University of Chicago Press, were invaluable. I'm grateful, too, for the advice of art historians Joanna Fiduccia, Anne Higonnet, Emily Bakemeier, and Antonia Bartoli, for correspondence with Roger Benjamin, Natasha Boas, Rhonda Garelick, Ranjana Khanna, James McDougall, Neil MacMaster, and Mark Polizzotti, and for the support of Diane Berrett Brown at the Whitney Humanities Center. Elaine Mokhtefi shared press clippings and notes on Baya.

In France, my thanks go to Claude Lemand of the Lemand Gallery; to Djamila Chakour, Nathalie Bondil, and Agathe Samson of the Institut du monde arabe; to Emmanuelle Farey of the Musée de la Vieille Charité in Paris, who invited me to give a talk in connection with the exhibition *Baya: An Algerian Heroine of Modern Art* in June 2023; to my friend Blanche Cerquiglini for her support; and to Lea Thalmard for helping me reach rights holders I never dreamed I could ever locate. I thank Hugo Guillotin at the Galerie Maeght for his welcome support, and Jean-Roch Giovachini at the Galerie Arthème for his knowledge of the postwar art world.

Working with images and with a huge trove of unpublished correspondence has involved exchanges and authorization requests too vast to acknowledge. Hamza Ayadat of the Ayadat Studio photographed documents and served as an interlocutor with Dalila Orfali, director of the Musée des Beaux-Arts in Algiers. I'm grateful to Catherine Camus and Elisabeth Maisondieu-Camus for permissions, to Abed Abidat of Images Plurielles and to Julie Pichon of the Hôtel des Ventes de Boulogne-sur-Mer for their help tracking down high-resolution scans, and to Alberto Ricci for his photographs. I appreciated Kate Rosenfeld's expertise in organizing and downloading illustrations in the summer of 2023.

In addition to the Archives nationales d'outre-mer, I was fortunate to be able to work at the Ashmolean Museum of Art and Archaeology at the University of Oxford, where the curator of the Pissarro

archive, Colin Harrison, shared his knowledge of the Pissarro family, as did David Stern at the Stern Pissarro Gallery in London. Victoria Baena contributed research assistance at the National Records Office at Kew Gardens; Susanna Magyar at the Courtauld Libraries in London; Michael Printy at the Sterling Library at Yale. The library specialists in twentieth-century periodicals at the Bibliothèque nationale de France opened additional doors.

My affectionate thanks to Mary Feidt and Eddie Lewis for their friendship and support, and for our rock at Bugeles, which sustains me. In October 2023 we visited the Baya exhibition at La Vieille Charité, and I saw everything anew through their eyes.

In Toulon, I rang the doorbell of Gérard Nabet, a former city councilman who knows his city by heart. He received me with good humor and proceeded to dig deep into municipal records on the now completely transformed Chemin de l'Hubac, eventually pointing me to the house where Frank McEwen taught painting on Orovida Pissarro's property in the late 1930s. Monsieur Nabet, through a cosmic coincidence, is the father-in-law of Marcel Reboul's son. Marcel Reboul, prosecutor at the Brasillach trial, makes a cameo appearance at Baya's opening, and so my chance meeting with Monsieur Nabet brought past and present together in an uncanny way. Thank you to Emile de Vendt for making the trip to Toulon possible.

I'm especially grateful to Alan Thomas at the University of Chicago Press and his assistant, Randy Petilos, supremely knowledgeable guide to rights and illustrations, and to Elizabeth Ellingboe; to my publisher Marie-Pierre Gracedieu at le Bruit du Monde in Marseille, who encouraged me from the start; to her partner, Adrien Servières, and their assistant, Sergey Belikov; to Laetitia Dore in the legal department at Editis; to Selma Hellal and Sofiane Hadjadj, publishers of the Éditions Barzakh, who know my gratitude; to Yamina Hellal for her invaluable reading; and to Sohila Lounissi and her team at the Imprimerie Mauguin for their kind welcome in Blida.

It is an honor to be translated by Patrick Hersant, not only a leading translator of English and American literature but an important theorist of translation whose essays are central to my seminars on

translation. This is our sixth collaboration! We're grateful to Julie Chenot and the staff at the Camargo Foundation for providing the ideal setting for our work.

The Algerian edition of this book is published with the generous support of a grant from the Whitney and Betty MacMillan Center for International and Area Studies at Yale; the Chicago edition with support from the Abakanowicz Arts and Culture Charitable Foundation. Support for publication of the French edition comes from the Hilles Publishing Fund at Yale's Whitney Humanities Center.

My heartfelt thanks go to my agent, Tanya McKinnon, who has encouraged me and kept me steady as she brilliantly navigated the trio of editions and rights.

Despite what I owe to the expertise, the challenges, and the generosity of these many people and institutions, all errors of fact and interpretation are strictly my own. I've made every effort to contact copyright holders, and I will be pleased to amend in future printings any errors or omissions.

I'm humbled by Baya's example—by her grace, her resilience in the face of suffering, her inextinguishable talent. May her colors help to heal this broken world.

Paris-Algiers-Cassis, December 2023

Notes

Chapter 1

1 HER COLORS: *Baya: Femmes en leur jardin*, ed. Claude Lemand, Anissa Bouayed, and Djamila Chakour, exhibition catalog, Institut du monde arabe, Paris, and Musées de Marseille/La Vieille Charité (Paris, Marseille, and Algiers: Éditions IMA, Éditions Images Plurielles, and Éditions Barzakh, 2022). Subsequent references are to *Baya: Femmes en leur jardin*.

2 NEWSREEL: Gaumont Pathé newsreel, November 1947, "Exhibition of work by BAYA, a fourteen-year-old Berber girl: a young Berber exhibits in Paris decorative drawings and sculptures that she made with no teacher and no artistic education." Reference: 4748EJ 36004. https://gparchives.com/index.php?urlaction=doc&tab=showExtraits&id_doc=228670&rang=3.

2 FAVORITE PAINTING: Franz Marc, *Die Grossen blauen Pferde* (1911), Walker Art Center, Minneapolis https://walkerart.org/collections/artworks/die-grossen-blauen-pferde-the-large-blue-horses (accessed July 18, 2023).

2 NOTES AND CORRESPONDENCE: References to Marguerite Caminat's notes, her chronologies, and her correspondence concerning Baya are housed at the Archives nationales d'outre-mer, Aix-en-Provence, Benhoura-Baya (73APOM [XXe siècle]), boxes 8 and 9. Referred to subsequently as Caminat Papers.

2 SIBYLLE: Interview with Sibylle de Maisonseul, Marseille, May 25, 2022, and subsequent correspondence.

2 YOUCEF OURAGUI: Interview, June 20, 2022 at the Imprimerie Mauguin, Blida. On Youcef Ouragui, see "Youcef Ouragui ou l'homme mémoire de Blida," *DjaZairess*, August 28, 2010, https://www.djazairess.com/fr/apsfr/86472. Trip to Blida with Selma Hellal, Editions Barzakh, June 20, 2022.

3 BAYA'S DAUGHTER-IN-LAW: Trip to Fort-de-l'Eau with Salima Mahieddine, July 11, 2022.

3 TRIBES OF ALGERIA: There is a rich literature on the carving up and mapping of tribes; for example, Didier Guignard, "Conservatoire ou révolutionnaire? Le sénatus-consulte appliqué au régime foncier d'Algérie," *Revue d'Histoire du XIXe siècle*, no. 41 (2010): 81–95.

Chapter 2

8 AIMÉ MAEGHT: For a life of Aimé Maeght, see Annie Gall, *Maeght le magnifique: Une biographie* (Paris: Bartillat, 1992), and Yoyo Maeght, *La Saga Maeght* (Paris: Robert Laffont, 2014).

8 LEGAL BATTLES: On the fight between Bonnard's heirs and the heirs of Marthe Bonnard, discovered by a genealogist in the winter of 1947—just before Maeght's departure for Algiers—see Françoise Cloarec, *L'indolente: Le mystère Marthe Bonnard* (Paris: Stock, 2016). Bonnard's deceased brother Charles had two children living in Algiers. The fight over the estate lasted until the early 1960s.

8 THE CITY: Jean-Pierre Bénisti, "Les artistes à Alger pendant la Seconde Guerre Mondiale," in *8 novembre 1942: Résistance et débarquement allié en Afrique du Nord: Dynamiques historiques, politiques et socioculturelles*, ed. Nicole Cohen-Addad, Aïssa Kadri, and Tramor Quemeneur (Vulaines sur Seine: Éditions du Croquant, 2021), 259–66.

8 MEET WITH JEAN PEYRISSAC: Interview with Stéphanie Peyrissac, Paris, January 5, 2023. On Peyrissac's painting and sculptures, see Marianne Le Pommeré and Laurent Guillaut, *Peyrissac* (Angers: Expressions contemporaines, 2002).

8 ANDRÉ GIDE: Chronology, Caminat Papers. Under Gide's patronage, Jean Amrouche founded the literary magazine *L'Arche* in Algiers in 1944; Max-Pol Fouchet, a poet and art critic, founded the monthly literary review *Fontaine* in Algiers in 1939.

9 HOW SURPRISED HE WAS: Aimé Maeght to Marguerite Caminat, June 6, 1947, Caminat Papers.

9 SECURED, CRATED, AND FLOWN: Customs lists of paintings and sculptures, Caminat Papers.

9 CAMUS AND BRETON: One newspaper imagines that the two men are meeting for the first time at the Maeght exhibition and shaking hands "in front of one of Baya's statues" (*Samedi Soir*, November 29, 1947, Caminat Papers, from the clipping service L'Argus de la Presse). A handwritten comment in the margins appears to be from Aimé Maeght, or, more likely, his secretary: "these indiscretions amuse them in the wings." Maeght would have subscribed to *L'Argus* and forwarded the articles about Baya's exhibition to Marguerite Caminat in Algiers. On Breton and Baya, electronic communication with Mark Polizzotti, August 29, 2022.

9 CAMUS WILL ATTACK BRETON: "This is the statement that André Breton must have regretted ever since 1933—that the simplest surrealist act consisted in going out into the street, revolver in hand, and shooting at random into the crowd." In Albert Camus, *The Rebel*, trans. Anthony Bower (New York: Vintage, 1993), 93.

10 MAURIAC: Jean Duché, *Le Figaro littéraire*, November 22, 1947.

10 MAURIAC WAS RIGHT: Albert Camus, lecture at the Dominican Convent, Tour Maubourg, December 1, 1946, in Albert Camus, *Œuvres complètes*, vol. 2 (Paris: Gallimard, Bibliothèque de la Pléiade, 2006).

10 QUEEN OF BEGINNINGS: André Breton, "Baya," in *Derrière le miroir* (Paris: Galerie Maeght, November 1947).

10 DAUGHTER AUBE: André Breton, *Lettres à Aube*, ed. Jean-Michel Goutier (Paris: Gallimard, 2009).

10 THE SHOW ON SURREALISM: *Le surréalisme en 1947: Exposition internationale du surréalisme*, présentée par André Breton et Marcel Duchamp (Paris: Maeght, 1947).

10 THE POPE OF SURREALISM: Jean Bedel, "Le Pape du surréalisme rentre en France." Interview with André Breton in *Libération*, May 30, 1946. Bedel, recalling the glory days of surrealism, remarks that André Breton was once the pope of surrealism, "just as, today, Monsieur Sartre is the acclaimed pope of existentialism."

10 THE PLAGUE: See his *Notebooks, 1942–1951*, vol. 2, trans. Justin O'Brien (New York: Knopf, 1965), on his dislike of success and the difficulty of authentic creation in the face of success.

10 A CONTACT: Mohamed Benhoura, Baya's official guardian, asks Camus to keep an eye on Baya in a letter dated September 22, 1947; Camus refers to his request in his November 18 and November 24, 1947, letters to Benhoura, Caminat Papers.

11 "I DON'T KNOW": Conversation with gallery owner and art publisher Claude Lemand, who donated an important collection of Baya's paintings to the Institut du monde arabe, at the Institut du monde arabe, November 12, 2022.

11 CHRISTIAN "BÉBÉ" BÉRARD: Jean Duché, *Le Figaro littéraire*, November 22, 1947.

11 INVITATION: Letter from Aimé Maeght to Madame Vincent Auriol, November 14, 1947, Caminat Papers.

13 DAUGHTER-IN-LAW JACQUELINE: On Jacqueline Auriol, French television archives, obituary: https://www.dailymotion.com/video/xfe9gc. My description is inspired by her 1947 Harcourt studio photo: https://www.photo.rmn.fr/archive/08-537821-2C6NU0TTBOSJ.html

13 NO CREDIT: Peyrissac to Maeght, October 14, 1947, in which he explains to Maeght that Marguerite wants her name kept silent; she considers her mission with Baya accomplished and only needs to reassure Baya's tutor (Benhoura).

13 LISTS: Caminat Papers.

14 THE ANXIOUS SKY: from Breton, "Baya" in *Exposition Baya, Derrière le miroir* (Paris: Maeght Gallery, 1947).

14 DIOR: Dior launched his first collection in 1947. For an illustrated anthology, see Richard Martin and Harold Koda, *Christian Dior*, exhibition catalog (New York: Metropolitan Museum of Art, 1996).

Chapter 3

17 JEAN PEYRISSAC: Jean Peyrissac to Aimé Maeght, October 23, 1947, on preparations for Baya's visit, Caminat Papers.

17 SURVIVED: Biographic details and her recollection of meeting Baya for the first time in her undated notes, Caminat Papers.

18 DIDN'T RECOGNIZE HER: On the linguistic misunderstanding, see the undated notes of Marguerite's first interviews with Baya, Caminat Papers. Three languages are in play in Baya's childhood: the Tamazight Berber of Kabylia, the spoken Arabic or Dardja of Algiers, and the French used with the settlers.

19 SIMONE: Wedding announcement, December 28, 1920, "Henri Farges, Croix de Guerre," courtesy Sibylle de Maisonseul.

19 STRELITZIA: Interview, Sibylle de Maisonseul, Marseille, May 25, 2022.

19 ANISSA BOUAYED: See her essay "Baya: Vie et œuvre," in *Baya: Femmes en leur jardin*, 236–79.

20 HENRI'S NAME: Henri Farges, secretary general of La France Combattante; see *Alger républicain* from 1945 and 1946 (gallica.fr); on rowing, *L'Écho d'Alger*, 1936 (gallica.fr).

20 BAYA'S DESCRIPTION: Baya, "récits d'enfance," in Caminat Papers.

21 CURTAINS: "Interview with André Breton," in *View: The Modern Magazine*, no. 7–8 (October–November 1941): "It seems to me that in times of grave exterior crisis, this curtain, visible or not, expressing the necessity of passing from one epoch to another, ought to make itself felt in some way in every work capable of facing the perspective of tomorrow." The context is Breton's praise of *Nude at the Window* by Morris Hirshfield, a self-taught New York painter he championed during his New York exile. Hirshfield's work is the subject of Richard Meyer's *Master of the Two Left Feet: Morris Hirshfield Rediscovered* (Cambridge, MA: MIT Press, 2022).

21 NEFERTITI'S CHIN: "Baya: récits d'enfance," Caminat Papers.

21 SARA MYCHKINE: Sara Mychkine articles on Baya in *Hiya*. https://hiya.fr/2022/05/18/baya-dans-lombre-du-musee-imaginaire-colonial/.

21 THE FARGES FARM: For an analysis of the photo and Marguerite's account of her first meeting with Baya, see also Anissa Bouayed, "Marguerite Caminat en son temps ou la 'découverte' de Baya," in *8 novembre 1942: Resistance et débarquement allié en Afrique du Nord; Dynamiques historiques, politiques et socio-culturelles*, ed. Nicole Cohen-Addad, Aissa Kadri, and Tramor Quemeneur (Vulaines sur Seine: Éditions du Croquant, 2021), 281–93.

23 FRANCIS JACK LEVY BENSUSAN: In a sidebar on Marguerite Caminat's civil register (état civil) his name appears as "Francis Jack Levy Bensusan MacEwen." Courtesy Sibylle de Maisonseul.

24 A STOPPING POINT: Interview Sibylle de Maisonseul, May 25, 2022.

24 *IF SHE COULD HAVE HER*: "Baya chez Marguerite et Frank," Caminat Papers.

26 BAYA TRAVELED: Details of the trip to Algiers in the chronology, Caminat Papers; Marguerite's bargain with Baya's grandmother, her reactions to the painting, etc., in her file on Baya's early days, Baya: récits d'enfance, Caminat Papers.

26 FÉLIX GOUIN'S LAP: "Baya chez Marguerite et Frank," Caminat Papers.

26 RUE ELISÉE RECLUS: Marguerite's scribble could either mean "rue" or "2 rue." 2, rue Elisée Reclus is the same building where Jean Senac, a poet who admired and collaborated with Baya, lived in the basement apartment. He was assassinated at that address the night of August 29–30, 1973.

27 BAYA IN THE CITY: Baya chez Frank et Marguerite, Caminat Papers.

28 VERY BEAUTIFUL PERIOD: Marguerite chronology, Caminat Papers.

28 MAY 1, 1945: The most vivid source is Annie Rey-Goldzeiguer, "Le monde du contact laminé" in *Aux origines de la guerre d'Algérie, 1940–1945: De Mers-el-Kébir aux massacres du Nord-Constantinois* (Paris: La Découverte, 2006), 425–27.

29 PAUL TUBERT: *L'Écho d'Alger*, May 1, 1945, 2. On the demonstration, "De légers désordres ont été provoqués par des éléments étrangers aux organisations syndicales," *L'Écho d'Alger*, May 3, 1945, 3, and "Des éléments troubles provoquent des désordres dans divers centres de l'Algérie," *Dépêche algérienne*, May 3, 1945, 2.

Chapter 4

30 SHE POSES: On Mireille as a seamstress, interview with Sibylle de Maisonseul, Marseille, May 25, 2022; On Baya and sewing magazines, interview, Salima Mahieddine, Algiers, July 11, 2022.

30 INSPIRED BY SCARLETT: *Autant en emporte le vent*, the first French translation of Margaret Mitchell's novel, was published by Gallimard in 1939, banned

by the Nazis in 1941, then reissued in 1945. See Pierre Assouline, *Gaston Gallimard: Un demi-siècle d'édition française* (Paris: Balland, 1984).

Chapter 5

37 EUROPEAN AND INDIGENOUS ARTISTS: On Racim, in addition to Roger Benjamin, *Orientalist Aesthetics: Art, Colonialism, and French North Africa, 1880–1930* (Berkeley: University of California Press, 2003), see Anissa Bouayed, "Histoire de la peinture en Algérie: Continuum et ruptures," *Confluences Méditerranée* 81, no. 2 (2012): 163–79.

38 RACIM'S WERE MULTIDIRECTIONAL: Benjamin, *Orientalist Aesthetics*, tracking the complex relations, influences, and counterinfluences of artists, museums, and institutions in colonial Algeria in the period just before Baya's birth. Racim's mastery of the Islamic miniature and his precolonial themes, coupled with his success in Europeans terms, make him an exceptional negotiator of what Benjamin calls "the path of the hybrid" (235).

38 MURAL: "Panneau de revêtement à la joute poétique," Département des Arts de l'Islam, Musée du Louvre, https://collections.louvre.fr/en/ark:/53355/cl010327350 (accessed February 1, 2023), currently exhibited at the Louvre, room 186, Denon wing, level -2. I'm grateful for the conversations with Ameziane Ferhani and Walid Bouchakour that led me to these sources.

39 ART ON BOTH SIDES: See Nadira Laggoune-Aklouche, "Resistance, Appropriation and Reappropriation in Algerian Art," *Modern & Contemporary France* 19, no. 2 (May 2011): 179–93, and Natasha Boas, in *Baya: Woman of Algiers*, exhibition catalog, Grey Art Museum, New York University, January 9–March 31, 2018.

39 TURKISH PALACE: For a history of both the Oriental Palace and the Winter Palace, see Marion Vidal-Bleu, *Villas et Palais d'alger* (Paris: Place des Victoires, 2014).

39 MINIATURES: "Je ne sais pas, je sens . . ." Baya interview with Dalila Morsly, Blida, 1993, reprinted in *Baya: Femmes en leur jardin*, 52–55.

Chapter 6

40 A MAN WITH SECRETS: Frank McEwen's marriage to Marguerite was formally dissolved in 1949. Noted on Marguerite Caminat's civil register, courtesy Sibylle de Maisonseul. His correspondence with his aunt Esther Bensusan Pissarro and her husband, Lucien Pissarro, are part of the Pissarro archives at the Ashmolean Museum of Art and Archeology in Oxford. They begin in 1928 and go to 1939 (some 240 letters), many about Frank's financial needs and his caretaking of the house and "cabanon" on the Chemin de l'Hubac. The articles about Frank in *Littoral Magazine* testify to his inclusion in the group of local

artists: the poet Léon Vérane, who writes about his restoration business, and Simon Ségal, whose art exhibition he reviews, both in *Littoral*—Segal and Vérane were also part of Marguerite Caminat's milieu, according to Anissa Bouayed (Vérane worked as a librarian in Toulon, like Marguerite). A letter from Esther Pissarro to Frances Wood in 1945 advises her not to resume contact with Frank.

42 HE WRITES TO LUCIEN AND ESTHER: Frank McEwen to "My dearest friends," August 27, 1937, Pissarro archives, Ashmolean Museum, Oxford, England.

42 TWO STUDENTS: Frank McEwen letter to Esther and Lucien Pissarro, January 31, 1938, Pissarro archives, Ashmolean Museum, Oxford, England.

42 FUTURE WIVES: Michael Gross, "Mary, Mary, Quite Contrary: The Life and Loves of Mary McFadden," *New York Magazine*, March 26, 1990, 40–48.

43 MARKED HIM AS A JEW: With the British bombing of the French fleet in Mers-el-Kébir in July 1940, the Vichy government in Algiers broke off all diplomatic relationships with Great Britain; consular duties were taken over by the United States

In theory, British subjects were not subject to Vichy's anti-Jewish statutes, though a file at the Foreign Office outlines the situation of at least one British subject, Algerian born, whose business was seized and given to an "Aryan" administrator. The British protest was mediated through the American consulate: "His Majesty's Government will claim similar compensation for any other British subject of the Jewish faith in Algeria who is treated as Mr. Dahan has been treated by the French authorities." FO 111/15 British National Archives, foreign office.

44 IN HIS LAST LETTER: Frank McEwen to "My dear dear Maître and Friend," dated 1939, Pissarro archive, Ashmolean Museum, Oxford, England.

44 BRITISH GENERAL INNES IRONS: Obituary, Frank McEwen, *The London Times*, January 17, 1994, reprinted in African Artists blogspot, https://africanartists.blogspot.com/2015/04/ (accessed February 1, 2023).

46 READ WRITES: Brochure "Peintures d'enfants anglais: Exposition organisée par le British Council," Paris: 1945, preface by Herbert Read, 3–6; noted in Marguerite's chronology, Caminat Papers.

47 HE SENDS THE CATALOG: See figure 13, cover of the brochure from the May 1945 exhibition, *Peintures d'enfants anglaise* (Paintings by English Children). Marguerite notes the arrival of the catalog and Baya's response as part of her Chronology, Caminat Papers.

Chapter 10

63 PAINTINGS AND STATUETTES: Jean Peyrissac to Aimé Maeght, October 27, 1947, and Marguerite Caminat to Aimé Maeght (n.d., copy for memory), Caminat Papers.

63 DRESSED AT ALL TIMES: Marguerite Caminat McEwen to Aimé Maeght before Baya's departure (n.d., copy for memory) Caminat Papers.

63 HE HAS ASSISTED: Jean Peyrissac to Aimé Maeght, October 27, 1947. The shipping forms and inventory of works are included in Caminat Papers.

63 SCHOOLS AND WORKSHOPS: See *Marie Cuttoli, The Modern Thread from Miró to Man Ray*, ed. Cindy Kang et al., exhibition catalog (Philadelphia: Barnes Foundation, 2020). The Palais Oriental, now Bibliothèque Ben Cheneb, trained young Algerian women in needlework in the late nineteenth and early twentieth centuries. The tile work has a supernatural quality: http://arts.medit.occ.pagesperso-orange.fr/palor.htm. For the early history of the embroidering workshops, see Rebecca Rogers, *A Frenchwoman's Imperial Story: Madame Luce in Nineteenth-Century Algeria* (Palo Alto: Stanford University Press, 2013).

64 ELLE MAGAZINE: *Elle*, December 23, 1947, photo caption, article unsigned.

64 DISTRAUGHT: Marguerite Caminat McEwen to Aimé Maeght, copy for memory, n.d., Caminat Papers.

65 AS I WRITE YOU: Marguerite Caminat to Aimé Maeght, November 10, 1947, copy for memory, Caminat Papers.

65 BENHOURA REFERRED: Mohamed Benhoura to Albert Camus, September 22, 1947, asking Camus to ask Maeght to show him Baya's paintings and to keep an eye out for her: "You can tell [Maeght] that you're a friend of the Cadi who liberated Baya from her family."

65 WITHOUT INCIDENT: Telegram, October 13, 1945, Caminat Papers.

Chapter 11

66 BY LODGING BAYA: Rosita Wertheimer to Marguerite Caminat, November 11, November 23, and December 10, 1947, Caminat Papers.

66 UNLOCKING ROSITA WERTHEIMER'S STORY: Interviews with Agnès Wertheimer, Rosita Wertheimer's granddaughter and Marcel Wertheimer's daughter, June 2023. Philippe Lançon, "Janet Malcolm en fait tout un Plath," *Libération*, February 8, 2023, reviewing Janet Malcolm's *La femme silencieuse: Sylvia Plath et Ted Hughes*, translated by Jakuta Alikavazovic (Paris: Éditions du Sous-Sol, 2023).

66 WHAT IT WAS LIKE: Interviews with Agnès Wertheimer, Paris, June 17, 2023, and Louveciennes, September 22, 2023.

67 RENÉ WERTHEIMER: Wertheimer was the director of *Le Figaro* for a year; for a time, he owned the newspaper *L'Eclair*, in which he published stories by Colette. His purchase of the chateau for his first wife, the painter Jacqueline Wertheimer, is described on the website of the town of Songeons in Picardy:

https://www.songeons.fr/monuments-chateau-statues.php (accessed July 23, 2023). Rosita Jauregui-Diaz's marriage to René Wertheimer was announced in 1930 (*Le Figaro*). Françoise, Rosine, Philippe, and Marcel were born in 1922, 1924, 1926, and 1930, respectively.

68 HER HUSBAND'S BANK ACCOUNTS: In 2002, the eldest daughter Françoise Wertheimer, on behalf of René and Rosita Wertheimer's children, filed a claim to their parents' dormant Swiss bank accounts, in response to a notice that they were eligible for lost assets owed to victims or targets of Nazi persecution: https://www.crt-ii.org/_awards/_apdfs/Werthmeier_Rene.pdf.

68 MARCEL WERTHEIMER'S BRILLIANT CAREER: On the history of the Institut agricole d'Algérie and Marcel Wertheimer's training as an agronomic engineer, see "Témoignages pour une école." https://www.aptalumni.org/global/gene/link.php?doc_id=1365&fg=1.

69 RICE AND COUSCOUS: Madame Wertheimer to Marguerite Caminat, Friday (n.d.), note in pencil, "before arrival," Caminat Papers.

69 CLOSER TO HER HEART: Two preparatory letters from Madame Wertheimer to Marguerite Caminat, dated Friday, and noted "before arrival," and October 8, 1947, Caminat Papers; five subsequent letters after Baya's arrival.

69 TENDER LETTER: Philippe Wertheimer to Mireille Farges, November 14, 1947, Caminat Papers.

70 POISSON D'OR: Baya to Marguerite, December 22, 1947 (on Maeght Gallery letterhead), Caminat Papers.

70 CAN WE REALLY KNOW: Madame Wertheimer to Marguerite Caminat, undated letter, marked "two days after the opening." On December 10, in another letter to Marguerite, she remarks, "It's rare for her to come out of herself."

Chapter 12

71 NELLY AND FRANK: Their joint opening is advertised in *L'Écho d'Alger*, June 16, 1944.

71 SOME KIND OF A SPY: Interview with Sibylle de Maisonseul, Marseille, May 25, 2022. Jean de Maisonseul, who loved a good story, surmised—tongue in cheek—that McEwen was a spy.

72 HEARTBROKEN: Nelly Marez-Darley to Marguerite Caminat, October 21, 1947, Caminat Papers.

72 CHARMING CREATURE: Nelly Marez-Darley to Marguerite Caminat, October 21, 1947, Caminat Papers.

72 AFTER THE OPENING: Nelly Marez-Darley to Marguerite Caminat, November 21, 1947, Caminat Papers.

Chapter 13

77 THE WORDS "SÉTIF" OR "GUELMA": On the Sétif and Guelma massacres, the uneven death count, and the opposition within Chataigneau's administration to his attempts to investigate: Rey-Goldzeiguer, *Aux origines de la guerre d'Algérie, 1940–1945*, 278. On the massacres, the failure of justice, and the revelations by José Aboulker, among others, see Jean-Pierre Peyroulou, *Guelma, 1945: Une subversion française dans l'Algérie coloniale* (Paris: Éditions la Découverte, 2009). The debates in the National Assembly throughout the month of July give a good sense of the misunderstanding in government.

77 AGITATORS: "Des Européens massacrés à Sétif et à Périgotville," *Combat* [Agence France-Presse], May 15, 1945, 1

78 DE GAULLE: For de Gaulle's compliment, see his *Mémoires*, vol. 3, "Le Salut" (Paris: Plon, 1959), 261. Chataigneau's staff opposed him at every opportunity. While the governor general was in Paris, the moderate leader Ferhat Abbas came to the Palais d'Hiver to congratulate the government on the end of the war and was promptly arrested. Abbas, a pharmacist from Sétif whose party had only just evolved from a gradualist party of integration to a proindependence party, stayed in jail for nearly a year.

78 EACH EUROPEAN CASUALTY: Division territoriale de Constantine, "Victimes européennes décédées," in *La guerre d'Algérie par les documents*, vol. 1, *L'Avertissement, 1943–1946*, ed. Jean-Charles Jauffret (Vincennes: Service Historique de l'Armée de Terre, 1990), 403–4.

78 "L.V.", THE JUDGE: Alice Kaplan, *Looking for The Stranger: Albert Camus and the Life of a Literary Classic* (Chicago: University of Chicago Press, 2018), 205.

78 COMMISSIONS TO INVESTIGATE: René Gallissot and Jean-Louis Planche, "Yves Chataigneau," in the *Dictionnaire Maitron Algérie*, https://maitron.fr/spip.php?article19589 (accessed July 9, 2023), paint a picture of Chataigneau as turning a blind eye to the militias; Aboulker praises Chataigneau in the national assembly (July 10 session, see below, **a war of numbers**) for the arrest of five of them.

79 THE FRONT PAGE OF *COMBAT*: "À Dachau subsistent le décor et les accessoires de l'horreur," *Combat*, June 20, 1945. The attacks on civilians in Guelma, unprovoked by any violent nationalist demonstration, lasted through June 26. On the disposal of victims' bodies in lime kilns, see the testimony of Marcel Reggui, who visited Guelma after the disappearance of two brothers and a sister and whose report, written in 1946 and kept private until 2008, describes the decision to incinerate the victims in the lime kilns, the ten days of nonstop burning, and the intolerable odor. Marcel Reggui, *Les Massacres de Guelma: Algérie, mai 1945: Une enquête inédite sur la furie des milices coloniales* (Paris: Éditions la Découverte, 2008).

79 A WAR OF NUMBERS: See the debates in the National Assembly [Débats de l'Assemblée Consultative Provisoire], July 11, 1945 (session of July 10) (https://gallica.bnf.fr/ark:/12148/bpt6k9617650p/f2.item) and July 19, 1945 (session of July 18) (https://gallica.bnf.fr/ark:/12148/bpt6k96176298/f1.item). On debates over the number of Algerians killed in Sétif and Guelma, see Joshua Cole, "Massacres and Their Historians: Recent Histories of State Violence in France and Algeria in the Twentieth Century," *French Politics, Culture, and Society* 28, no. 1 (2010): 106–26, and Annie-Rey Goldzeiguer, *Aux origines de la guerre d'Algérie*, 23, for the surprisingly specific number of Algerian victims ("1,340") given by the governor general; the estimates have varied over the years from 45,000 to 85,000.

79 PAUL CUTTOLI: The debate on Algeria in the Assemblée Consultative on July 10. The debate between José Aboulker and Paul Cuttoli (the ex-husband of Peyrissac's friend Marie) was covered in *Alger Républicain* on July 11, 1945.

80 THE RIGHT-WINGERS: See the pamphlet by Paul-Dominique Crevaux, *Yves Chataigneau: Fossoyeur Général de l'Algérie* (Algiers: Les Éditions Nationales, 1948).

80 SINGLE LEGISLATIVE BODY: For a critique of the two separate and unequal electoral colleges of the Algerian Assembly, see, from unexpected quarters, John F. Kennedy's July 2, 1957, speech to the US Senate supporting Algerian sovereignty: https://www.jfklibrary.org/archives/other-resources/john-f-kennedy-speeches/united-states-senate-imperialism-19570702 (accessed July 19, 2023). The governor general who succeeded Chataigneau, Naegelen, fixed the first 1948 elections so that the second college elected no representatives from the nationalist parties.

81 MARRIAGE OF LOVE: Camille Ernest, the newly arrived prefect of Algiers, in his November 10, 1947, speech to the Conseil General of Algiers. He is quoting from Deputy Albin Rozin's 1895 speech to the National Assembly: "'Il faut, pour que les Musulmans soient heureux, que les colons le soient aussi; il faut, pour que les colons soient heureux, que les musulmans le soient également. C'est un mariage de raison qui doit être accompli.' Eh bien, c'est à ce mariage de raison que je vous convie aujourd'hui, avec le fervent espoir qu'il se transformera un jour prochain en un mariage d'amour." Archives nationales d'outre-mer, GGA 8CAB 61.

83 A DANGEROUS GAME: Ethan Katz describes the traces of Ben Ghabrit's actions as "fragmentary scraps of a great jigsaw puzzle." "Did the Paris Mosque Save the Jews?" *Jewish Quarterly Review* 102, no. 2 (Spring 2012): 256–87. See also Mohammed Aïssaoui's portrait of this fascinating cleric in *L'étoile jaune et le croissant* (Paris: Gallimard, 2012). Through a series of interviews with people who knew or whose parents benefited from Ben Ghabrit's protection during the Occupation, Aïssaoui questions his exclusion from Yad Vashem's list of

"The Righteous among the Nations"—which includes not a single Arab or Muslim from the Maghreb.

83 L'AURORE: André Chassaignon, "Monsieur Vincent Auriol visite l'Afrique du Nord à Paris," *L'Aurore*, August 20, 1947, p. 1.

83 EDITORIALS: Albert Camus, "Crise en Algérie," in *Combat*, May 1945, reprinted in "Crisis in Algeria," *Algerian Chronicles*, ed. Alice Kaplan, trans. Arthur Goldhammer (Cambridge, MA: Harvard University Press, 2013), 85–107.

84 GROUND ZERO: Henri Aboulker, "Dialogue avec mon ami musulman," June 26, 1945, and "Nos amis les colons," July 21, 1945, two in a series of front-page editorials in *Alger Républicain*.

84 THE SPECIAL ORGANIZATION: On the birth of the O.S., see Hocine Aït Ahmed, *Mémoires d'un combattant: L'esprit d'indépendance, 1942–1952* (Paris and Algiers: Éditions Bouchène, 1990), 125–48.

85 NELLY MAREZ-DARLEY: Nelly Marez-Darley to Marguerite Caminat, November 21, 1947, Caminat Papers.

86 MARGUERITE'S FRIEND MARCELLE SIBON: Marcelle Sibon to Katherine Anne Porter, February 2, 1945. University of Maryland Special Collections and University Archives, Katherine Anne Porter papers.

Chapter 14

87 HER FRIEND'S TONE: Marcelle Sibon to Marguerite, November 14, 1947, Caminat Papers.

87 HAPPINESS IN PARIS: Marcelle Sibon to Marguerite Caminat, October 20, 1947, Caminat Papers. For a fuller picture, see her correspondence with Katherine Anne Porter, 1936 and thereafter at University of Maryland Special Collections and Archives. They include details of Marcelle Sibon's wartime exodus and the boxes of food and supplies she received from Porter after they resumed contact in 1945, as well as her circle of writers and editors. The Katherine Anne Porter side of the correspondence is housed in the Porter archives at the Library of Congress, Washington, DC.

88 THE RUE DE TÉHÉRAN: Marcelle Sibon to Marguerite Caminat, November 21, 1947, Caminat Papers.

88 FRANK CAME TO THE OPENING: Baya to Marguerite, dated "after the opening" (après le vernissage), Caminat Papers.

88 GALLERY OWNERS: Marcelle Sibon to Marguerite Caminat, November 21, 1947, Caminat Papers.

Chapter 15

92 THE INK: René Guilly, "Baya, la petite fille de la sorcière," *Combat*, November 14, 1947.

93 HENRI SMADJA: As told by Roger Grenier and recounted numerous times, for example, by Herbert Lottman, *Camus: A Biography* (New York: Doubleday, 1979), 423.

93 THE TITLE: Albert Camus, "La Grèce en haillons," June 5, 1939, in *Alger républicain*, the first of a series on *Misère de la Kabylie*.

94 RECTIFICATIONS: Lists of inaccuracies in the press coverage of the Maeght exhibition, Caminat Papers.

94 NEW MAGAZINE: "Une Française, une Américaine, une Canadienne, et une Kabyle prouvent que tout est possible," *Elle*, December 23, 1947, 3, unsigned.

96 XAVIER LE CLERC: Xavier Le Clerc, *Un homme sans titre* (Paris: Gallimard, 2022), 16–17.

97 LE GRAND ZOISEAU: "Le Grand Oiseau," *Derrière le miroir*, back cover (Paris: Maeght Gallery, 1947).

97 A MYTHICAL CHARACTER: Edmonde Charles-Roux, "Baya la Douce," in *Baya*, exhibition catalog, Musée Réattu, Arles, April–June, 2003.

98 PEYRISSAC: L'exposition Baya, *Derrière le miroir*.

99 THE SOURCE OF THE LIES: Rosita Wertheimer to Marguerite Caminat, dated "mardi matin," Caminat Papers.

99 NUMEROUS VISIONS: Marguerite Caminat notes on interviews with Baya, "Récits de l'enfance," n.d., 73APOM 8.3, Caminat Papers.

Chapter 16

100 GOLDEN WITH LEAVES: Baya to Marguerite (from Maeght Gallery), November 17, 1947, Caminat Papers.

101 "NICE" AND "VERY NICE": Baya to Marguerite, November 17, 1947 (dictated), Caminat Papers.

101 AIMÉ MAEGHT WIRES: Telegram dated November 21, 1947, Caminat Papers.

101 MY OPENING: Baya to Marguerite, "Bien chère Marguerite," letter dated "après le vernissage."

103 STRUCK BY THIS WORLD: "I'll find it very strange to see myself later," Baya to Marguerite Caminat, December 24, 1947, Caminat Papers. On the newsreel, see chapter 1, above.

103 SAINT CATHERINE'S DAY: Baya to Marguerite, n.d., a few days after November 25, 1947, St. Catherine's day, Caminat Papers.

104 *LE MONDE* ALSO PREDICTS: Review of the Maeght show, *Le Monde*, November 24, 1947.

105 THE LITTLE UNTOUCHABLE: Robert Charroux, "Enfants prodigues du 20ème siècle: Ervin Lazlo (Franz Liszt no. 2) et Baya (sorcière)," n.d., 1947, Caminat Papers.

105 *BLANQUETTE DE VEAU*: Baya to Marguerite, dictated on Maeght letterhead, n.d. but close to the Christmas holidays. Caminat Papers.

105 A CHARMING LETTER: Albert Camus to the Cadi Benhoura, November 24, 1947, Caminat Papers.

105 CAMUS'S REASSURANCE: Cadi Benhoura to Baya, November 28, 1947, Caminat Papers.

107 HIS PROFESSION: "Arriving passenger and crew lists," Aimé Maeght traveling on the S.S. *Nieuw Amsterdam*, arriving from Rotterdam, December 2, 1947, return planned for December 20 (accessed on ancestry.com, August 21, 2023).

107 EXCLUSIVE RIGHTS: Aimé Maeght to Marguerite Caminat, n.d., on Holland Line letterhead, letter fragment, 3, 1–2 missing, Caminat Papers.

109 ANDRÉ CHASTEL: André Chastel, "Vraie et fausse naïveté," *Une semaine dans le monde*, November 29, 1947.

109 THE BUYERS AND THE PRICES: Caminat Papers. The lists are sometimes inconsistent. The purchase of *Femme au vase jaune entre les rideaux* for 15,000 old francs is attributed to Mme Guggenheim on one list, but appears on a list of "reserved paintings" under the name "M. Deltcheff." Of that sale, Baya should have received 7,500 francs. A worker's minimum monthly salary in 1947 was set at 7,000 francs. See "Evolution des salaires et des traitements en 1947," *Economie et statistique*, https://www.persee.fr/doc/estat_1149-3720_1948_num_3_2_10168 (accessed August 21, 2023).

110 TWO MONEY ORDERS: Undated letter from Guiguite Maeght to Marguerite Caminat. Caminat Papers.

110 TWO GENERATIONS REMOVED: Interview with Stéphanie Peyrissac, January 2023.

111 AURIOL'S GREAT-GRANDCHILDREN: Electronic communication to the author from Rachel Auriol, January 3, 2023; from Mathias Millon, in charge of documentary research at the French National Archives at Pierrefitte-sur-Seine, February 24, 2023; and from Muriel Barbier in the collection of presidential gifts at the "Mobilier National," March 9, 2023.

111 HEAD ARCHIVIST FOR DIOR: Electronic communication to the author from Solène Auréal-Lamy, Responsable de la documentation et des achats Dior Heritage, March 9, 2023.

111 I GET LUCKY: Gazette Drouot, Hôtel des ventes de Boulogne-sur-mer, lot 219, "Femme et végétations" circa 1945, acquired by Nelly Marez-Darley in Algiers

between 1943 and 1945, signs of pinholes and water stains, sold at auction, June 6, 2022: https://drouot.com/l/18273178-mahieddine-baya-1931-1998-br-frau-und-vegetation-ca-1945-br.

112 **WERTHEIMER CHILDREN**: See chapter 11, "Baya's Hosts," on the Wertheimer family.

112 **WEARING A PURPLE HAT**: Is it a hat or a scarf? Opinions are divided, though I opt for the hat because of the extravagant headdresses in many of Baya's paintings from this early period, reminiscent of the models in 1940s sewing magazines. Agnès Wertheimer suggests in an electronic message dated January 2023 that the painting may well have been a gift to Rosita Wertheimer to thank her for lodging Baya. So far we've found no letter dating the gift, though the style is reminiscent of her earliest paintings from 1945–46.

Chapter 17

115 **TRULY BEAUTIFUL**: Guiguite Maeght to Marguerite Caminat on Baya's patience with photographers, undated letter marked "just before the opening"; Baya to Marguerite Caminat, undated letter marked "after the opening"; Rosita Wertheimer to Marguerite Caminat, undated letter marked "Tuesday morning," all from November 1947, Caminat Papers.

115 **A GENRE HE PURSUED**: Telephone interview with Céleste Trétout and Eric Vibart, Association des amis d'André Ostier, November 8, 2023.

117 **CHARLES-ROUX'S 1948 PORTRAIT**: *Vogue Magazine*, February 1948, 88–89, 103. Photograph by Arik Nepo.

117 **EDMONDE CHARLES-ROUX**: Dominique de Saint Pern, *Edmonde, l'envolée* (Paris: Stock, 2022) on her beginnings at *Vogue*.

117 **WRONG**: Marguerite Caminat's copy of the February 1948 issue of *Vogue*, Caminat Papers.

117 **PHOTOGRAPHIC ESSAY**: Desmond Russell, "Les Enfants et leurs Mères," *Vogue: Paris*, February 1948, 85–87.

119 **ROSITA WERTHEIMER'S WHIMSICAL PREDICTION**: Mme Wertheimer to Marguerite Caminat, December 10, 1947, Caminat Papers.

119 **A FABRIC**: Procès verbal de constat, March 3, 1948, and accompanying letter to Marguerite Caminat, March 10, 1948, Caminat Papers.

119 **ONLY STARON**: Marguerite Maeght to Marguerite Caminat, undated letter, probably spring 1948.

Chapter 18

120 **THE GUEST BOOK**: Last displayed in the 1998 Baya retrospective at the Maeght Gallery. Interview with Hugo Guillotin, Maeght Gallery, 42 rue du Bac, Paris, January 6, 2023.

120 MY OWN EYES: André Marchand to Marguerite Caminat, December 29, 1947, Caminat Papers. Letter © Artists Rights Society (ARS), New York / ADAGP, Paris.

120 THE PAINTERS' FACES: Rosita Wertheimer to Marguerite Caminat, dated "two days after the opening," Caminat Papers.

121 YOU WOULD HAVE BEEN HAPPY: Rosita Wertheimer to Marguerite Caminat, two days after the opening ["deux jours après le V"], Caminat Papers.

121 THE GLORIES: Aimé Maeght to Madame Vincent Auriol, November 14, 1947.

121 TO PAINT LIKE A RAPHAEL: The source is an editorial by Herbert Read in the *Times*, October 27, 1956: "Since the remark you attribute to Picasso in your leading article today was made in my presence, and since it has gained currency in several distorted forms, perhaps you would allow me to put on record what Picasso actually did say. I had been showing him around an exhibit of children's drawings sent to Paris by the British Council. He looked at them very carefully, and when he was finished, he turned to me and said (I will not pretend to remember the French words he used); 'When I was the age of these children I could draw like Raphael: it took me many years to learn to draw like these children.'" Roland Penrose reveals the circumstance of Picasso's famous quip in his *Picasso: His Life and Work* (Berkeley: University of California Press, 1981), 275.

122 HOPI RESERVATION: On Breton in the United States, see Mark Polizzotti, *Revolution of the Mind: The Life of André Breton* (New York: Farrar, Straus, and Giroux, 1995), 505. On his enthusiasm for Native American art, see Jean Bedel, "La Pape du surréalisme rentre en France," interview with André Breton in *Liberation*, May 30, 1946.

122 MATISSE BROUGHT: Benjamin, *Orientalist Aesthetics*, on Matisse in Algeria.

123 AFTER WE WATCHED: Baya to Marguerite, December 3, 1947, Caminat Papers. Aimé Maeght discussed his documentaries on the painters he represented in a radio interview by Alain Bosquet in February 23, 1971, Radio France, replayed on France-Culture: "I am the only person to have films about Bonnard. He was never filmed by anyone other than me. I have films on Matisse while he was creating a portrait of my wife, among other works. On Braque, I have 800 meters of film, on Miró, I have seven films." https://www.radiofrance.fr/franceculture/podcasts/les-nuits-de-france-culture/aime-maeght-je-suis-le-seul-a-avoir-des-films-sur-bonnard-ou-de-matisse-faisant-le-portrait-de-ma-femme-8609594.

123 AS COMFORTABLE: "Journal éclair" on the Baya exhibition, Pathé Actualités, https://gparchives.com/index.php?urlaction=doc&tab=showStory&id_doc=228670&rang=1. Référence 4748EJ36004, Exposition Oeuvres de Baya, Fillette Berbère de Quatorze Ans: Une jeune Berbère expose à PARIS des dessins décoratifs et des sculptures qu'elle a exécutés sans maître et sans éducation artistique.

123 ARTICLE ON BAYA: "Baya ou la Révélation de l'art musulman," *Alger soir* (December 17, 1947).

124 CONSECRATED IN *VOGUE*: Bertram D. Wolfe, "Rise of Another Rivera," *Vogue*, 92:9, November 1, 1938, 64, 65, 131. A common theme of the press coverage of Kahlo's exhibition was her emergence from the shadows of her better-known husband, Diego Rivera.

124 HER DISDAIN: Frida Kahlo to Nickolas Muray, February 16, 1939, Nickolas Muray Papers, Smithsonian Institution, https://www.aaa.si.edu/collections/items/detail/frida-kahlo-paris-france-letter-to-nickolas-muray-new-york-ny-491 (accessed August 8, 2023). She was irritated in part by the fact that he mixed her art with "junk" purchased on his travels in Mexico.

Chapter 19

125 BAYA HAS TRULY LEFT HELL: Jean Peyrissac, "Exposition Baya" in *Derrière le miroir*, no. 6 (Paris: Galerie Maeght, 1947), 2, dated Algiers 1947. In her own notes on Baya's childhood, Marguerite seems to be quoting Peyrissac's essay, with one important addition: In her version, Baya's tragedy exposes the tragedy of an entire society: "None of the faces she painted reveal the hell of her childhood," she wrote, "the great dark, tragic fresco that was the life of her people." Notes on Baya's childhood experiences, n.d., Caminat Papers.

126 MARGUERITE'S CHRONOLOGY: Chronology, Caminat Papers.

126 A CENOTAPH: On Baya and mourning, see Ranjana Khanna's insightful "Latent Ghosts and the Manifesto: Baya, Breton, and Reading for the Future," in *Algeria Cuts: Women and Representation, 1830 to the Present* (Stanford: Stanford University Press, 2008), 173–210.

127 AUTOMATIC WRITING: André Breton, *Manifestoes of Surrealism*, trans. Richard Seaver and Helen R. Lane (Ann Arbor: University of Michigan Press), 29.

127 CHARLES ESTIENNE: "Sur Baya," 1947 typescript discovered by Anissa Bouayed in Caminat Papers and reprinted in *Baya: Femmes en leur jardin*, 34–35.

128 VISIONS OF THE ORIENT: Paul Chadourne, "Dix artistes peignent 'La Girafe' et Baya met le rêve en couleurs," untitled clipping, 1947, Caminat Papers.

Chapter 20

129 THE TRIUMPHANT RETURN: Yvonne Lartiguaud, "Baya peintre et sculpteur de quatorze ans est revenue hier de Paris," *Alger Républicain*, January 7, 1948.

129 BAYA'S FATIGUE: Marguerite Maeght to Marguerite Caminat, draft copy conserved by Marguerite Caminat, dated March 1948, Caminat Papers.

130 EXAMPLES OF "ART BRUT": See Anissa Bouayed, "Baya, vie et oeuvre," *Baya: Femmes en leur jardin*, 255–56, for an account of Dubuffet's mixed responses to Baya's work. Disappointed after their 1948 meeting (her art was "too nice," he wrote to Jean Paulhan) he suggested to Marguerite that Baya should take up glue paint. In 1978, Marguerite donated a number of Baya's gouaches to his collection in Lausanne. Under the direction of Michel Thévoz, the Collection d'Art Brut purchased other paintings. There are now twenty-five works by Baya in the Lausanne collection, many painted before 1947.

131 COMES TO NAUGHT: There are countless versions of the Baya-Picasso encounter, which Baya describes humorously in a 1993 interview with Dalila Morsly, "Je ne sais pas, je sens," reprinted in *Baya: Femmes en leur jardin*, 52–55. Correspondence between Guiguite Maeght, Marguerite Caminat and the Madoura studio tells the story of her unfinished work. Caminat Papers.

131 NO LONGER VENTRILOQUIZED: Baya to "Ma très chère petite Maman," October 9, 1950, Caminat Papers.

134 DENISE CHESNAY'S OWN FUTURE: Denise Chesnay, born Denise Bensimon in Algeria in 1923, moved to Paris in 1945 to paint. An up-and-coming "lyric abstract" painter, she was included in Maeght's 1950 edition of "Les Mains éblouies." Michel Ragon's essay in *Derriere le miroir* no. 32, October 1950, finds in the group a renewal of the three major tendencies of art between the wars: expressionism, surrealism, and abstraction. I identified Chesnay via a letter Maeght sent to Peyrissac on October 27, 1947, as he was organizing the first show of "Les Mains éblouies" (Jean Peyrissac archives, coll. Stéphanie Peyrissac). He was concerned he hadn't heard from Marguerite and imagined that Nelly Marez-Darley, irked not to have been included in the "Mains Eblouies" group, had told Marguerite he was exhibiting Chesnay. Worried that despite her "noble spirit," Marguerite was angry and hurt, he urged Peyrissac to find out what was wrong. I've found no other mention of Denise Chesnay in the Caminat papers—and Baya refers to her only as "Denise," but Peyrissac's letter and the confirmation by Chesnay-Desjardin's children of her relationship with McEwen is conclusive.

134 YOUNG PAINTERS: For the catalog of the exhibition, see *Young Painters: An Exhibition of Paintings of the École de Paris*, arranged by the British Council in Paris for the Scottish Committee of the Arts Council (Edinburgh: Arts Council of Great Britain, 1952).

134 THE DEMISE OF THEIR RELATIONSHIP: Denise Desjardins, *Jeu de l'amour et de la sagesse* (Paris: Albin Michel, 1989).

134 HER EARLY DAYS IN PARIS: For Denise Desjardin's memories of life in the Paris art world, as well as photographs of the artist and her work from 1940s and 1950s, see Guillaume Darcq's 2007 documentary, "Denise Desjardins: De

la révolte au lâcher-prise," quoted here: https://www.youtube.com/watch?v=kfRwaid3PUQ (accessed January 20, 2023).

Chapter 21

136 BAYA TO OULD RUIS: Chronology, Caminat Papers.

136 ADOPTIVE MOTHER: In private correspondence from the 1960s (Caminat Papers). Baya addresses Marguerite as "my very dear mother"; "the kindest of mothers" (in a Mother's Day letter); in interviews she specifies "adoptive mother" or "adoptive family." See, for example, *El Moudjahid*, interview with M. Baghdadi, November 22, 1979; *Horizons 200*, interview with Samit, April 29, 1986; an interview with Dalila Morsly in 1993, reprinted in *Baya: Femmes en leur jardin*, 52–53: "I started very young, I started with Marguerite, my adoptive mother . . . my adoptive mother wanted to make sure that I didn't lose my religion."

137 DOUBTLESS BY BENHOURA: In 1957–1958, Benhoura would play an important role in French policy and propaganda aimed at Muslim women. What light these political positions shed on his personal relations with Marguerite Caminat and Baya in the 1940s is unclear, though he enjoyed a sphere of influence and remained convinced of the value of French-Muslim unity. See Neal McMaster, *Burning the Veil: The Algerian War and the 'Emancipation' of Muslim Women, 1954–1962* (Manchester: Manchester University Press, 2006), available on the Manchester Hive, file:///Users/ayk4/Downloads/null-9781526146182.00020.pdf (accessed July 30, 2023). Benhoura supported propaganda efforts made by the colonial government during the Battle of Algiers to convince Muslim women to remove their veils in the interests of "modernity." Much earlier, in January 1948, Marguerite wrote to Marguerite Maeght to say how happy she was that Baya would attend a gala at the Cercle Franco-Musulman without a veil (Caminat Papers). In 1958, a year after the anti-veil campaign, Benhoura was named by de Gaulle to a commission of Muslim elites to study a possible reform of Muslim marriage law and the statute of women. He opposed the reform with this much-quoted phrase: "For Muslims, personal law constitutes more than a mystique, it is the essence of their religion, which no human force will make them repudiate" (*Le Monde*, June 13, 1958). In a series of editorials published in *Le Monde* from 1957 to 1961, he defends de Gaulle and Muslim personal law, decries the separate but unequal electoral colleges in the Algerian Assembly, and speaks out strongly in favor of a "yes" vote for the French referendum on Algerian self-determination (*Le Monde*, September 23, 1959).

137 MARRY HER HIMSELF: Interview, Salima and Bachir Mahieddine, December 29, 2022.

137 MARGUERITE SAVED TWO LETTERS: Ould Ruis to Cadi Benhoura, February 12, 1953, and Ould Ruis to Marguerite Caminat, January 12, 1954, Caminat Papers.

138 THE SHOCK OF THAT SEPARATION: Interview with Salima Mahieddine, December 29, 2022.

138 WERE MARRIED: Exchange with Sibylle de Maisonseul, April 13, 2023, and notation on Marguerite Caminat's civil register (*état-civil*), courtesy Sibylle de Maisonseul.

138 YOYO MAEGHT REMEMBERS: Telephone interview with Yoyo Maeght, February 25, 2023.

138 ENOUGH GREEN PAINT: Baya interview with Moulay B, *La semaine de l'émigration*, December 12, 1984, quoted in *Baya: Femmes en leur jardin*, 261.

138 JEAN AND MIREILLE DE MAISONSEUL: See the account by Anissa Bouayed of Baya's return to painting, and the encouragement of Jean and Mireille de Maisonseul and of Mahfoud Mahieddine, "Baya: vie et œuvre," *Baya: Femmes en leur jardin*. The wariness around European interference in Baya's career is visceral in Zohra Sellami's unpublished essay "Le mystère de Baya," her interview with Baya in Blida, photocopy from *Sud*, November 1970, 59–62, courtesy Elaine Mokhtefi.

138 ARRESTED AND IMPRISONED: Jean de Maisonseul was a member of Albert Camus's movement in favor of a civilian truce in January 1956. In one of his rare public statements on the war after the failure of the truce, Camus wrote to *Le Monde* to protest de Maisonseul's arrest. See "Letter to *Le Monde*," May 28, 1956, https://www.lemonde.fr/archives/article/1956/05/30/une-lettre-de-m-albert-camus_2254949_1819218.html.

139 BAGS OF CLAY: Baya to Marguerite, December 13, 1962, Caminat Papers.

139 FIVE DIFFERENT WATERCOLORS: Baya to Marguerite, December 11, 1961, ff. Caminat Papers.

139 THE COLOSSAL TASK: *Miró: L'œuvre graphique*, ed. Marguerite Benhoura, Anne de Rougemont, and Françoise Gaillard (Paris: Musée d'art moderne de la ville de Paris, 1974).

139 AN EXAGGERATED VERSION: Telephone interview with Yoyo Maeght, Marguerite Caminat's goddaughter and author of *La Saga Maeght* (Paris: Robert Laffont, 2014), February 25, 2023.

142 BENEVOLENT ANGEL: Miró's personal dedication to Marguerite: *Revue de la Bibliothèque Nationale*, no. 35–38 (1990): 44.

142 JEAN DE MAISONSEUL: Douglas Johnson, Obituary: Jean de Maisonseul, *Independent*, June 14, 1999, https://www.independent.co.uk/arts-entertainment/obituary-jean-de-maisonseul-1100219.html, and inter-

view with Sibylle de Maisonseul, July 30, 2023. De Maisonseul was officially attached to the newly established French embassy in Algiers and paid by the French government as a *coopérant*, first in his administrative role in the museum and later as a faculty member at the University of Algiers.

143 NEGOTIATES WITH ANDRÉ MALRAUX: On the restitution to the Musée des Beaux-Arts of the French masterpieces, see Andrew Bellisari, "Colonial Remainders: France, Algeria, and the Culture of Decolonization (1958–1970)" (PhD diss., Harvard University, Department of History, 2018), https://dash.harvard.edu/handle/1/4927603/browse?type=subject&value=imperialism. De Maisonseul argued successfully with André Malraux, de Gaulle's minister of culture, that the work of Monet, Renoir, Delacroix, Pissarro, and Gauguin was part of Algeria's rightful artistic heritage. Despite Malraux's support, it took until 1969 for the French to return the three hundred paintings and drawings to Algiers.

143 HE PRAISES THE DIRECTION: Jean de Maisonseul, "Baya l'enchanteresse," catalogue de l'exposition Baya, Musée Cantini, Marseille, 1982–1983, reprinted in *Baya: Femmes en leur jardin*, 44.

143 A FIRST EXHIBITION: The brochure from the November 1963 exhibition at the Musée des Beaux-Arts (Caminat Papers) includes a list of the paintings exhibited in the Salle Ibn Khaldoun. In addition to Baya: Mohamed Aksouh, Hacène Benaboura, Abdullah Benanteur, Mohamed Bouzid, Abdelkader Guermaz, M'hamed Issiakhem, Mohammed Khadda, and Azouaou Mammeri. Baya's art is represented by ten paintings, the largest number by a single artist in the exhibition: *Femme et enfant*; *Femme à la cruche*; *Femme jouant avec un paon*; *Femmes bleues et rouges*; *Femme au bord de la rivière*; *Femme et enfant dans un intérieur*; *Femme et oiseaux en cage*; *Femmes au jardin*; *Femme au palmier*; *Femme en vert au grand paon*.

145 HOW STRANGE IT FEELS: Baya to Marguerite Caminat, July 11, 1963, Caminat Papers, quoted in *Baya: Femmes en leur jardin*, 263.

145 BAYA'S PAST AND PRESENT: "Le mystère de Baya," Zohra Sellami's unpublished essay, based on her interview with Baya in Blida, photocopy from *Sud*, November 1970, 59–62, courtesy Elaine Mokhtefi. A few more details on this publication and its author: *Sud* was sponsored by the Algerian Ministry of Culture, but when a new minister took over, the publication was suspended, and the interview never appeared. Sellami, who wrote regularly for the F.L.N. magazine *Révolution Africaine*, has a story as dramatic in its own way as Baya's. In 1971, she married the former Algerian president Ahmed Ben Bella, and joined him in a former French prison where he'd been detained since Houari Boumédiène deposed him in a 1965 coup d'état. *New York Times*, May 10, 1979.

146 SHONA TRIBES: On Frank McEwen and the Shona School: Frank McEwen, "Personal Reflections," in *Contemporary Stone Carving from Zimbabwe*, a photographic essay on the Yorkshire Sculpture Park (Yorkshire Sculpture Park,

1990), 26–31, and Frank McEwen, *The African Workshop School* (Rhodesia: Mardon Printers, n.d.). Ronald Penrose, who replaced Frank as the Fine Arts Officer for the British Council in Paris, portrays him with bemused affection as a man unwilling to reveal his origins. He praises his talent as a curator, his remarkable circle of artist friends, and his gift for navigation. To take up the directorship of the National Gallery of Rhodesia, McEwen sailed from Paris to Salisbury in a yacht he'd kept on the Seine. See Roland Penrose, *Scrapbook, 1900–1981* (New York: Rizzoli International, 1981), 226–27.

147 FRANK NEVER MENTIONED: Letter from Frank McEwen to Anne Thorold, January 26, 1991, Pissarro Archive, Ashmolean Museum, Oxford.

147 EASIER TO SAIL ON: On his life on the sea: McEwen's obituary says that he sailed by fishing boat from Toulon to Algiers in 1940. *London Times*, January 17, 1994, reprinted in https://africanartists.blogspot.com/2015/04/.

147 WOOD-PANELED LIBRARY: "Baya, une peintre algérienne derrière le miroir du postcolonialisme," France Culture, May 20, 2023. Alice Kaplan interviewed by Tewfik Hakem at the Musée des Beaux-Arts, France-Culture. https://www.radiofrance.fr/franceculture/podcasts/toute-une-vie/baya-1931-1998-une-peintre-algerienne-derriere-le-miroir-du-post-colonialisme-6783531 (accessed July 19, 2023).

147 THE NAME "MARCEL REBOUL": Drafted lists of Marguerite's suggestions for "personal friends to invite to the opening," dated 1947. Caminat Papers. On Marcel Reboul, see Alice Kaplan, *The Collaborator: The Trial and Execution of Robert Brasillach* (Chicago: University of Chicago Press, 2000).

149 SHE REPRESENTS TO ME: Salima Mahieddine to Alice Kaplan, electronic communication, January 20, 2023, with her authorization.

149 THE ALGERIAN POSTAL SERVICE: Stamped envelopes are conserved in Caminat Papers.

150 MENTAL LANDSCAPE: Sofiane Hadjadj, electronic communication to the author, August 17, 2022. On El Moustach, the pseudonym of Hicham Gaoua, see "El Moustache, Le Visage Humaniste du PopArt en Algérie," *The Casbah Post*, April 11, 2018, https://www.thecasbahpost.com/el-moustach-le-visage-humaniste-du-pop-art-en-algerie/.

150 CONFLICTING INTERPRETATIONS: In "La Prairie Amoureuse," a 1982 interview with Baya in *Algérie-Actualité*, Ameziane Ferhani defends the artist against the fierce criticism she faced: she was considered by some critics too decorative and insufficiently pictorial (an oblique reference to a 1970 article by Fethy Yellès in *Algérie-Actualité*), not experimental or self-theorizing enough, or—the ultimate accusation—"she works with the French" (after a show at the French cultural center). In the interview, Baya describes her difficulties working with the Gallery of the Algerian Union of Plastic Arts (l'UNAP) and the

challenge of juggling her national and international exhibitions with her family life. In "Baya, vie et oeuvre," *Baya: Femmes en leur jardin*, Anissa Bouayed recounts these challenges decade by decade, and documents the consecration of Baya's art through exhibitions in Tunis, Palestine, Lausanne, Morocco, Marseille, and her decision to remain in Algeria and continue to show her work during the decade of terror in the 1990s. In 1998, the year of her death, she attended a celebration of Algerian artists at the annual communist party "Fête de l'Humanité" in Paris. That same year, the Maeght Gallery in Paris organized a retrospective Baya show, publishing a catalog that included her 1947 work along with reprints of Breton and Peyrissac's contributions to *Derrière le miroir*. In "Seeing Baya Anew," *New York Review of Books*, May 11, 2023, I review two recent Baya exhibitions: *Baya: Femmes en leur jardin*, at the Institut du monde arabe in Paris (November 8–March 26, 2023) and its expanded version at La Vieille Charité in Marseille, "Baya: Une héroïne algérienne de l'art moderne" (May 11–November 26, 2023), which was extended after more than 100,000 visited the exhibition in its first five months. Exhibitions outside France have taken place in New York (2018, Grey Art Museum), Sharjah, United Arab Emirates (Sharjah Art Gallery, 2021), at the Abu Dhabi Art Fair (2022) and at the Venice Biennale, where three of her paintings represented Algeria in the central pavilion (2022). As this book goes to press, I've heard about at least three books devoted to Baya soon to be published in France and Algeria as well as seventeen works loaned by Algerian collectors and friends of Baya for an exhibition at the Guessoum Antique Gallery in Algiers, upon the twenty-fifth anniversary of her death, https://www.elmoudjahid.dz/fr/culture/vibrant-hommage-a-baya-mahieddine-guessoum-antiquites-et-ses-amis-au-rendez-vous-208301 (accessed November 15, 2023).

Index

Note: Page numbers set in italics refer to illustrations. Unattributed works of art are by Baya.

Abbas, Ferhat, 83, 85, 170n
Abdi, Bahia (mother), 17–18, 51, 53, 94–96, 125–26
Aboulker, Henri, 79, 83–85, 148
Aboulker, José, 79, 85
abstract expressionism, 85
abstraction, 128, 131
Achiary, André, 78
Agricultural Institute of Algeria, 68
Al-Bouraq (Prophet Mohammed's celestial steed), 37, *37*
Algeria: Baya's adult life in, 3, 136–46; Baya's art in, 143, 145, 147, 148, 149–50, *150*, 181n, 183n; Baya's celebrity in, 3; French painters' engagement with, 122; independence of, 143, 149; Jews in, during World War II, 24, 42–43, 82, 167n; nationalism in, 77, 82; politics in and concerning, 11–13, 20, 28–29, 62, 77–86, 138–39, 181n; violence in, 29, 77–79, 83–84, 170n. *See also* Algiers, Algeria; colonialism
Algerian Assembly, 80
Algerian Peoples' Party, 29, 77
Alger Républicain (newspaper), 20, 84, 129

Alger-Soir (newspaper), 123
Algiers, Algeria: Baya's celebrity in, 8–9, 143, 145–50; Baya's life with Caminat in, 2, 9, 26, 28, 46, 58–59; Baya's return to from Paris, 129; Camus and, 10–11; McEwen in, 23–24, 26, 42–44, 147
Amrouche, Jean, 9
âne bleu, L' [The blue donkey], *60–61*
Arabic language, 19
art brut, 10, 128, 130, 178n. *See also* outsider art
art of Baya: in Algeria, display/influence of, 143, 145, 147, 148, 149–50, *150*, 181n, 183n; beginnings of, 2, 4–6, 8–14, 26, 30, 32–34; birds as subject, 59, 73, 76, 97, 112, 115, 126, 151; Caminat as subject, 17, 21, 89, 91, 111–12; children's art as touchstone for, 26, 34, 46–47; color in, 1, 2, 6, 9, 11, 14, 37, 76, 104, 112, 143, 151; eyes as rendered in, 89; influences on/comparisons to, 37–39, 49, 73, 109, 112, 122–24, 128–29, 151; locations of, 110–12; McEwen and, 26, 34, 44, 46, 72–73, 87–88, 99, 109; Mireille Farges as subject,

art of Baya (*continued*)
36–37, 89, 114; mothers as subject, 53, 55, 73, 76, 112, 126, 149–50, 151; pause in painting, and resumption of, 138–39, 143, 145; recent exhibitions and publications of, 183n; reception of, 2, 5–6, 73, 109, 117, 120–28, 143, 182–83n; sales of, 14, 57, 89, 91, 102, 107, 109–10, 123, 137, 174n, 178n; shapes and patterns in, 14, 36, 37, 39, 73, 76, 128, 143, 151; signatures on, 126, 127, 149; skirts as subject, 14, 32, 33; spontaneous creativity ascribed to, 9, 11, 26, 121–22, 126–28; subject matter, 14; titles given to, 53, 110–11. *See also* paintings and drawings, Baya's; press coverage and popular portrayals of Baya; sculptures, origins of Baya's; *and individual works by title*

Arts and Letters (radio show), 100
Auriol, Jacqueline, 13, 95, 96, 126
Auriol, Jean-Claude, 13, 111
Auriol, Jean-Paul, 13, 111
Auriol, Michelle, 11–13, 100
Auriol, Vincent, 83, 111
Aurore, L' (newspaper), 83
automatic writing, 127

Balenciaga, 14
Baudelaire, Charles, 55
Beach, Sylvia, 88
Ben Bella, Ahmed, 181n
Ben Ghabrit, Si Kaddour, 11, 81–83, 100, 101, 103, 131, 171–72n
Benhoura, Mohamed, 39, 46, 56–57, 62–65, 84, 105–6, 136–39, 142, 179n
Bénisti, Louis, 71
Benjamin, Roger, 166n
Bensusan, Francis Jack Levy. *See* McEwan, Frank
Bensusan, Moses, 40

Bensusan, Samuel, 40–41
Bérard, Christian "Bébé," 11
Berber culture, 37, 39, 52
Berber language, 18, 73
birds, as subject matter in Baya's art, 59, 73, 76, 97, 112, 115, 126, 151
Blida, Algeria, 2–4, 136–38, 145, 149
Boas, Natasha, 39
Bonnard, Pierre, 8, 13, 123, 162n, 176n
Bordj el Kiffan, Algeria, 4–5. *See also* Fort-de-l'Eau, Algeria
Bouayed, Anissa, 19, 37
Boumédiène, Houari, 181n
Braque, Georges, 8, 13, 72, 100, 102, 120–21, 126, 128, 131, 134, 176n
Braque, Marcelle, 131
Brasillach, Robert, 14, 147–48
Breton, André, 9–10, 13–14, 21, 72, 84, 100, 102, 103, 122–24, 162n, 183n; Surrealist Manifesto, 127
Breton, Aube, 10
British Council, Paris, 44, 46, 71, 87, 121, 134
Bureau, Mademoiselle (tutor), 58

Cadi Benhoura. *See* Benhoura, Mohamed
Caminat, Marguerite: in Algiers, 23–24, 26, 84; appearance of, 22, 89; as an artist, 22, 39, 42, 62, 71; Baya's employment with, 24, 26–28; Catholicism of, 138; correspondence with Baya, 58, 88, 100–102, *101*, 131, 133–34, 137–39, 142, 145; correspondence with Sibon, 87–89, 91; correspondence with the Maeghts, 9, 13, 64–65, 96, 101–2, 107, 109, 115, 131, 178n; death of, 143; discovery of Baya's talent by, 2, 21, 26, 34; employment as an archivist in Algiers, 28, 37, 39, 46; employment as an archivist with Maeght Gallery, 91, 139, 142; at the

Farges farm, 20–22; first meeting with Baya, 21; French connections of, 13–14, 147–48; life shared with Baya, 9, 28, 46, 58–59; and Maeght Gallery exhibition, 13–14, 17, 87–92, 94, 97, 101–2, 109–10, 120–21; Marez-Darley's report to, 71–73; marriage to Benhoura, 138, 139; marriage to McEwen, 22–23, 28, 42, 64–65, 87, 147; McEwen portrait of, 27–28; and modernism, 6, 123; notes and documents relating to Baya, 2, 6, 20–21, 24, 28, 47, 50–53, 94, 96–98, 110, 117, 126, 136–37, 142–43, 177n; as recipient of proceeds from sales of Baya's art, 110; relationship with Baya, 6, 9, 13, 24, 26–28, 33, 50, 56–57, 64–65, 133–34, 136–39, 142, 179n; reliability of her information about Baya, 2, 6, 20–21, 50–51, 96, 99, 129; in retirement, 20–21; romance with Benhoura, 62–64; stewardship of Baya's art, 119; as subject in Baya's art, 17, 21, 89, 91, 111–12; in Vallauris with Baya, 130–31

Camus, Albert, 9–11, 62, 71, 83–84, 93, 105–7, 126, 134, 139, 148, 162n, 180n; *The Stranger*, 78

ceramic tableaux, 37

Cercle du progrès, 62

Cercle Franco-Musulman, Algiers, 37–38

Chadourne, Paul, 128

Chagall, Marc, 115, 127

Chanderli, Ibrahim Slimane, 56, 110, 136–37

Charles-Roux, Edmonde, 97–98, 117, 126

Charroux, Robert, 104–5

Chastel, André, 109

Chataigneau, Yves, 11, 39, 78–84, 101, 103, 126, 130, 148, 170n

Chesnay, Denise, 44, 46, 71, 131, 133–34, 178n

children's art, 26, 33–34, 44, 46–47, 72, 121–22, 176n

Clément, René, *Forbidden Games*, 46

Colline Gallery, Oran, Algeria, 71

colonialism, 3, 21, 57, 62–63, 77–85, 105–6, 122, 138–39, 148–50. *See also* France: and the politics of Algeria

Combat (newspaper), 79, 83, 84, 92–94

Copley, John Singleton, 41

correspondence, Baya's with Caminat, 58, 88, 100–102, *101*, 131, 133–34, 137–39, 142, 145

Courbet, Gustave, 143

Croix de Feu, 62

Cuttoli, Marie, 63–64, 79

Cuttoli, Paul, 79

Dachau concentration camp, 79

Dalí, Salvador, 115

"Dazzling Hands, The" (group of artists), 120, 131

Degas, Edgar, 143

de Gaulle, Charles, 78, 80, 179n

Delacroix, Eugène, 143, 181n; *Women of Algiers in Their Apartment*, 121, 122

Deltcheff, M. and Mme, 111

Dépêche, La (newspaper), 29

Derrière le miroir (exhibition brochure), 10, 58, 63, 97–98, 125

Desjardins, Arnaud, 134

Desjardins, Denise. *See* Chesnay, Denise

Deux femmes [Two women], *48*

Dinet, Nasreddine, 38

Dior, Christian, 14, 103, 105, 111, 115, 119

Djebar, Assia, 58

dresses and skirts: of Kabylia, 35; as subject matter in Baya's art, 14, 32, 33

Drouot auction house, 111

Dubuffet, Jean, 48, 128, 130, 178n

Duval, Raymond, 79

Index | 187

Écho d'Alger, L' (newspaper), 20, 29
École du Louvre, Paris, 93
education, 57–58, 81
El Gazali, Mohamed "El Haffaf," 29
Elle (magazine), 64, 94–96
El Moustach, 150
El Okbi, Cheik, 62
Estienne, Charles, 127–28
existentialism, 10
expressionism, 131

Farges, Henri, 13, 19–22, 24, 29, 30, 62, 66, 68, 85
Farges, Mireille, 19–20, 22, 30, *31*, 32–33, 58, 68–69, 89, 102, 114, 130–31, 136, 138, 142
Farges, Renée, 20, 22
Farges, Simone, 19–20, 24, 62, 66, 68, 136
Farges, Yvonne, 20, 22
Farges farm, 5, 19–22, 23, 24, 56, 66, 68, 76, 110, 112, 149
Fath, 14
Faure, Francine, 71
Femme aux cheveux bleus [Woman with blue hair], 89, *90*
Femme aux trois tapis [Woman with three rugs], 35–37, *36*
Femme avec chapeau mauve [Woman with purple hat], 114
Femme avec palmier [Woman with palm tree], *144*, 147
Femme candelabre [Candelabra woman], 132
Femme debout et femme couchée [Woman standing and woman lying down], *108*
Femme en vert au grand paon [Woman in green with peacock], 152–53
Femme et enfant en bleu [Woman and child in blue], 73, *75*, 76
Femme et végétations [Woman and vegetation], 111–12, *113*

Femme robe à fleurs blanches [Woman in white flowered dress], 14, *15*, 16
Femmes à la guirlande [Women with garland], 135
Ferhani, Ameziane, 182n
Focillon, Henri, 43
folk tales, told by Baya, 58, 97–99, 107
Fort-de-l'Eau, Algeria, 4, 19, 21, 24, 26, 30, 34, 56–57, 68. *See also* Bordj el Kiffan, Algeria
Fouchet, Max-Pol, 9, 71
France: Fourth Republic, 93; Nazi occupation of, 23–24, 30, 67–68, 82; and the politics of Algeria, 11–13, 20, 28–29, 62, 77–86, 138–39; postwar hardships in, 68–70, 86; United States' postwar relationship with, 85–86. *See also* colonialism; French Resistance; Paris, France
France Combattante, La, 20, 29, 62, 85
French language, 19, 57–58
French Resistance, 13, 20, 29, 30, 62, 78, 93, 117

Gallery of the Algerian Union of Plastic Arts, 182n
Gallimard, 10
Gauguin, Paul, 143, 181n
Gaumont, 123
Gide, André, 8, 142
Givenchy, 14
Gouin, Félix, 20, 22, 26
Gouin, Laure, 20–22
grandmother of Baya: Baya's legal emancipation from, 56–57, 91; Baya's life with, 4, 18–20, 53; Baya's mistreatment by, 51–52, 56; French fantasies of, 52, 92, 93, 94–96, 98–99; transfer of Baya to Caminat, 24, 26, 50
grand oiseau, Le, conte no. 9 [The big bird, tale no. 9], *98*

188 | Index

grand zoiseau, Le (folk tale by Baya), 58, 97, 99
Great Mosque of Paris, 11, 79, 81, 83, 100, 131
Greene, Graham, 88
Guelma, Algeria, massacre, 78–79, 170n
Guggenheim, Mme, painting bought by, 109, 111
Guggenheim, Peggy, 111
Guilly, René, 92–94

Haddad, Ali (brother), 4, 17, 19, 20–22
Haddad, Mohammed (father), 17, 51, 94, 125–26
Hadj, Messali, 29, 77
Hadjadj, Sofiane, 150
Hellal, Selma, 3
Hirshfield, Morris, 164n
Hitler, Adolf, 23, 83
Hopi Reservation, 122

Ingres, Jean-Auguste-Dominique, 36
Islamic miniatures, 37, 39, 128

Jews, 23–24, 42–44, 82
journalism. *See* press coverage and popular portrayals of Baya
Joute poétique [Poetic jousting] (anonymous ceramic artist), 38–39, *38*
Julien Levy Gallery, New York, 123–24

Kabylia, Algeria, 3, 18, 35, 52, 93, 96, 112, 128
kafala (regime of protection for children), 57
Kahlo, Frida, 123–24, 177n
Kandinsky, Wassily, 128
Kennedy, John F., 80–81

Laggoune-Aklouche, Nadira, 39
Lançon, Philippe, 66

Lebanon, 78
Le Clerc, Xavier (born Hamid Ait Taleb), 96–97
Leclerc de Hauteclocque, Philippe, 69
Littoral (magazine), 42
Longo, Maria-Teresa, 40
Louvre, Paris, 107

Madoura pottery workshop, Vallauris, France, 131, *132*, *133*
Maeght, Adrien "Dédé," 102
Maeght, Aimé: advice concerning Baya's art, 119; Baya's art in collection of, 14, *15*, *16*, 143; and Baya's folk tales, 58, 97–99, 107; commission received by, 109; correspondence with Caminat, 9, 13, 64–65, 96, 101, 107, 109, 178n; documentaries of, on modern artists, 123, 176n; host of Baya in Paris with family, 64–65, 69–70, 100–103, 105, 107, 109, 131; introduction to Baya's art, 8–9, 28, 63, 72, 95; and the politics of Baya's gallery show, 11–13; press coverage arranged by, 65, 99, 115; promotion of Baya in United States, 85, 107, 109; sales of Baya's work, 85–86, 89, 91, 107, 109–10, 174n; and surrealism, 10. *See also* Maeght Gallery, Paris
Maeght, Bernard, 70, 100, 102, 129, *130*
Maeght, Marguerite "Guiguite," 14, 69–70, 100–103, 106–7, 115, 119, 121, 129, 131
Maeght, Yoyo, 138
Maeght Gallery, Paris: Baya's exhibition at, 8–16, 39, 77–86, 88–89, 91, 100–103, 117, 120–22, 125–28, 143, 148, 151; Caminat as archivist with, 139, 142, 143; Chesnay's work shown in, 134, 178n; political significance of Baya's exhibition at, 11, 13, 77–86, 105–6; retrospective of Baya's work

Index | 189

Maeght Gallery, Paris (*continued*) in, 183n; visitors to Baya's exhibition at, 9–14, 78–79, 81–84, *82*, 88–89, 101–2, 120–22, 126, 162n. *See also* Maeght, Aimé

Mahieddine, Bachir (son), 4, 53, 146, 149

Mahieddine, Baya: ancestors of, 3; appearance of, 2, 4, 14, 53, 117, 145–46; beginning of art career, 2, 4, 6, 8–9, 26, 30, 32–34; children of, 3, 4, 137, 139, *140–41*, 149; death of, 183n; employment with Caminat, 2, 24, 26–28; farm work, 2, 4–5, 19, 20–22; hardships of, in youth, 20, 47, 51–52, 56–57; interpretations of the life of, 150–51; legal emancipation of, 56–57, 62, 91; literacy of, 6, 57–58, 97, 99, 139; marriage of, 137–39; muteness of, when first living with the McEwens, 21, 50; name of, 126; parents of, 17–18, 51, 53–56, 94–96, 125–26; personality of, 50; photographs of, *viii*, 12, 21–22, 23, 25, 59, 74, *82*, *104*, 115–19, *116*, *118*, 125, *129*, *130*, *133*, *140–41*; physical maturation of, 70, 109; receipt of proceeds from sales of art, 110; statements about art, 11, 127; tuberculosis, 129; uncle of, 4, 18, 56; youth in Algeria, memories and tales of, 39, 50–55, 96; youth in Algeria, sensory experiences of, 35. *See also* Algeria; Algiers, Algeria; art of Baya; correspondence, Baya's with Caminat; folk tales, told by Baya; grandmother of Baya; Paris, France; press coverage and popular portrayals of Baya

Mahieddine, Mahfoud (husband), 137, 139, *140–41*, 142

Mahieddine, Salima (daughter-in-law), 3–5, 53, 55, 148–49

Maisonseul, Jean de, 138–39, 142–43, 146, 180n, 181n

Maisonseul, Mireille de. *See* Farges, Mireille

Maisonseul, Sibylle de, 19–20

Malraux, André, 67, 143, 181n

Manet, Édouard, 36

Marc, Franz, *The Large Blue Horses*, 2, 112

Marchand, André, 120–21

Marez-Darley, Nelly, 71–73, 76, 85–86, 91, 99, 101, 103, 109, 111–12

Margaret, Princess, 146

Marie-Claire (magazine), 33

Matisse, Henri, 8, 13, 16, 39, 72, 100, 109, 112, 121–23, 127–29, 176n

Mauriac, François, 10, 11, 84

Maywald, Willy, 115; photographs of Baya, 12, 74, 115–16, *116*

McEwen, Frank, 40–49; in Algiers, 23–24, 26, 42–44, 147, 166n; appearance of, 22, 42, 88; artistic training of, 40; and Baya's art, 26, 34, 44, 46, 72–73, 87–88, 99, 109; Baya's early drawing of, *45*; and Chesnay, 44, 46, 71, 131, 133–34; child of, 40–41; and children's art, 26, 34, 44, 46–48, 47, 72, 121; finances of, 22, 40–42, 44; Jewish heritage of, 23–24, 40; in labor service, 71; Marez-Darley and, 71–72; marriages of, 40, 42; marriage to Caminat, 22–23, 28, 42, 44, 64–65, 87, 147; mental and physical health of, 41; obituaries of, 147; painting restoration work of, 40–42, *43*; in Paris, 46, 71–72, 87–88, 99, 101–2, 121, 131, 133–34; Penrose on, 182n; photograph of, *43*; portrait of Caminat, 27–28; in Rhodesia, 146–47; as spy, imagined, 71, 169n

McEwen, Stewart, 23, 41

Memmi, Albert, 59

Miró, Joan, 131, 139, 142, 176n

Moch, Jules, 130
modernism: Baya's relationship to, 123; Caminat and, 6, 123; and children's art, 121; French painters' engagement with Algeria, 122; and non-Western cultures, 6, 121–22
Modes et travaux (magazine), 32, 33
Modigliani, Jeanne, 72
Mohammed, Prophet, 37
Monde, Le (newspaper), 104
Monet, Claude, 143, 181n
mothers, as subject matter in Baya's art, 53, 55, 73, 76, 112, 126, 149–50, 151
Musée des Beaux-Arts, Algiers, 143, 146, 147, 148
Museums of France, 93
Mychkine, Sara, 21

Napoleon, 3
Napoleon III, 143
National Assembly, France, 79, 80, 85
Native Americans, 122
Nazis, 9–10, 23, 30, 67–68, 82–83, 112, 148
Nepo, Arik, portrait of Baya, 117, *118*
newsreel featuring Baya, 2, 81, 103, 123

Oiseau en cage entouré de deux femmes [Caged bird surrounded by two women], 145
orientalism, 37–39, 122, 128
Ostier, André, 115; photographs of Baya, *viii*, *116*, *129*, *130*
Ould Ruis family, 136–37
Oulémas, 85
Ouragui, Youcef, 2–3
outsider art, 48. *See also* art brut

paintings and drawings, Baya's: kitchen table as site of creation, 4, 146; origins of, 4, 32–33; paintings within, 16, 17. *See also* art of Baya

Paintings by English Children (exhibition), 44, 46–48, *47*, 121
Palais d'Hiver, Algiers, 39, 63
Palais Oriental, Algiers, 39, 64, 168n
Paris, France: arrangements for Baya in, 63–64, 66–70; Baya hosted by the Maeght family in, 64–65, 69–70, 100–103, 105, 107, 109, 131; Baya's clothing in, 64; Baya's departure for, 63–65; Baya's gallery show in, 11–14, 77–86, *82*, *88*–89, 100–103, 105–6, 117, 120–22, 125–28, 148, 151; Baya's life in, 70, 100–109; Baya's return from, 129; beginning of Baya's art career, 2, 5, 9–14; British Council in, 44, 46, 71, 87, 121, 134; Marez-Darley's account of Baya in, 71–73
Paris Museum of Modern Art, 100, 107, 123
Parti Populaire Algérien, 29, 77
Penrose, Ronald, 182n
petit écho de la mode, Le (magazine), 33
Peyrissac, Jean, 8–9, 13, 17, 63–64, 71, 98–99, 110, 123, 125–26, 143, 177n, 183n
Piaget, Jean, *The Child's Conception of the World*, 122
Picasso, Pablo, 39, 115, 121–23, 128, 131, 133, 134, 176n; *Women of Algiers* series, 121
Pissarro, Camille, 40, 143, 181n
Pissarro, Esther (née Bensusan), 40–44
Pissarro, Lucien, 23, 40–44, 147
Popular Front, 62
Porter, Katherine Anne, 86, 88
postage stamp designs for the *Protection de la mère et de l'enfant*, 149–50, *150*
press coverage and popular portrayals of Baya: annoyances of, 70, 89, 102, 115, 130; criticisms of, 89, 91–96; journalists' questions and Baya's answers, 11; Maeght's arrangement

Index | 191

press coverage and popular portrayals of Baya (continued)
 of, 65, 99, 115; misconceptions and falsehoods in, 52, 88–89, 91–99, 93, 104–5, 117; names of gallery opening attendees, 120; newsreel featuring Baya, 2, 81, 103, 123; photographs in, 115–19; spontaneous creativity imputed to Baya, 11, 95, 121–22, 126–28
"primitive" art, 128. See also art brut; outsider art

Racim, Mohammed, 37–39, 166n; *Al-Bouraq*, 37–38, 37
Racim, Omar, 37
Radoudia (aunt), 51
Read, Herbert, 46, 121, 176n
Reboul, Marcel, 14, 147–48
René, Denise, 134
Renoir, Pierre-Auguste, 143, 181n
Resistance. See French Resistance
Retour de la Chasse, Algeria, 17
Rêve de la mère [Dream of the mother], 53, 54, 55
Rideaux jaunes [Yellow curtains], 17, 18, 21, 111
Rivera, Diego, 177n
Rivier, M. and Mme, 123
Romance (boutique), 119
Rossellini, Roberto, *Rome, Open City*, 46

Saâl, Bouzid, 77
Saint Catherine's Day, 103
Scarlett O'Hara (fictional character), 30
sculptures, origins of Baya's, 34. See also art of Baya
Ségal, Simon, 167n
Sellami, Zohra, 145, 181n
Senac, Jean, 165n

Sétif, Algeria, massacre, 29, 77–79, 83, 85, 138
Shona tribal art, 146–47
Sibon, Marcelle, 84, 86–89, 91, 99, 109, 111–12
Sidi M'Hamed tribe, 3, 17, 18–19, 53
Signoret, Simone, 19
skirts. See dresses and skirts
Smadja, Henri, 93
Sorbonne Université, Paris, 40, 43
Special Organization of Algerian revolutionaries, 84–85
Staron, Claude, 14, 109, 111, 119
Statut de l'Algérie (1947), 80
strelitzia, 19–20
surrealism, 9–10, 26, 124, 127–28, 131

Thévoz, Michel, 48
Toulon, France, 4, 13–14, 22, 27, 33, 41, 87
Tubert, Paul, 29

United States: cultural and economic significance of, 85–86; Maeght's visit to, 85, 107, 109

Vallauris pottery studios, France, 121, 130–31
veiling, 179n
Vérane, Léon, 42, 167n
Vichy France, 24, 82, 167n
Vogue (magazine), 102, 103, 117, 124

Wertheimer, Agnès, 112
Wertheimer, Françoise, 67
Wertheimer, Marcel, 67–68, 114; photograph of Baya on the Farges farm, 25
Wertheimer, Philippe, 67–69
Wertheimer, René, 67, 112, 168–69n
Wertheimer, Rosine, 67, 69, 131

Wertheimer, Rosita, 66–70, 99, 100–103, 106, 109, 112, 115, 119, 121, 131, 169n; host of Baya in Neuilly, 64, 66–67, 68–70
witchcraft, 52, 92, 93, 94–96, 98–99
Woman with Yellow Vase between the Curtains, 109, 111
Wood, Frances, 40–41
World War I, 126

World War II, 9–10, 20–24, 44, 67–68, 126, 147. *See also* French Resistance

Young Painters of the Paris School (exhibition), 134

Zimbabwe, 146